2/05

Food in Painting

Food in Painting

FROM THE RENAISSANCE TO THE PRESENT

Kenneth Bendiner

REAKTION BOOKS

For Nancy, Ezra, Mayumi, Zachary and Claire

Published by Reaktion Books Ltd
79 Farringdon Road
London EC1M 3JU, UK
www.reaktionbooks.co.uk

First published 2004
Copyright © 2004 Kenneth Bendiner

Printed in Hong Kong

British Library Cataloguing in Publication Data

Bendiner, Kenneth, 1947–
 Food in painting: from the Renaissance to the present
 1. Food in art 2. Art, Modern 3. Art, Renaissance 4. Art, European
 5. Art, American
 I. Title
 704.9'496413
 ISBN 1 86189 213 6

Contents

Introduction

'A dinner which ends without cheese is like a beautiful woman with one eye.' That is Aphorism no. XIV in Jean Anthelme Brillat-Savarin's *The Physiology of Taste* (1825), a meditation on eating that employs the science of nutrition, philosophical speculation and personal history to analyse the savours of the table.[1] In a mere fourteen words, this French royalist gourmet alluded to the digestive aid purportedly offered by cheese, the proper order of dinner courses, the horror of mutilation, the alliance of visual tastefulness with the taste of the palate, and the mingling of food pleasure and sexual pleasure. Brillat-Savarin's charmingly imperious tone remains inimitable. But his breadth and brevity are not, and this book similarly takes up a wide range of themes about food in a few pages. But it examines food and its history only as they appear in paintings since the fifteenth century; and it is as much about art as it is about cuisine.

This book includes art from the confident era of the Renaissance to the caustic period of Postmodernism. For most of this time, food images represent material contentment. Pop Art in the 1960s began to mock this soothing vision of food, and Postmodern artists, after 1970, continued the assault. Still, most food paintings presented in this book express a deep physical satisfaction, and that pleasure is the focus here.

The chapters of this book chart the passage of food from purveyor to belly and beyond. Chapter One discusses paintings of the gathering and selling of food; chapter Two, the preparation of food; chapter Three, the meal; and chapter Four, food's purely symbolic and decorative representation. Each chapter attempts to treat the images chronologically, but at times the linear pattern is broken to amplify a point or draw a larger connection.

This is not an artist-centred examination of great masters of food painting. The emphasis is on the ideas, sometimes unconscious, that underlie pictures of feasts and dead animals and fruit

and silver. But the images play a greater role than mere illustrations of some historical change in diet or culinary method. The book concentrates on the paintings. It examines eating habits, class distinctions, new-found edibles, literary associations, and the religious and medical beliefs of various societies and periods in order to enrich the appreciation of the images. This book, however, is not an artificial gathering of unrelated works – an invented excuse to study the social contexts of individual images. There is a genuine history in the grouping of paintings, a lineage outside the usual movements and divisions of Western art history.

Food paintings constitute a separate line of development that passes through the linear course of art history. Food images echo and revise their predecessors, incorporating the character of their different societies, but they are never quite divorced from their own particular history as depictions of food. One can say the same of Crucifixion images, ruler portraits or battle scenes down through the centuries. As in those cases, the meanings and innovations of individual paintings and their periods come through more powerfully when studied as a distinct group, because the changing variables become more apparent. Seventeenth-century Dutch artists developed the vital core of food imagery. Earlier food paintings now seem more important in the light of what Dutch painters in the seventeenth century wrought from them. And much food painting afterwards looked back to the seventeenth-century Dutch Republic for direction and ideas and appropriate form.

Despite the fact that people have long considered specific kinds of food as badges of group identity, for more than two hundred years the history of art shows nothing but Dutch menus in meal paintings. There are almost no Italian paintings of spaghetti; or French paintings of bouillabaisse or *bœuf bourguignon*; and only a few pictures of American hotdogs before the 1960s. For most of the time, the conventions of Dutch food imagery dominate any scent of nationalism or regionalism. However, certain kinds of food subjects – tea parties and restaurant scenes, for example – did not find their definitive modes in the Baroque Netherlands, and while a twentieth-century artist such as Henri Matisse owed much to the explosion of food painting in the seventeenth-century Netherlands, he also built upon other sorts of food images, such as those of Paul Cézanne. The history of food paintings depends on more than seventeenth-century art, and this book sets out to do more than just identify the significant monuments. It aims to portray the whole broad range of food painting, and it is the entire lineage of imagery that counts.

Although this book presents some theoretical frameworks for understanding food imagery, especially 'fetishism' as conceived by Marx and Freud, and the anthropological views of Claude Lévi-Strauss, doctrinaire pronouncements and unrealistic interpretations are avoided as much as possible. One morning in Amsterdam, while queuing to get into the Rijksmuseum, a man stood in front of me who must have weighed over 130 kilograms. At the time, I thoroughly believed those art historians who, with all kinds of support from contemporary emblem books and inscriptions on prints, claimed that most seventeenth-century still-life paintings of food condemned worldly pleasure. Such subjects were so-called *vanitas* images. Edibles of all sorts symbolized the insubstantiality of material life.[2] But I also suspected where in the museum I would find the big man. And I found him where expected, staring at canvases of cooked fish, hams, pies, grapes, plucked geese, sausages, cabbages, lemons, apples, pears, ale, wine, salt and costly spices. The finger wagging had turned somehow into lip smacking. If the painters and their patrons had intended to criticize and dampen the taste for the fleshly delights of palate and stomach, they had evidently failed, or maybe failed to recognize the tempting smell of reality beyond the moral ideal involved. In this book, an open-minded approach prevails.

MEDICINE

A number of important themes occur in more than a single chapter. The alliance of food and medicine, for instance, appears everywhere and can involve matters far different from modern notions of nutritional health. Ancient medical beliefs pervade food images from the Renaissance far into the nineteenth century. An outdoor still life of 1826–7 by Eugène Delacroix (illus. 1), for example, includes cooked lobsters in a pile of dead game – an unlikely combination, yet partly explicable as a picture of the foods that physicians traditionally recommended to be eaten together. For centuries, artists had displayed dead game fowl and hares alongside cooked lobsters in kitchens, larders and the field (illus. 2). They did so because these kinds of foods supposedly balanced each other for better health.

According to the medical concepts of Galen and other ancient writers, followed by physicians throughout the Middle Ages and beyond, each individual person had a particular temperament, composed of four elements: air (which was warm and moist), earth (which was cold and dry), fire (which was hot and dry) and

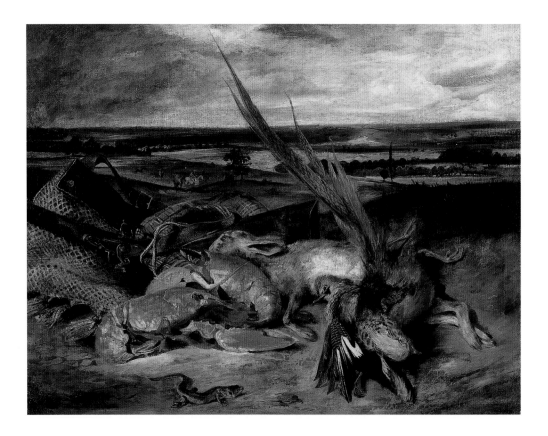

water (which was cold and wet). Similarly, every foodstuff had a particular character of warmth and coldness, dryness and wetness (usually identified with its watery, fiery, earthly or airy habitat).

In this scheme of things, the goal of a good diet was to prevent an individual's temperament from becoming unbalanced. To achieve this, the diet should not have a preponderance of any one elemental quality. The dryness of a certain food should be countered by combining it with foods of a wet character. Foods that are warm and wet should be combined with foods that are dry and cold. And so on. Cooks in the Middle Ages and Renaissance spent a great amount of time chopping and mashing foods, because good health depended on a thorough mixing of opposites. Things were complicated because there were four degrees of each elemental character, and the means of cooking also affected the degree of dryness, or coldness, etc., of any food. For example, boiling food added some wetness and warmth. Roasting added dryness, as did salting. Physicians could argue about the specific degree of coldness or wetness that a food might possess, and about the character of individual temperaments, but they accepted

1 Eugène Delacroix, *Still-life with Lobsters* (1826–7), oil on canvas. Musée du Louvre, Paris.

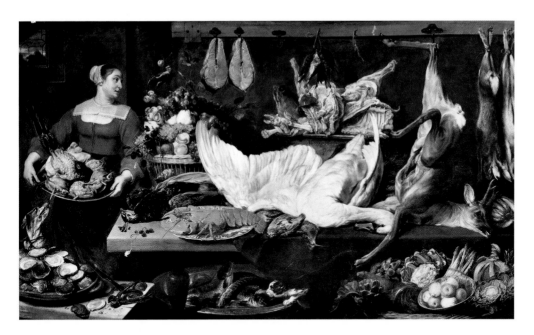

2 Frans Snyders, *The Pantry* (*c.* 1620), oil on canvas. Musées Royaux des Beaux-Arts de Belgique, Brussels.

the basic premises of this system for hundreds of years. The balance of foods at meals was the most important part of dietary health.[3] In some ways, the idea is not so different from modern directives to eat a proper range of proteins, carbohydrates, etc., at each meal. The inculcation to drink white wine with fish and fowl, still current, probably derives from this ancient scheme of medicine. Different wines have different degrees of 'dryness', and the 'dryness' of white wine was the corrective for the 'moistness' of fish and birds of the air. The need for balance also extended to qualities of taste, and in the Middle Ages and Renaissance sweetness had to be balanced by bitterness (or sourness). Sweet-and-sour sauces and bittersweet ingredients appear repeatedly in fourteenth- and fifteenth-century cookbooks.[4]

The pronouncements of ancient science, no matter how unscientific they seem today, underlie a great deal of art. One of the early painters of food market pictures, Joachim Beuckelaer, for example, produced a group of four market paintings of the four elements – air, earth, fire and water – each image devoted to the foods of one particular element.[5] Beuckelaer's understanding of food might not have been very different from Delacroix's two hundred years later. Delacroix's lobsters undoubtedly have the properties of wetness and coldness to balance the relative dryness and warmth of the land-bound hare and air-borne European jay nearby. The pheasant, largely a ground bird, but able to fly at low altitudes for short distances, was widely considered the most

perfectly balanced of foods.[6] Even a progressive nineteenth-century food writer such as Brillat-Savarin, who prided himself on his modern scientific understanding of diet and digestion, occasionally fell back on ancient medical lore, and mentioned foods that 'heat' the body, and those that 'cool' the organs, etc., very much in the tradition of Galen. Brillat-Savarin's book on the physiology of taste was published at the same time that Delacroix exhibited his lobster still-life painting.

THE BIBLE

Religion, even more than medicine, infiltrates much food painting and cannot be neatly contained in a single chapter. Several potent eating episodes in the Bible affected deeply a whole range of food imagery in the West. Painters often depicted the Marriage Feast at Cana, the Miracle of Loaves and Fishes and the Supper at Emmaus. But the most theologically significant food scenes, painted again and again, relate to the Garden of Eden and the Last Supper. The fruit of Eden remains unnamed in the Bible, but from the sixteenth century onward it almost universally appears in representations of the Fall of Man as an apple.[7] Hugo van der Goes's slinky portrayal of *Adam and Eve* (illus. 3), painted around 1470, is a prime example of the subject. St Augustine of Hippo most strongly interpreted the fruit-eating sin of Adam and Eve as a metaphor of sexual inter-course, and his linkage of fruit and sex stuck. In van der Goes's painting, the large apple is coloured like the flesh of the two miscre-ants and their devilish tempter. The un-Classical nudity of the fifteenth-century Northern figures, awkward and skinny, serves to heighten the licentious tone of the image. In van der Goes's depic-tion of fruit-plucking, the exact moment when a living organism turns into an object is shown. The sin is manipulable, alterable, an inanimate thing of still life at the disposal of mankind's will. That the Fall of Man came of eating, that the consumption of food could be a metaphor of the acquisition of forbidden knowledge, gives the subject of food, one would have thought, an enormous importance in Western culture. Ironically, perhaps to play down the centrality of eating in our lives and as a vision of sin, food imagery in the arts has almost always ranked low, a matter of vulgar comedy or anti-heroic ordinariness. Nevertheless, the sinful fruit in van der Goes's painting look delicious. The act of sin here becomes not offensive but understandable, in both edible and sexual terms.

Certainly no painter during the centuries under discussion ever forgot the connection between fruit and fornication, and the intro-

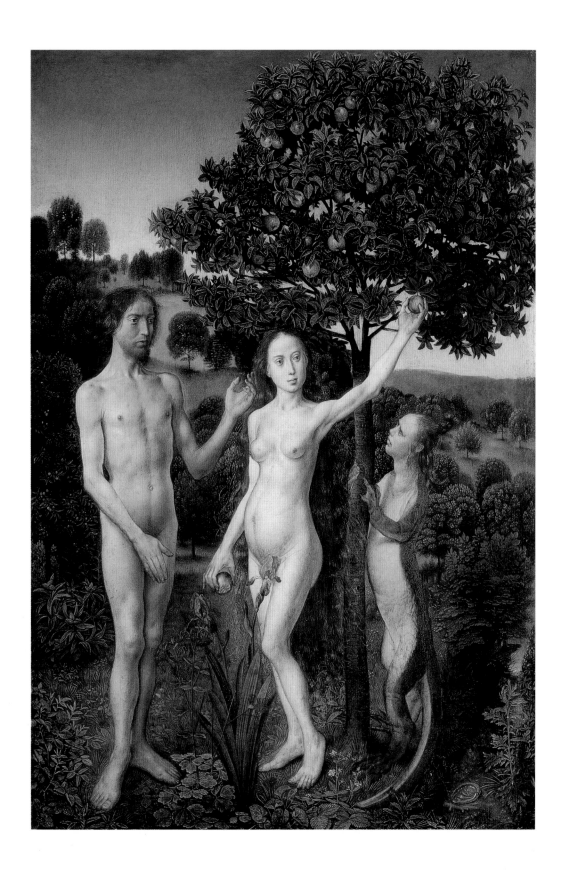

duction of man into a world of mortality in consequence. Here is a food that irreparably stands for our inevitable death on earth, outside paradise, as well as the seductive nature of sin. Even Mary Cassatt, habituated throughout most of her career to the anti-symbolic and the anti-mythological tenets of realism, could not forget the example of Eden late in the nineteenth century. In an eighteen-metre mural for the Woman's Building at the World's Columbian Exposition of 1893 in Chicago, she depicted women picking fruit. As she explained in a letter of 11 October 1892 to Bertha Palmer, they were 'young women plucking the Fruits of Knowledge and Science'.[8] Cassatt's fruit pickers, it can be assumed, rework the theme of Eden anew, doing away with traditional associations of sin. Cassatt rejected the apple's conventions, but used those conventions to make her point. The paintings that she derived from her mural project in the 1890s continue the theme of Eden, enriching it with close-up images of meditative fruit-pickers, staring into space or at the objects of their attraction with gravity and deliberation. In one, a naked baby held by a nurse or young mother strains for an apple on a tree (illus. 4). The whole series of pictures appears to be Cassatt's contemplation of the chief subject of her art – the care of children. Unmarried and childless herself, she seems to contemplate the meaning of sex and its consequences, the sins of Eden and the charms of babies. She offers no conclusion to these thoughts, only their gravity. Her grandiose musings on humanity, deliberately open-ended, are typical of late nineteenth-century Symbolism, and, like many food paintings of the time, such works attempt to probe the depths of meaning in the stuff we eat.

In paintings of traditional biblical subjects, such as Michelangelo da Caravaggio's *Supper at Emmaus* (illus. 96), the apples and other fruit in the basket on the tavern table almost automatically take on a symbolic religious power. In this scene of the resurrected Christ revealing himself to his astonished disciples, the grapes suggest the wine of Holy Communion, and the apple here might identify Jesus as the New Adam, who counteracts the Fall of man from Paradise. Even Caravaggio's selection of autumnal fruit (and the slightly rotten appearance of that fruit) have been interpreted as references to Christ's death – the season of dying equated with his mortality.[9] On the other hand, very similar fruit appears in Caravaggio's famous still-life, the *Basket of Fruit* (illus. 5), but here the religious implications are less certain. Furthermore, he also included apples and other fruit in several playfully homoerotic paintings of sensuous young men – and while allusions to sin (with the

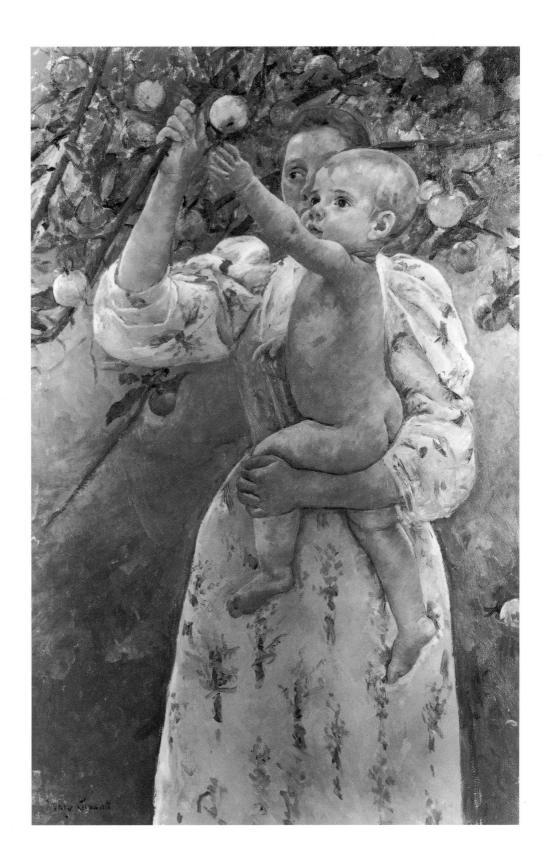

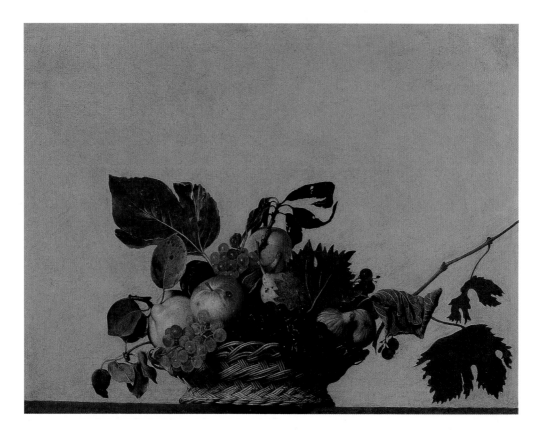

Garden of Eden in mind) might be invited in such works, one would hesitate to call the fruit serious religious imagery in these cases.[10] Not every apple in art deals with Adam or Eve or Christ or death. The context of the depicted apple must be assayed – within the image, within the artist's œuvre and within the society in which the work was produced.

Apples in art can have non-biblical meanings as well. For example, in the Judgement of Paris, a mythical beauty contest of Greek goddesses, the mortal Paris gave an apple to Aphrodite (the Roman Venus) as the winning prize, and, from the sixteenth century onward, numerous artists painted that storied beauty pageant with fruit as the great symbol of sexual power (illus. 6).[11] Furthermore, many artists also created portraits of women with apples and other luscious fruit as accessories. The fruit in such works allude to the Judgement of Paris, and pay tribute to the women's beauty. The fact that Paris's apple of discord eventually led to the Trojan War did not seem to hamper fruit as female insignia. In this context, the fruit becomes a symbol of pagan allure, not biblical sin. In some portraits, a servant offers fruit to a beautiful woman – as Paris did

5 Michelangelo da Caravaggio, *Basket of Fruit* (*c.* 1600), oil on canvas. Pinacoteca Ambrosiana, Milan.

opposite:
6 Niklaus Manuel Deutsch, *Judgement of Paris* (1517–18), tempera on canvas. Offentliche Kunstsammlungen, Basel.

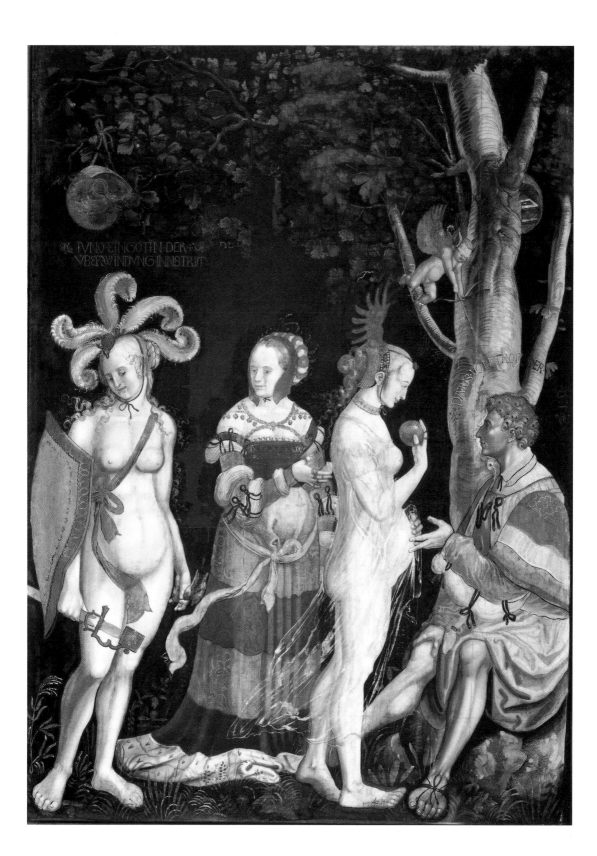

to Venus; in others, the fruit merely accompanies the woman and hints at her likeness to the goddess of love. Even in the late nineteenth century, in Valentin Serov's portrait of the innocent-looking Vera Mamontova with peaches (illus. 147), the myth of fruit as a beauty prize, even if not always apples, still plays a role. Eve and Venus are both queens of eroticism, but their broader meanings and contexts differ, and in looking at paintings of fruit, it is wise to distinguish the fruit of Eden from the apple of the Judgement of Paris.

Equal in importance to the Old Testament Eden episode are the New Testament passages describing the Last Supper. Here is the most powerful vision of eating conceivable – food is a means of becoming one with God, as well as a representation of Christ's sacrifice for mankind. Jaime Huguet's fifteenth-century rendering of the subject (illus. 88) depicts the crucial moment when Christ holds out the chalice of wine and claims that this is his blood. Of course, the bread on the table, which Christ declared to be his body, is also shown. (Note too the apple on the table – a sign that Christ is the 'New Adam'.) The ingestion of wine and blood becomes a communal act, binding the eater with the deity. In the Roman Catholic Church, the wine and wafer consumed during Communion are held to be literally the body and blood of Christ, but even outside Catholicism, bread and wine can easily take on profound religious resonance, given the scriptural presentation of the Last Supper. The cooked lamb that is also visible in Hughet's *Last Supper* indicates not only the proper food of the Jewish Passover, which Jesus and his disciples were celebrating, but also the martyrdom that Christ will soon undergo for mankind, likening Jesus to a sacrificial lamb.

Although Christ is often represented as a lamb in art, it is very rare, except in Last Supper images, to see him alluded to with a cooked lamb. The bread and wine of the Last Supper, given immense significance by Christ's own words, are another matter. They are highly potent and frequent symbols of Christ and his sacrifice, and of communion with him. As with apples, however, one must be cautious. It is often difficult to ascertain whether a picture of bread, no matter how humble the context, might signify Christ's body, or the Holy Communion, or simply Christian faith. Again, the specific context, the other elements in the image, the general outlook of the artist and the society in which it was produced must all be taken into account. Wine, grapes, wheat or any form of biscuit are all open to this Christian interpretation.

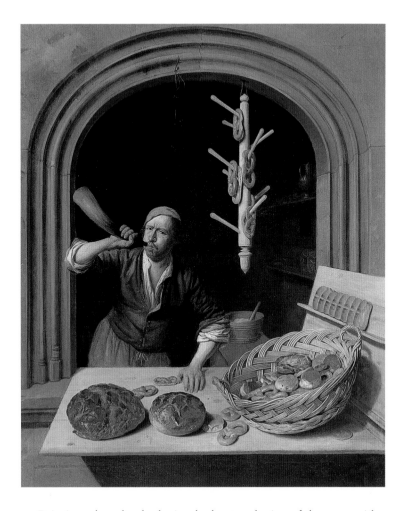

7 Job Berckheyde, *Baker* (*c.* 1681), oil on canvas. Worcester Art Museum, Massachusetts.

Paintings that clearly depict the host and wine of the mass with chalice and other accoutrements of the ceremony, or that show Christ instituting the Eucharist as a sacrament of the Church, are unambiguous. But what about Job Berckheyde's painting (illus. 7) of a baker? Is this merely a portrait of a Dutch shopkeeper, trumpeting the readiness of his wares to be sold? Breads, rolls and pretzels are displayed, crisp and glowing. Above the vat of flour or dough, on a shelf at the right, is a ewer that might contain wine. The Calvinist sensibility of most of the Dutch Republic in the seventeenth century, the happy commercialism of the scene as a whole, and the lack of any definite Christian devices or symbols strongly suggest that the painting is not an image about Christ or the Eucharist or anything religious.

A painting of 1910 by the Hungarian artist Adolf Fényes, titled *Poppy Seed Cake* (illus. 8), presents a fascinating case. The

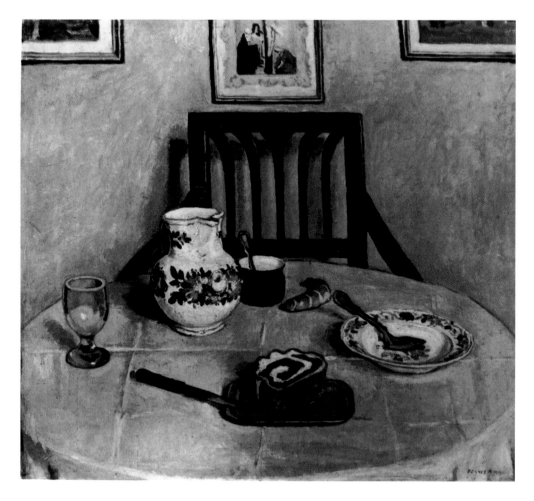

humble objects depicted on the clean white tablecloth might seem to be the most ordinary teatime accessories. In a modestly informal arrangement, the painter shows an empty wineglass, a white jug decorated with flowers, a small pot of sugar or cream, a croissant and an empty bowl with large serving spoon; in the foreground is a piece of poppy-seed cake on a small tray with a knife. The pattern of the cake and its overall shape are wonderfully undulant. Giving a majestic structure to this array of food and serving utensils is the armchair in the centre of the picture, firm and architectonic. And directly above the chairback hangs a painting, only partially visible, yet easily discernible as a depiction of the *Crucifixion* with weeping figures at the base of the Cross. Two additional pictures, on either side of the central *Crucifixion*, cannot be read, but their symmetrical balance gives a hint of grandeur to what seems an ordinary breakfast nook. Is the Christian picture

8 Adolf Fényes, *Poppy Seed Cake* (1910), oil on canvas. Hungarian National Collection, Budapest.

within the picture merely the usual decor of an early twentieth-century Hungarian house? Or is this an indicator of the painting's religious theme? Do the croissant, bread and wineglass constitute a delicate avowal of Christian faith? Or are they the ordinary appurtenances of a charming home? The Christian interpretation wins my vote. The compositional factors give great weight to the *Crucifixion*, and the careful placement of the other items further suggests a meaningful organization. As one ponders the relationships of these objects, the empty and full vessels, the crossing creases of the tablecloth, it is easy to see a host of Christian allusions in the still life.

If there is a Christian theme in this painting, one can see how, in the twentieth century, objects could be toyed with and individualized to a great extent. Given the other suggestions of Christian meaning, even the poppy-seed cake with the large knife by its side takes on symbolic depth – perhaps this flour-based pastry too is the body of Christ, with bloodlike fluent lines, hacked and sorrowful, lying on its tray.

THE CONTEMPT OF THE FAMILIAR

The importance of food in religion and medicine failed to elevate the status of food painting. Art theorists and art academies from the sixteenth century onward widely and consistently placed still-life painting, especially food still-life painting, on the bottom rung of the artistic ladder of subject matter.[12] And how many passages of great literature or music or dance or film devote themselves to food? Only the comic ones – as burlesques of serious subjects. In the movie *Love and Death* (1975) Woody Allen wittily represents the rivalry of Napoleon and the Duke of Wellington in terms of 'beef Wellington' and the pastries called 'Napoleons'. The two foods lack the grandeur and dignity of 'Love' or 'Death' or anything else important – and through Allen's manipulation of foodstuffs, history becomes charmingly ridiculous. The problem with food as a subject in art is its familiarity. We all face food several times each day. We recognize the social role of meals – to carry on business, assist love-making or mark rites of passage. But the utter commonness of food in every single person's life every day of the year makes it unexceptional, mundane, not worth extensive consideration.

Most of the time, painters of food sought to dignify their images and make them appealing. Except when mocking peasants or the like, they didn't turn their paintings into laughing affairs.

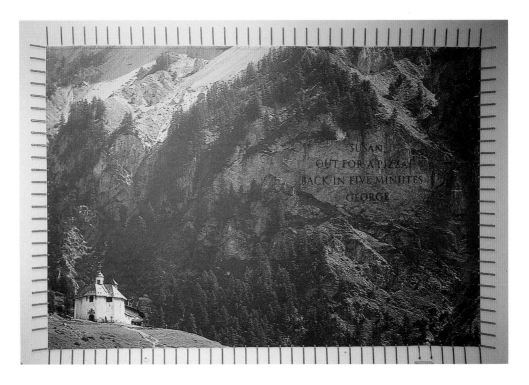

A taste for comic food painting appears mostly among Post-modern painters, who work against the predominant tradition of attractive food imagery. Wim Delvoye's travel-brochure-beautiful representation of the Alps of 1996 (illus. 9) includes food by name. Carved ridiculously in gigantic letters on a mountainside in the painting is the humdrum note: *Susan, Out for a Pizza – Back in Five Minutes – George*. What belongs on a Post-it on the door of a refrigerator makes its way mock-heroically into grandiose nature. And it's really the pizza reference that makes the image amusing. Almost any other trite statement – 'Susan, I Love You', 'Susan, You're Beautiful', or even 'Susan, You Missed Your Appointment' – could conceivably possess some dignity as a monumental inscription. But a food reference produces an automatic comic response. Food is too common to be dignified. Delvoye also quashed the sensual appeal of food by avoiding a visual representation of it.

The insignia of governments and institutions are telling in this regard. While images of wheatsheaves and boars and elks appear on the seals and coats of arms of nations and armies, they aren't found there in edible form. A piece of white bread instead of a wheatsheaf would seem silly on a flag or medal. Boars may have power, but pork chops apparently do not. Deer

9 Wim Delvoye, *Susan, Out for a Pizza – Back in Five Minutes – George* (1996), laser ink-jet paint on canvas. Collection of the Fonds National d'Art Contemporain, Puteaux.

are fine, but venison steaks do not inspire allegiance. Only banquet scenes, as will be seen later, can occasionally rise to mildly heroic heights as a food subject.

The very insignificance of food as a subject in art, however, gives it some advantages. Like doodling for a Freudian, food for the art historian can be the one area where conscious rules and dignified ideas need not hold sway – and the real urges and concerns of a painter or his society can rise to the surface. There's a certain freedom in the margins of art – where experiment and indulgence can operate – because the field is not centrally important. In other words, more can be learned about someone from his backyard than from the street façade of his house.

THE MOUTH AND THE FRUIT

In looking over the whole array of paintings of food since *circa* 1400, two things become apparent: images devoted exclusively or preponderantly to fruit far outnumber pictures of any other food subject; and only very rarely are people shown literally with food in their mouths. The latter fact reminds one of the endless beer, wine and whisky advertisements in the United States since the late 1940s that never show the actual imbibing of alcoholic beverages. On billboards, magazine pages and the television, glasses are lifted, liquid is poured, and satisfied looks and sounds are made, but no one ever puts glass to lips. Federal regulations prevent any imagery of direct consumption – it might make alcohol too attractive, or tell children how to use these dangerous substances. There is a kind of conspiracy to hide the awful truth that alcohol is for drinking purposes, a kind of lie that everyone knows about, but accepts or hardly notices, because it is not so very important. In painting, on those few occasions when people actually chew or put spoon to mouth or open wide to receive some morsel, the person involved is almost always an untutored child, or a figure of amusement or evil, someone boorish or ridiculous or abhorrent. The act of eating appears repulsive. In the less august world of satirical prints (e.g., those of James Gillray), people in the act of eating appear everywhere. Prints are the medium of savage attack and gross indecencies. Painting rarely admits such unrefined material.

The abundance of fruit at first seems unrelated to this disinclination to illustrate eating, but it is equally curious. Fruit assuredly has never comprised the greatest part of the European or American

diet. Yet the isolation of fruit as a subject of art spread rapidly after Caravaggio painted that simple basket of fruit on a table (illus. 5), without figures, without market setting, without the additional constituents of a meal.[13] Fruit probably owes its favoured role in art to visual appeal. Pears, cherries, oranges and other fruits have the colour, firm, large shapes and manipulability to be handsome knick-knacks or bold sculptures. Since at least the eighteenth century, people have placed fruit in bowls or on furniture in places other than dining tables or kitchens – as decoration. They do not do this with cabbage or carrots or eggs, or hams or beef jerky or herring in wine sauce or other slow-perishable foods. Fruit has a special place as the most beautiful of foods – something not just for eating. In 1857 one writer on modes of dining remarked: 'Fine and rare fruits of various kinds are usually chosen for the dessert, for the pleasure they afford by their contrasting beauty.'[14]

The preponderance of fruit in art does seem related to the disinclination to illustrate eating. Both features veil the necessities of consumption. The satisfying of our needs, the swallowing of animals and plants, chopped or whole, the sheer requirements of staying alive, it seems, are not refined pictorial fare. Fruit speaks of beauty rather than repellent ingestion. Both features mitigate the recognition that beneath all the finery and thanks to God and social intercourse of the dining table, eating is a crude action. At the other end of the alimentary canal, there are faeces – food depleted and turned offensive. Shit is the opposite of tasty food. But it participates in the same process. Faeces have no saving grace of attractiveness. The hole of production appears suspiciously like the hole of consumption at the other end of the body. The half-human bird-demon in Hell in Hieronymus Bosch's *Garden of Worldly Delights* (illus. 10) is one of those rare figures in painting shown eating. In one continuous act, this monster-man gobbles up sexual sinners and gluttons and excretes them into a deep pit.

Annibale Carracci's *Bean Eater* (illus. 11) represents the more amusing side of images of eating. It shows a gross peasant with open mouth, gulping down his meal. In a similar vein, seventeenth-century Dutch and Flemish paintings of drunken peasants, stupid, ugly and comic, frequently show them vomiting (illus. 81, 97). The Belgian artist Wim Delvoye produced a Postmodern rendition of the same repellent vision in 2001. With the help of scientists, he created an excrement machine called *Cloaca*, which replicates human digestion. The room-sized conveyor belt of tubes, grinders and jars of chemicals is fed twice a day, and duly

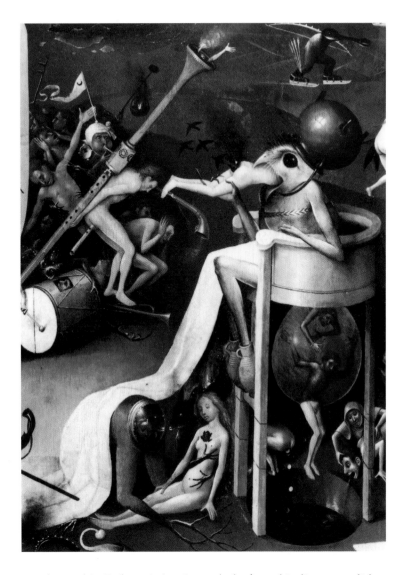

10 Hieronymus Bosch, detail of right panel, 'Hell', from *The Garden of Worldly Delights* (*c.* 1500–15), oil on panel. Museo del Prado, Madrid.

produces shit, Delvoye's ironic symbol of mankind's accomplishment.[15] Only such raw visions of hell and comedy depict the literal intake of food, and they are rare before Postmodernism. The prevalence of fruit and the avoidance of actual eating both make food pictures appetizing – even when they may symbolically represent death or sin. As that fat man at the Rijksmuseum certainly recognized, the grander meanings of food imagery do not preclude a salivary reaction.

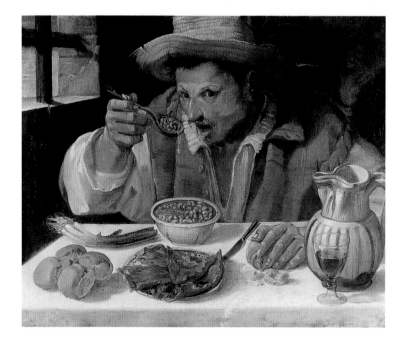

11 Annibale Carracci, *Bean Eater* (c. 1585), oil on canvas. Galleria Colonna, Rome.

FETISHISM

Food pictures, especially still-life paintings, also represent pleasure in a more profound way, related fundamentally, it seems, to the concepts of fetishism spelt out by both Marx and Freud. When we look at food and pictures of food (except for scenes of suckling infants), we look at living things that have become objects. The wheat in the field has become bread on the table. The ox in the pasture has become hamburger on a bun. In setting the parameters of this book, it was necessary to decide whether scenes of pigs in a sty or of orange groves should be included. But such agricultural subjects, like pictures of flying geese or deer hunts, are merely proto-food subjects. What makes something food, almost always, is its alteration from living thing to dead object. And that fact is what connects food images to fetishism as construed by Marx and Freud. Fetishism is the replacement of a living subject by an inanimate object. In capitalist society, according to Marx's theory of commodity fetishism, the value of human labour is falsely perceived as residing in the physical products of that labour. And the human connection of producers to their collective labour appears falsely as a social relationship between objects. In Marx's view, capitalist exploitation depends on the transformation of labour power, or the ability to work, into a commodity bought and sold on the market.[16] In Freud's outlook, fetishism is the replacement of

a human subject of sexual attraction by an object or an isolated body part, and is a mechanism of denial. To avoid anxiety (especially castration anxiety), in Freud's view, the male fetishist denies woman as the object of his desire and instead embraces something safer – an inanimate object or truncated body part.[17] Both Marx and Freud saw fetishism as a recognized illusion. Marx claimed that knowledge of the fetishistic illusion promoted by capitalism did not erase the power of that illusion. Freud felt that fetishism must involve a split ego, one part recognizing the source of anxiety and the other denying it. While one might not accept all the broader structures of Marx and Freud, it does seem that the fetishism of food – the replacement of a living thing with a dead object – is central to paintings of food. It is fetishism that gives food pictures their most enduring sense of pleasure.

For both Marx and Freud, fetishism is a means of control. The capitalist replaces the value of human labour with the market value of an object in order to dominate the working class. Freud's fetishist replaces female sexuality with the sexuality of an object in order to dominate his anxieties. In food paintings, nature itself is under the greatest control. Animals and plants have become manipulable objects. Food fetishism differs from the fetishism of Marx and Freud in that it is not an illusion or a self-deception. When the lamb becomes a lamb chop, we see a truthful transformation of life into dead matter; it also becomes small, manageable, compliant, a thing at our disposal. The trees and plants and animals

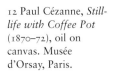

12 Paul Cézanne, *Still-life with Coffee Pot* (1870–72), oil on canvas. Musée d'Orsay, Paris.

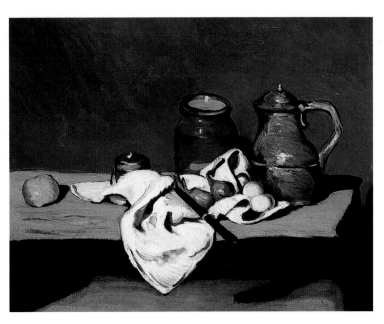

of the earth become shredded and chopped and softened and warmed for our taste and survival. And when, as is often the case, food acts symbolically, as sin, or death, or life's frivolities, those things and values, as food, become manipulable, under our control. Meyer Schapiro was right when he described the satisfaction of personal control that Cézanne found in still-life painting, and this is a fundamental part of still-life painting in general (illus. 12). Cézanne could satisfyingly sublimate and manipulate his life and problems in still-life subjects. His famous apples, in Schapiro's argument, represented his sexual longings, and when the artist orchestrated and disciplined that fruit in his paintings, he took command of his unseemly lusts. He satisfied his need for calming self-control.[18] Fetishism, like so much else in food images, establishes a tone of contentment, not just the satisfaction of tasting and eating, but the power to control one's environment. Food paintings, devised by humans, reinforce the mastery of man.

The clearest portrayal of the fetishist reduction of the organic to an object belongs to the art of Andy Warhol. His Campbell's Soup cans present food as metal and paper and lettering (illus. 13). Packaging replaces nourishment. His works of this sort are fundamentally social criticisms of a world become insensitive, inhumane,

13 Andy Warhol, 200 Soup Cans (1962), casein, spray paint and pencil on cotton. John & Kimiko Powers Collection, Carbondale, Colorado.

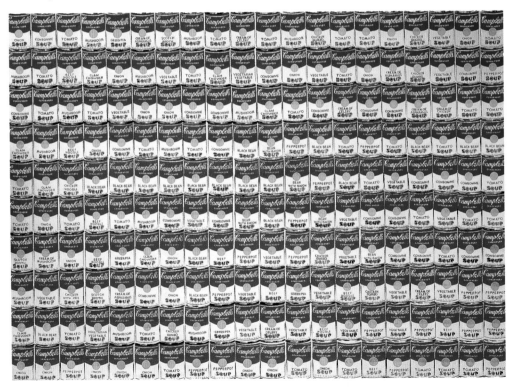

frivolous, dead and overrun by commerce. But the public failed to perceive the negative vision, as did most critics. Instead, the line-up of soup cans was viewed with delight; it elicited warm reminiscences of post-war childhoods, and seemed to depict the fun-filled, colourful objects of our modern industrial lives. Warhol's similarly de-individualized line-up of photographs of electric chairs and car crashes were consistently recognized as critical comments on modern insensitivity – but not his food pictures.[19] Food means pleasure. The power of fetishism to give us reassuring control proved stronger than Warhol's moral disdain.

PLACEMENT AND PATRONAGE

In the fifteenth century most food images belonged to larger religious narratives, and were situated on altars and commissioned by or for the Church. In the sixteenth and seventeenth centuries food paintings became more secular and independent, and our understanding of their placement and patronage is more problematic. In which rooms of private houses and under what circumstances were food paintings displayed? And who bought them? In one case in sixteenth-century Italy, a series of market paintings was produced for a room where dining usually took place.[20] And several art theorists of the sixteenth and seventeenth centuries in England, Italy and the Netherlands advised collectors to hang paintings of particular subjects in specific rooms of a dwelling; food pictures, not surprisingly, were to be placed in kitchens.[21]

But practice does not always adhere to theory, and a statistical survey of inventories of art collections in the seventeenth-century Dutch Republic, undertaken by John Loughman and John Michael Montias, showed that food paintings were hung all over Dutch houses – in great public rooms, in sleeping chambers, in the kitchen, in the corridors, in the entrance halls, in the family rooms. 'Kitchen pieces' are listed as having been hung near paintings of religious subjects, landscapes, historical scenes, portraits and genre scenes. There appears no consistency in the hanging of food paintings. The social level of their owners also seems unspecific. Loughman and Montias found still lifes in the wealthiest households and in more modest homes. The holdings of the lowest strata of society remain unrecorded, and pictures of seventeenth-century interiors, if they can be trusted as representations of room decor and not just symbolic references, tell us little about food paintings.[22] Only two Dutch seventeenth-century paintings of rooms in which still-life pictures appear are known to me. One

is a tailor's shop, in which the painting is used as a hat rack. The other shows a modestly proportioned room with an expensive marble floor. A small, dark still life with fruit hangs above a mirror and near two landscapes on an adjacent wall.[23] The situation in the Netherlands bears great weight, because this is where still-life and food painting appeared in the greatest numbers, and these are the chief sources of later still-life food painting. Dutch and Flemish works were collected throughout Europe, and the original consideration of placement, if there were any, might have been influential.

Another archival study by Loughman indicates that, in at least some cases, the Dutch and Flemish owners of food paintings were involved in the food industry.[24] He discovered a town chef in Antwerp who died in 1629 with five still-life paintings by Frans Snyders in his estate; a widow of an Antwerp fish vendor in 1655 who owned five paintings of still-life subjects; and a Dordrecht grocer in 1655 who possessed five 'banquet' still-life paintings of food. These were people probably high up in the food industry. But then again, a baker and his wife in the mid-seventeenth century commissioned Jan Steen to paint their portrait – and they are shown with the baker's delectable wares (illus. 26). Apparently, even such modest professionals could afford to purchase or commission paintings. Nevertheless, the pictures are too numerous and widespread to suggest that everyone who owned a food painting in the seventeenth-century Dutch Republic worked in the food trade, and the numbers and spread of food subjects increased in later centuries.

It would be wonderful to learn who owned the early, highly innovative food still-life paintings produced by Pieter Aertsen and Joachim Beuckelaer in the mid-sixteenth century and where they were hung (illus. 15, 18 and 24) – this information might reveal the original purpose or meaning of such unusual works. But this is unknown. A glance at depictions of eighteenth- and nineteenth-century interiors reveals little about patronage or placement. Neither are there any statistics. To catch a glimpse of later twentieth-century habits in the display of food painting, I leafed through numerous issues of *Architectural Digest*, studying photos of the interiors of the homes of the wealthy. Often I found that dining rooms included food paintings. But when the owners of the house owned really expensive food paintings by celebrated artists such as Vincent van Gogh, Cézanne, Matisse, Picasso or Warhol, those images frequently hung in the main living rooms. Evidently the creator and monetary value of a food picture, as much as its subject, determine where it will hang.

The Market

Markets are social venues and places of trade. Paintings of markets depict the exchange of goods and money, and the social give and take that such activities generate. This chapter begins by looking at a powerful image of food distribution (illus. 14). It represents the Hebrews in the desert gathering the manna that God had rained down upon the ground to feed the Chosen People. This painting from around 1470 by an unknown Netherlandish artist called the Master of the Manna is not really a market scene, because nobody pays for the goods. The difference in expression between this work and the true market scenes that follow illustrates the importance of payment, of exchange, in the market theme. There is something unpleasant, it seems, about getting a free lunch. The manna painting appears hateful, bitter and desperate. The market scenes that follow, in contrast, are lively, joyous and soothing.

According to the Book of Exodus (chapter 16), the strange nourishment called manna fell from the sky daily and fed the Hebrews for 40 years, but it rotted after each day, and could not be preserved or hoarded. The biblical episode declares God's power to satisfy perfectly our physical requirements, but also recognizes man's insolent doubts about perpetual help from above. The Hebrews are forced to trust in God's continuing assistance, because what they fail to eat immediately is destroyed.

The Bible describes manna as small and white, like coriander seed, and claims it tasted like wafers made of honey. The Master of the Manna's painting, however, hardly conveys sweet delight. Primarily, the image is an anti-Semitic diatribe. Gross, stereo-typed physiognomies and the standard conical hats of medieval representations of the Jews immediately establish the antagonis-tic tone. These Jews who are greedily gathering manna were no doubt meant to castigate the race for miserliness and money-grubbing – taking advantage of a free meal. That which is free is somehow repellent, something unfair, in this artist's view. The

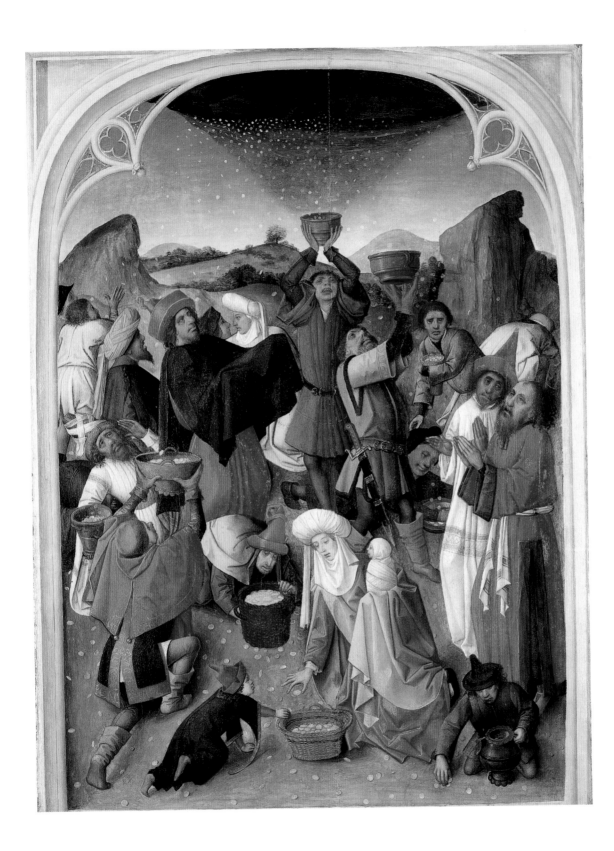

14 The Master of the
Manna, *The Gathering
of Manna* (1470),
oil on panel. Musée de
la Chartreuse, Douai.

market, like food obtained through the labours of the field, demands some sacrifice of sweat or money. Only a few artists during the periods covered by this book illustrated the story of manna, and, when they did so, they usually likened manna to the bread of Holy Communion – another miraculous food from God.[1] But the outlook of the Master of the Manna was not unique. Nicolas Poussin illustrated the story around 1640 in a painting now in the Louvre in Paris. He emphasized the varied emotions generated by the fall of manna, and included greed prominently among the responses.

The Master of the Manna's painting also brings to mind the desperate tone that pervades the whole history of eating before the eighteenth century, and this aspect of the picture helps us to understand the psychological function of market scenes. Despite the anti-Semitism, most of the Jews in the painting scramble for food with pitiful expressions and fearful gestures. They live from day to day in a desert, dependent on miracles to survive. The historian / sociologists Norbert Elias and Stephen Mennell have perceived Western eating until *circa* 1700 as an anxious cycle of fast and feast, largely caused by insecure food supply and bolstered by religious dictates.[2] People would get by on subsistence fare for long periods, always aware that food production and availability might end at any time due to uncertainties of transport, trade, weather or war. Then, on feast days, they would gorge themselves, because the next meal might never come, and if it did come it would probably be meagre. According to these sociologists, for long periods eating was a violent, unnerving swing between starvation and stuffing.

Only with the rise of a relatively secure food supply in the West in the eighteenth century, brought about by increased trade and better transport, did the tone of insecurity disappear. According to Elias and Mennell, great famines became a thing of the past, and if local food production failed, there were means of securing food readily from other areas. The security of the food supply affected eating habits and the entire perception of food. In upper-class circles in the eighteenth century, people looked back on the gargantuan feasts of previous times as boorish displays of gluttony. In 1783 Louis-Sebastien Mercier wrote that,

> in the last century, they used to serve huge pieces of meat, and pile them up in pyramids. These little dishes, costing ten times as much as one of those big ones, were not yet known. Delicate eating has been known for only half a century. The delicious cuisine of the reign of Louis XV was unknown even to Louis XIV.[3]

Elias and Mennell seem to have read history correctly. Exquisite gourmet cuisine arose when anxiety no longer ruled the appetite. One no longer had to eat as if one's life depended on it. The rise of fine restaurants in the later eighteenth century was part of this development. It is noteworthy that in English, the noun 'taste' comes to mean an ability to discriminate on matters of aesthetics and beauty only in the very late seventeenth century. What was a gross physical sensation associated with eating became a delicate affair of exquisite judgement. The effects of a secure food supply and the consequent new delicacy of cuisine will be apparent when kitchen scenes are discussed. But the history of feast-and-famine sensibility also underlies pictures of markets and food sellers. These images seem to exist to quell anxiety, to portray a never-ending supply of victuals. The satisfactions of food paintings serve to relax the viewer, not just in fetishistic terms but also in terms relevant to a world where whether or not one will eat again soon is uncertain.

Tradition remained strong, however, and although sources of food were secure and, perhaps, anxieties no longer needed calming, market scenes of the eighteenth, nineteenth and twentieth centuries basically differ not at all from earlier representations. They always show a day when supplies will last forever. But what was wishful thinking before 1700 became reality thereafter. Pictures of abundant food, no matter what the reality, seem to trigger a habitual, Pavlovian, response – satisfaction through reduced anxiety. But with the fifteenth-century manna painting in mind, there is also an awareness that tasty fullness must be purchased.

Later periods extended the development perceived by Elias and Mennell. Industrial processing and improved food production, as well as better transportation, meant that even the working class in the nineteenth century could afford some meat. Previously, the staple food of the poor was gruel, a mixture of water and cereal. In 1865 Thomas Archer described the horrendous living conditions of the London poor, and although he found everything about the diet of these wretched people foul, the diseased and disgusting stuff they ate was nevertheless meat – a distinct upgrade from previous generations:

> I have already spoken of the difficulty in guessing what can be the food on which these people live, and the sties, cowsheds, and slaughter-houses suggest to the inquiring mind a terrible association with the large number of shops where the coarsest parts of meat seem to share the space with what butchers call offal. Cow-heels, bullocks'-hearts, kidneys, and livers, thin and poor-looking

tripe, and sheep's-heads are amongst the uncooked portion of the stock; while the cooked viands are represented by piles and chains of bruised, and often damaged-looking, saveloys, black-puddings, and a sort of greasy cakes of baked sausage-meat, known as 'faggots', sold for a penny or three farthings, and made of the haslet and other internal portions of the pig. It is often the case that these shops have some display of joints of meat, coarse, poor, and flabby-looking, but they bear no proportion to the staple trade. It would be curious to inquire how many Bethnal Green pigs, or if any Bethnal Green cows, ever find their way to a regular dead-meat market, there to come under the observation of an authorised inspector.[4]

In 1900, when an American factory worker earned a dollar a day, he could buy a frankfurter on a bun from a street vendor, with a great array of garnishes, for one cent. He could easily give himself and a large family meat – and without the expense of cooking equipment or kitchen (although it was probably advisable not to enquire into the contents of the frankfurter). Nevertheless, the lavishness of modern food production in no way diminished the pleasant shudder induced by visions of overstuffed markets.

Meat takes centre stage in meals in the West – the vegetables and starches act as accessories. It is always rack of lamb with carrots and escalope potatoes, not the other way round. Pictures of meat in the market or on the table should first of all be placed within the traditional liturgical calendar of the Roman Catholic Church, as the food of choice, wealth, pleasure and un-frugality. The Church's restrictions on meat on certain days of the week and during Lent, from early Christian times until the Second Vatican Council in the 1960s, attest to the centrality of meat in the diet. Those times of the Church's year when meat was forbidden constitute periods of suffering; one denies oneself physical satisfaction so as to do penance, or to purify oneself, or to understand Christ's pain. The meatless days of the calendar changed over the centuries and varied in different countries, but in looking at food paintings it is important to note whether or not a Lenten subject or the opposite is depicted. Religious proscriptions greatly determined the diet and paintings of that diet in the West.[5]

Before the nineteenth century, when meat became a much more frequent part of the diet for most of the population in the West, it would seem that all these Christian demands to abstain from flesh would have been a purely academic or rhetorical issue, because meat was the daily sustenance of only the wealthy. But Lenten laws often proscribed animal products as well as meat

itself. Thus eggs, butter, milk, cheese and the bits of bacon and lard that gave flavour to the diet of the poor were also frequently forbidden. Without milk to enrich and liquefy the daily porridge, or animal fat and cheese to spread on bread, meals could be sullen affairs. Yet the substitutes, olive oil, fish and vegetables of all sorts, could make handsome meals. Nevertheless, the consumption of salt fish rather than fresh fish among the poor usually made the meatless days less than thrilling, and it should not be forgotten when looking at a seventeenth-century painting of bread and fish (illus. 42) that it represents a kind of mortification of the flesh, a religious injunction to suffer and purify. This study of market scenes begins with pictures of butcher shops and stalls, which purveyed the expensive stuff of the non-ascetic. It also considers the beginnings of such food subjects.

Food figured prominently in two important transitions in Western art – the introduction of secular peasant subjects into large-scale paintings, and the empowerment of still-life painting. The artist Pieter Aertsen, who worked in Antwerp and his native Amsterdam, pioneered both categories of subject. In 1550 he produced *The Peasant Feast* (Kunsthistorisches Museum, Vienna), and in 1551 he completed the *Butcher's Stall with the Flight into Egypt* (illus. 15), possibly the first panel picture in which inanimate objects take precedence over living subjects.[6] These interrelated developments toward secularization placed food and eating in the foreground. In 1559 Aertsen also produced an innovatory picture, in which a market scene with figures stands as the primary subject: *Market Scene with Christ and the Woman Taken in Adultery* (Staedel Institute, Frankfurt).[7]

Ancient Greek artists had produced food still-life paintings, and the mention of such works in Classical literature (especially Pliny the Elder's tale in his *Natural History* of Zeuxis painting a basket of grapes so realistically that birds tried to eat the picture) no doubt in part inspired the development of still-life painting in the sixteenth century, when enthusiasm arose throughout Europe for all things Classical.[8] There exist too a few precedents closer in time to Aertsen's: some rare fifteenth-century paintings of non-food objects, and some paintings of trophies of the hunt (illus. 22).[9]

Still, a work such as Aertsen's *Butcher's Stall* remains particularly impressive. Figures and inanimate objects appear together – and the objects dominate. A religious subject is represented, but it has become a small background scene, dominated by victuals. Sausages, sides of beef, pig's hocks, leg o' lamb, tripe, a cow's head, a pig's head, chickens and a tub of lard fill the foreground. And the stall is not really just a butcher's shop, because it displays

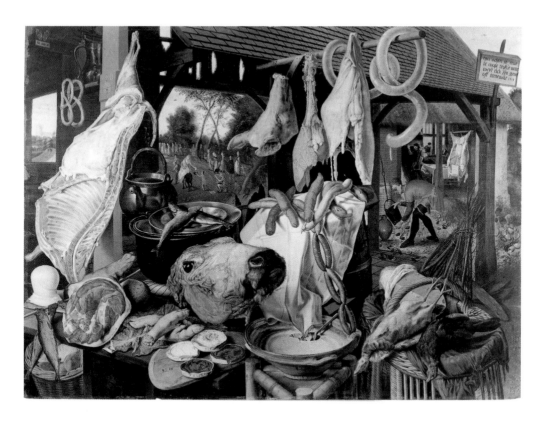

non-meat provisions too: pretzels, fish and dairy products. But
the plump, juicy, blood-red, slaughtered flesh overwhelms all else
in this large painting. Everything except the food appears tiny,
and it is the gigantic scale as much as the sheer amount of space
devoted to the butcher's stall that gives the food an outlandish
domination. The miniscule Holy Family exists next to an enormous
pig's ear, and the dramatic difference in size still astonishes today.
Perhaps for the first time here, secular food dwarfed traditional
Christian themes, and the *Butcher's Stall* was not unique – Aertsen
and his followers produced numerous other large market scenes
with small religious subjects as mere addenda.

Art historians have interpreted this phenomenon in several ways.
Georges Marlier and J. A. Emmens have seen the secular elements
as pointed contrasts to the religious subjects. The purported aim is
to show the morally reprehensible blotting out of spiritual truths
by gross materialism.[10] Numerous later art historians have agreed
with this hypothesis. Walter Friedlander and Keith Moxey, on the
other hand, see the same works as indicative of the growth of
secular interests in the sixteenth-century Renaissance, and the
consequent diminishing of traditional concerns with religion.

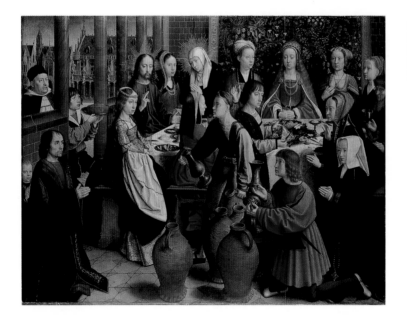

16 Gerard David,
Marriage at Cana
(*c.* 1500), oil on panel.
Musée du Louvre,
Paris.

Moxey has made a particularly good case, and places the development in the context of the Reformation, when religious images became more and more suspect, even in Catholic Flanders, as the Church was accused of numerous abuses. In this scenario, the religious imagery of Aertsen represents idolatrous indecencies properly belittled.[11]

For those who see a critical attitude toward worldliness at work in these novel subjects, various items of food take on sexual meanings, either in the form of suggestive shapes or punning names or arousing properties (and the links between ardour and eating are also discussed below). Physical love is contrasted to spiritual love. But whichever interpretation is correct, both make food a carrier of secularization, a force of materialism, a thing very much of the worldly senses. Very few commentators perceive the meats in the *Butcher's Stall* as a sacramental symbol, or as a reiteration of the small religious scene in the distance (even those who see the background subject as representing a scene of Christian charity rather than the flight of the Holy Family). Such religious subjects form a contrast to secular culture, whether that distinction is a matter of moral blindness or merely growing earthiness. Even Aertsen's low-class banquet scenes, where no actual religious contrast appears, must have seemed to his sixteenth-century contemporaries vividly distinct from traditions of social grace or spiritual meaning, something rudely earthy, whether compared to images of aristocratic feasts

opposite:
17 Gerard Horenbout,
Meal of a Prince
(*c.* 1510–20), water-
colour on parchment;
from the *Brevarium
Grimani*. Biblioteca
Marciana, Venice.

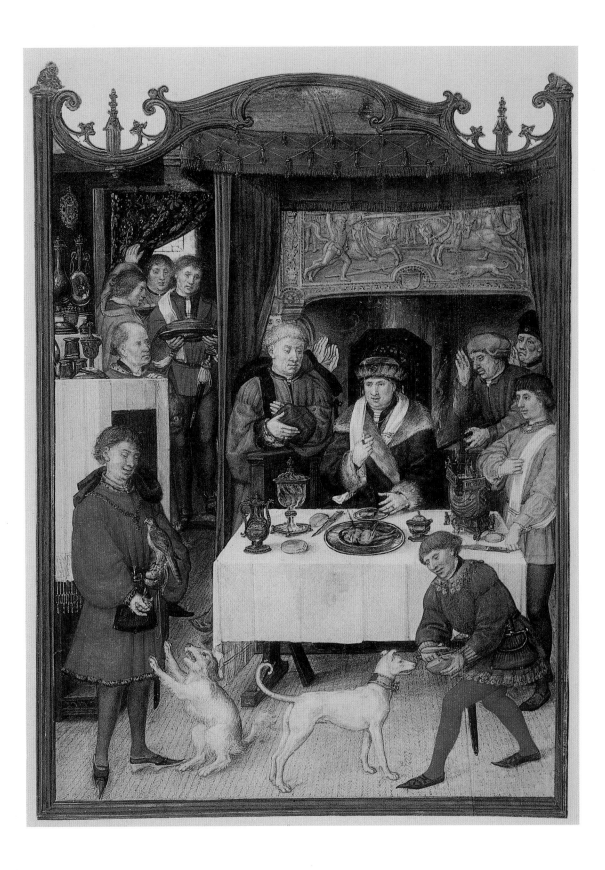

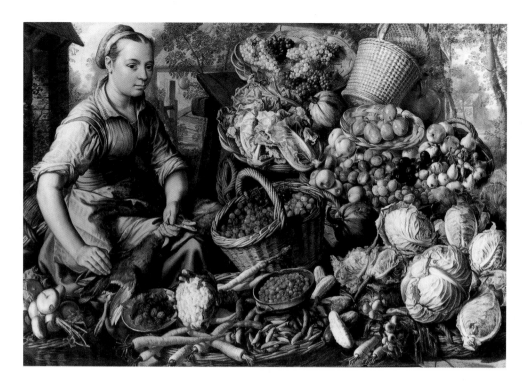

18 Joachim Beuckelaer, *Market Woman with Fruit, Vegetables and Poultry* (1564), oil on panel. Museum Schloss Wilhelmshöhe, Kassel.

(illus. 17) or religious eating subjects (e.g., *Marriage at Cana, Last Supper, Christ at Emmaus*; illus. 16, 88 and 96).

Aertsen's novelties use food to give a smell of the world. The stuff of eating means physicality, fleshly pleasures, the gross body of worldly existence. This food may be dead matter, but it seems to throb with the pulse of bodily life, heightening the impression of gross materiality. Aertsen's nephew and follower, Joachim Beuckelaer (illus. 18), carried on his vision of the marketplace with exactly the same lively, plentiful, earthy qualities, and numerous later painters of the subject followed suit.

Aertsen essentially defined the market picture in Western art. But there are also some alternative approaches. How a different character and meaning can be created with the same ingredient can be seen in Rembrandt van Rijn's *Slaughtered Ox* (illus. 19). A beef carcass similar to the one in the right distance of Aertsen's *Butcher's Stall* is displayed in Rembrandt's glowing image. But here, a hundred years later, the dead animal, lashed to a wooden support, hangs alone in darkness, a pitiful body, lacerated and truncated. Rembrandt's moving butcher still-life seems a kind of crucifixion, a meditation on Christ's death on the Cross.[12] The isolation of the carcass and its darkling environment mark the difference from the riot of foodstuffs in Aertsen's work. Yet even if this majestic human-

opposite:
19 Rembrandt van Rijn, *Slaughtered Ox* (1655), oil on panel. Musée du Louvre, Paris.

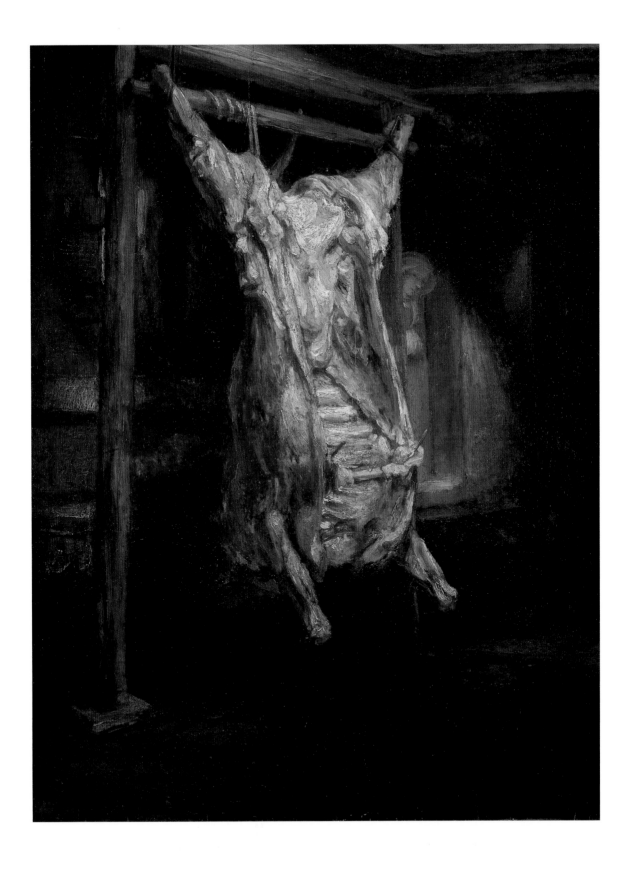

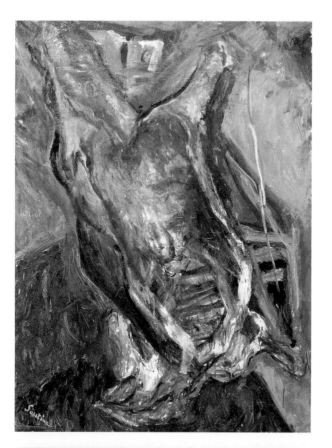

20 Chaim Soutine,
The Slaughtered Ox
(*c.* 1925), oil on canvas.
Albright-Knox Art
Gallery, Buffalo,
New York.

21 Annibale Carracci,
Butcher Shop (1582–3),
oil on canvas. Christ
Church Picture Gallery,
Oxford.

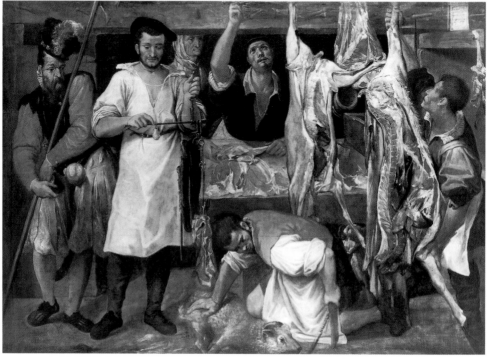

like carcass refers to Christ's death, it too treats the subject of materiality. Christ's incarnation, God become mortal flesh, is the subject, and that too concerns physicality, worldliness. The death of Christ, if that indeed is the theme underlying Rembrandt's painting, is made even more poignant by the presentation of God as dead meat. The fetishistic transformation of the living into dumb object becomes a profound conception of Christ's role on earth. Whether the abundant stuff of common meals or Jesus himself, food stands in these varied images as a representation of material existence.

In the twentieth century Chaim Soutine took up Rembrandt's subject and turned it into an expressive vision of suffering (illus. 20). The fury of Soutine's onslaught of paint changes more than the tone of Rembrandt's work. Soutine's carcass, like Rembrandt's, likens itself to a human body, but it seems to writhe and bellow. His ox appears dying, not dead, in pain, not beyond feeling. The effect, despite the pathos, lies closer to the throbbing life of Aertsen's bustling market.[13] Rembrandt's ox remains the unusual work, the sombre meat amid a riot of happy cutlets.

Butcher's meat could also be comical. The Italian Baroque master Annibale Carracci presented burly butchers in a large canvas of the 1580s (illus. 21). The Carracci family of painters apparently had relatives in the meat trade, but here the tradesmen look a little silly, weighing meat for a soldier customer (who opens his purse to pay) and carrying out the other duties of meat sellers with mildly caricatured faces and postures. The literal carnality of the scene may possibly be a sexual pun, and the entire image a comic view of a gross trade, as was often depicted in the Italian theatre of the period. Barry Wind has proposed such an interpretation, but other scholars see this large-scale painting as an unfunny example of the artist's down-to-earth realism. Annibale Carracci challenged ideals of beauty on occasion with gross pictures of peasants eating (illus. 11), and his butchers may be of similar ilk.[14] In either case, again, material reality is the general meaning of food. And comedy, including sexual suggestion, can affirm realism, cutting down pretentious subjects, creating art from the amusing ordinariness of the world. In all these meat scenes, we are not led off to some distant vision, but brought home to the humble truths of fleshly existence. Whether moral warning or sacred contemplation or farce, we come to face our own immediate material circumstances. And the particular sort of material stuff – animals become objects – appears to give us a feeling of control of our world, a sense of mastery – no matter what the larger meaning of the pictures may be.

Although meat stands as the expensive fare, the food of the wealthy, these meat shops hardly seem part of the luxury trade.

All of them expose bloodied limbs and viscera, unrefined guts, carnage and butchery as in war, and such market goods do not seem to have much to do with class-consciousness. The soldier customer in the Carracci painting reveals what is really involved – strength. He needs his ration of flesh to keep fit. As recipe books from the fourteenth century through to the nineteenth declare, meat, especially red meat, is the stuff needed for manly vigour and labour. These meat stalls have the hurly-burly character of toughness and energy. Even Rembrandt's sombre carcass displays brute power in its large form and stretched muscles. And if Wind is right in seeing the soldier's puffed-out groin, his stiff codpiece, as a rude sexual sign, this only reinforces the manly force of the meaty subject.

The hanging meats and piles of food in Aertsen's and Carracci's paintings reflect the source of such market imagery – hunting scenes, in particular, paintings of dead game as trophies of the chase. Such images preceded Aertsen's novel market pictures. Jacopo de' Barbari's dead partridge with knight's gauntlets (illus. 22), clearly dated 1504, is a prime early example of the genre. Here is a forebear of Delacroix's game pile of the 1820s (illus. 1), which was looked at in terms of dietary theory in the Introduction. Indeed, all the counters and stalls of Aertsen and of a hundred followers who portrayed food markets from the sixteenth century onward stem from paintings of the trophies of the hunt.

The distinction between the hunt subject and the market subject rests on social class. As the armoured gloves and sword in Jacopo de' Barbari's painting indicate, hunting is the prerogative of the knight, the aristocrat, the upper class of society. The dead market animals, even when they are the same kind of beasts as those killed in the hunt, belong to the world of common folk. In the market one acquires food by payment. In the field it is acquired by skill and strength and the social rights of sport. For centuries throughout Europe, countless laws preserved the exclusive right of the upper classes to hunt most game animals. Poaching was often punished severely.[15] Market scenes represent the democratization of the pleasure of aristocratic food gathering. It has become cheapened and cash-driven, but the display of dead animals in the market retains some flavour of sporting triumph. The link between meat and man's joyous superiority over wild animals is vaguely remembered in the common marketplace.

The market scene did not replace the game picture; it merely grew from it, and the two genres coexisted for centuries. In general, still-life pictures of the hunt changed little over time. Frans Snyders's works of this sort in the seventeenth century differ very

22 Jacopo de' Barbari, *Still-life with Partridge and Gauntlets* (1504), oil on panel. Alte Pinakothek, Munich.

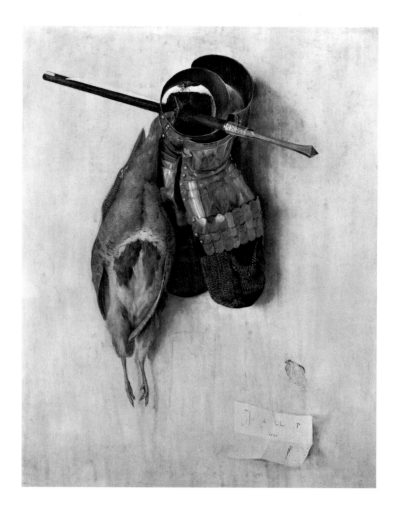

little from those by eighteenth-century masters such as Alexandre-François Desportes (illus. 23) and Jean-Baptiste Oudry. Informal piles of dead game on the ground, often placed unnaturalistically near mounds of complementary fruits and vegetables, appear with hunting equipment – and often a hunting dog, who sniffs hungrily at the trophies of the chase. There was little change because the hunt subject at heart expressed respect for ancient privileges, conservative values, the old ways.

Delacroix's *Still-life with Lobsters* (illus. 1) in part continued this tradition. It too celebrates the chase. The pink-jacketed riders in the distance and the Scottish plaid game bag in the foreground also associate the image with Delacroix's enthusiasm for British culture. For all its conservatism, however, the painting also shows some anomalies. The riders in the distance are dressed for hunting foxes, not for the kind of edible game we see in the

foreground. Of course, the lobsters may represent a balanced diet, or even a nice cold lunch during the hunt, but it is odd to see cooked seafood plunked down in the middle of a pile of raw game. Lee Johnson looked at these oddities and assumed that Delacroix sought to make a fine colour ensemble – and disregarded reality.[16] Another scholar proposed a political meaning for the delicious lobsters.[17] And indeed, maybe there exists a political colouration of this work that reinforces the conservative associations of hunt trophy painting. Delacroix had depicted lobsters before this still-life of 1826–7. In 1822 he published a lithographic cartoon attacking reactionary politicians. The politicians, parading at Longchamps during Easter, stand atop huge lobsters. Lobsters naturally move backwards, and in Delacroix's lithograph they evidently symbolize and satirize the backward-looking ideology of certain political figures. His *Still-life with Lobsters* conceivably makes similar comments. A relative of Delacroix, General Charles-Yves-César Coetlosquet (1783–1837), whose country estate the artist visited in the summer of 1826, commissioned the painting. Coetlosquet was a Napoleonic general and a count, and would be unlikely to have shared Delacroix's republican leanings. He was probably far right of the artist, and perhaps Delacroix's painting alludes to those views. In any event, the hunting subject in general concerns class-consciousness.

Delacroix's painting serves to remind us too how complex images can be. Matters of health, aesthetic colour unity, politics and British life all seem to mingle in this scene of food gathering. And this image is not unique. Desportes' traditional sporting still-life of 1711 (illus. 23) might, like the Delacroix, have a medical component in addition to its social function. The hunting dog who hungers after the dead game, a standard character in such images, perhaps was meant to encourage the onlooker to respond similarly. Virtually every medical book on diet from the Middle Ages into the modern period recommends a healthy appetite. The desire to eat is a sign of a healthy body. Food pictures may have served as appetite facilitators; nor was a salivating dog always needed. The depicted food was stimulation enough. In 1759 the Enlightenment *philosophe* Denis Diderot applauded the food still-life paintings of Jean-Baptiste-Siméon Chardin: 'You take the bottles by the neck if you're thirsty; the peaches and grapes excite your appetite and you want to grab them.'[18]

All Aertsen's market scenes and almost all those painted by later artists present visions of plenty. Market pictures display abundance even when they depict Lenten fare: Aertsen's fishmongers (illus. 24) have giant salmon, mullets, mackerel and other

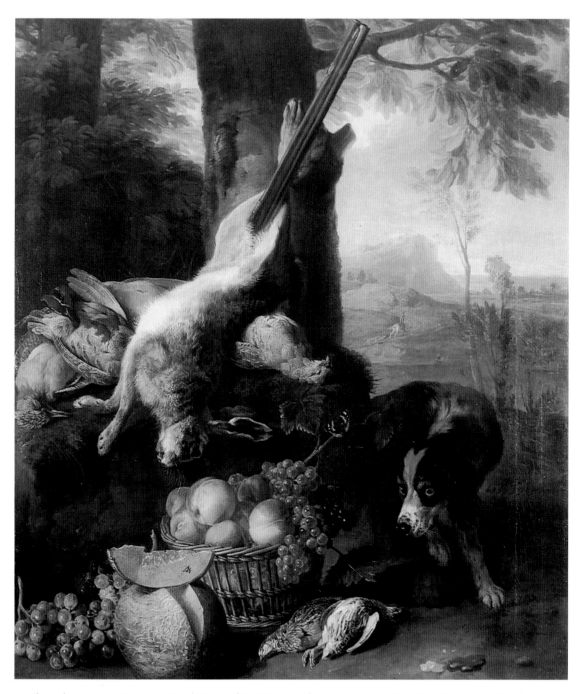

23 Alexandre-François Desportes, *Dead Hare and Fruit* (1711), oil on canvas. State Hermitage Museum, St Petersburg.

24 Pieter Aertsen,
*Peasants with Market
Goods* (1560s), oil on
panel. Wallraf-
Richartz-Museum,
Cologne.

fish that are kept in place with difficulty. The unending supply of
food tumbles out of the picture. Such scenes of outrageous abun-
dance are fantasies. The paintings by Aertsen and his followers,
for example, often combine fruit and vegetables that were harvest-
ed in different seasons. Moreover, it is unlikely that such markets
with goods overflowing existed before the nineteenth century.
The disarray in sixteenth-century market paintings by Aertsen,
Beuckelaer (illus. 18) and Vincenzo Campi (illus. 25) adds to
the air of abundance. So multitudinous is the gathering of meats,
fish, vegetables and all else in these marketplaces that strict order
cannot be maintained. Buckets, baskets and barrels overflow,

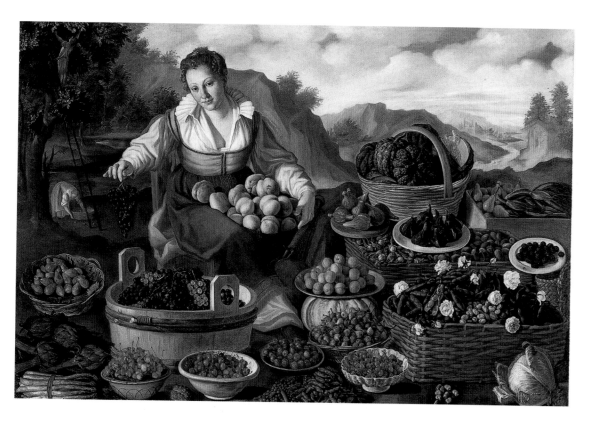

25 Vincenzo Campi,
Fruit-seller (*c.* 1580),
oil on canvas.
Pinacoteca di Brera,
Milan.

and heaps of food spill into the space. And the disorderly display continued in later market paintings.

The seventeenth-century Flemish animal painter Frans Snyders produced numerous paintings of gargantuan piles of food for sale that slide off the counters (as do the mounds of food in his pantry paintings, illus. 2). Disarray, in fact, is a prime feature of food images. Dutch seventeenth-century still-life paintings of food present delightful riots – not orderly arrangements of edibles, plate and glass. And eighteenth- and nineteenth-century market pictures usually appear only slightly less disarranged than earlier market scenes. With markets, certainly, the disorder means surplus rather than chaos. So plentiful is the supply of food that it cannot be grasped or rationed or compartmentalized easily. Markets represent the opposite of famine and give a sense of security.

Abundance can be found in all sorts and periods of market paintings – outdoor sellers, indoor counters, still-life pictures, crowded city squares and roadside stands. In the sixteenth century, Vincenzo Campi's *Fruit-seller* (illus. 25) sits amid a sea of food. She has more peaches than she has places to put them, and the plump fruit mount up on her lap – fruit pickers in the distance

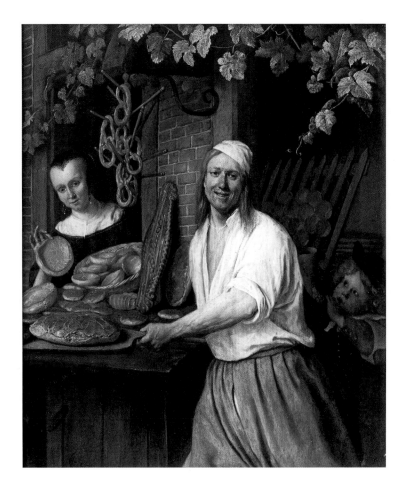

26 Jan Steen, *Baker and his Wife (Arend and Catherina Oostwaert)* (c. 1658), oil on panel. Rijksmuseum, Amsterdam.

gather yet more goods for sale. Artichokes and asparagus add variety to the symphony of fruit. Campi's buxom fruit-seller offers us a succulent bunch of grapes, and her gesture merely reiterates what the material in the foreground expresses – an invitation to sample the rich array of food that almost piles into our own laps. In the seventeenth century, Job Berckheyde's baker (illus. 7) announces with a blast of his horn the abundant availability of the staff of life, and Jan Steen's baker and his wife smile with joy at their plentiful wares (illus. 26).

In the eighteenth century Johann Zoffany's street vendors in Florence (illus. 27) present their wares close to the picture plane; indeed, there is hardly room for the vendors – or the viewer – to move, all of which heightens the sense of abundance. As usual, the plentiful produce is ungovernable. Baskets tilt and containers burst. The scene includes ragged beggars, who conceivably stand for the transience of the edible delights – even the finest of

opposite:
27 Johann Zoffany, *Fruit Market, Florence* (c. 1775), oil on canvas. Tate Britain, London.

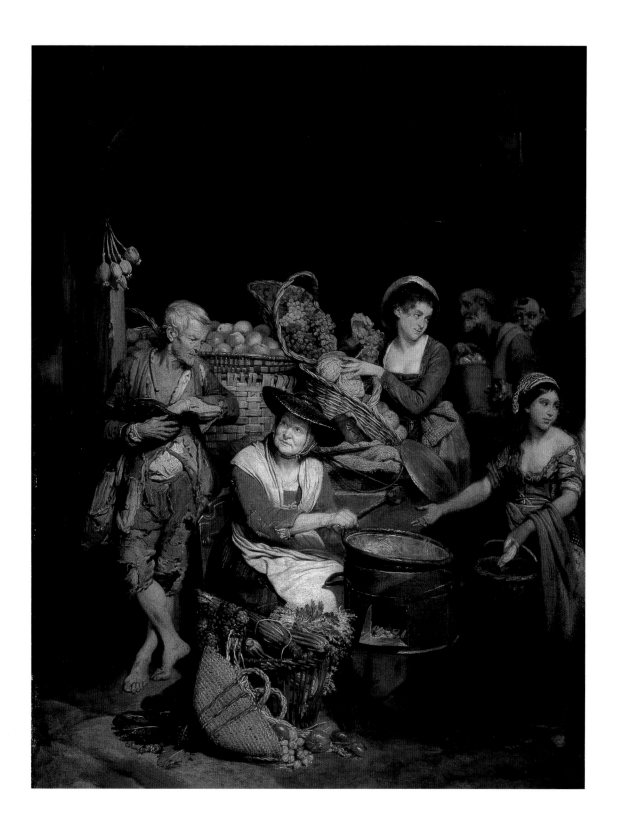

these fruit and vegetables and hot goodies will waste away like the impoverished figures. (At about the time of this market picture, Zoffany painted some self-portraits in which he holds such *vanitas* items as hourglass and skull.) But we should note too that the chief beggar on the left stands next to the robust saleswoman of hot food, and the contrast of the two relatively elderly figures shows the difference between those who have food and those who do not. Rather than a rebellious criticism of the injustice of society, Zoffany's image merely underscores the goodness of food.[19]

In a nineteenth-century painting of a fruit market display by the Impressionist Gustave Caillebotte (illus. 28), the goods for sale are more ordered than in Campi's or Zoffany's images. The boxed and paper-wrapped fruit, so neatly arranged in industrially produced disposable containers, indicate, ever so slightly, the giant change in the nineteenth century towards mechanized and grandly organized food processing, packaging and distribution on a global scale. But still, even here, the various foodstuffs for sale press tightly against each other, and the loose packaging adds a note of disarray. Even in its greater order, Caillebotte's

28 Gustave Caillebotte, *Fruit Stall* (1881–2), oil on canvas. Museum of Fine Arts, Boston, Massachusetts.

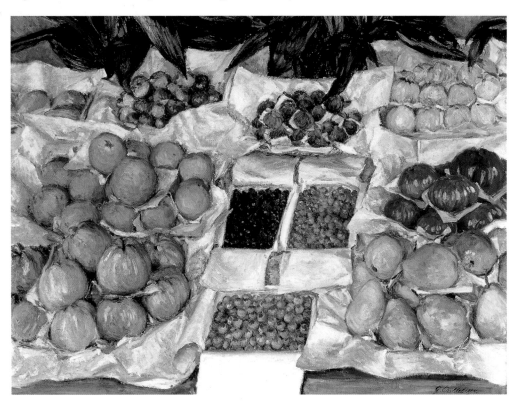

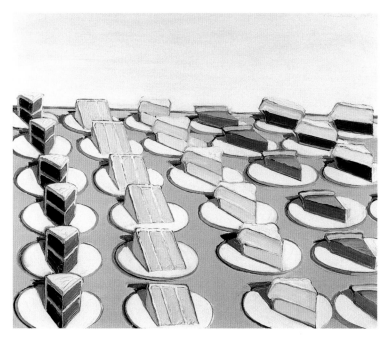

row-upon-row of fruit speaks of abundance by sheer repetition. Furthermore, the close-up view of his market stall – filling the entire canvas – suggests a blanket of food that stretches beyond the borders of the painting.

In the twentieth century an even more regimented arrangement of food by Wayne Thiebaud (illus. 29) also implies an unending stream of processed goodies. Thiebaud's gooey and machine-made desserts, repetitiously aligned and un-individualized in a store display, no doubt criticize crass American commercialism, like other works linked to Pop Art in the 1960s, but they still envision a world of plentiful food. Warhol's line-ups of food packages (illus. 13) make the same point as Thiebaud's and Aertsen's pictures. Food usually means satisfaction, delight, appreciated nourishment – even when it might have a satirical edge. The soup cans also satisfy, ultimately, in their vision of endlessness. The food, no matter how mechanized, stretches on infinitely, a vision of copiousness in the tradition of Aertsen.

This centuries-long lineage of abundance in the marketplace acts like a therapy, a calming statement that society will provide all and more than one needs – if one can pay. The commercialism of the Pop artists bears some resemblance to earlier market scenes. Unlike manna, these goods are all for sale. Underpinning market images stands a foundation of exchange: work or wealth traded for pleasure and survival.

On a modest level, still-life painters of market goods could occasionally give their subjects the majesty and concentration of a more 'serious' theme. Rembrandt's beef carcass is a prime example, but one finds some of the same qualities in the hands of less august artists and on a smaller scale. An oil painting of 1697 on paper by a minor artist, Adriaen Coorte (illus. 30), is a truly majestic presentation of the humble vegetables of the market. The entire work is devoted to a bunch of asparagus, tied together as they would be sold in the market. They lie at an angle on a stone ledge, or table, or sill. The lighting of these delicate spears turns them into translucent tubes of paper-thin fragility, set amid a haunting Baroque darkness. The asparagus themselves seem to radiate light, rather than merely receive light from some outside source. The tied bunch sits askew upon a lonely, somewhat wilted asparagus spear, which drips over the edge of the stone lintel. The whole fasces of glowing vegetables is upturned by one dead stalk, and the very security of the bunch is ever-so-slightly put in doubt. The twine that binds the bunch together is also unsafe, frayed, unsure. And so are the papery skins of the yellow-green plants that separate and unwind at their cut bases. The tiny differences among the asparagus spears are also noticeable. Coorte treated the little band of market produce with such sensitivity and gave the hypnotically isolated subject such effulgence that one wants to see it as more than a bit of fresh greens, and, as with Rembrandt's painting, something symbolic of God or humankind as a whole – with relations of the individual to the group set out in a problematic configuration. Rarely has the significance of the insignificant been so adeptly suggested. The riotous abundance of markets by Aertsen and Beuckelaer seem far away from this quiet vision of a tiny piece of nature, bought and sold and perhaps filled with questions of life and death and the meanings of purchasing sustenance in a darkened universe.

The Spanish painter Francisco de Zurbarán's sculpturesque studies of fruit (illus. 31), lined up gravely, as if on an altar, have some of the same power as Coorte's image. In the twentieth century Salvador Dali built upon such seemingly sacred seventeenth-century still-life pictures to give an immaterial power to his Surrealist canvases – using light to create hallucinatory visions of common food.

Paintings of markets also display healthfulness. No rottenness appears. None of the goods for sale in these scenes by Aertsen, Beuckelaer, Campi, Carracci, Caillebotte and even Thiebaud show insects or discolouration suggesting spoilage. The cauliflowers and green leafy vegetables bloom with freshness. The fish have lively

30 Adriaen Coorte, *Asparagus* (1697), oil on paper on panel. Rijksmuseum, Amsterdam.

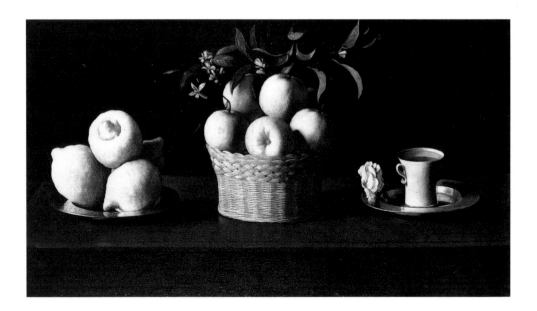

31 Francisco de
Zurbarán, *Still-life
with Oranges, Lemons
and a Rose* (1633),
oil on canvas. Norton
Simon Museum of Art,
Pasadena, California.

hues. The meat is red. And the fruits swell with juice. The market
paintings, like the Desportes painting noted earlier, act as appetite
stimulators. They also seem like modern advertisements, selling
the goodness of their products through sensory attraction. They
describe the exchange of money for survival and health. Although
rooms set aside exclusively for dining were practically non-
existent before the late seventeenth century, one can imagine
market pictures hanging in rooms where food was eaten – whetting
the appetite for reasons of health, and also speaking of trade –
commending the goodness of economic activity. Some of Vincenzo
Campi's food pictures were apparently commissioned for place-
ment in a room used for dining.[20] Maybe this was the function of
many more of such images, although there is insufficient informa-
tion on the matter. The whole novelty of market scenes speaks
most powerfully of secularism, as Moxey claims. This is a triumph
of secular thought, man-made order, Renaissance culture.
Trade, money, physical well-being, worldly concerns seem to be
celebrated here. And nourishment, food, stands at the centre of
this Renaissance vision, a properly earthly, physical and healthy
part of the new civilization of the West. That vision continued
unabated in later market pictures.

Vincenzo Campi's fruit-seller (illus. 25) seems to offer not only
succulent grapes but herself. With a light smile and pretty tilt of
the head, she gazes at us, displays her décolletage, and spreads
her thighs to exhibit juicy peaches. The likening of food to sexual
parts, and of eating to sexual acts is very old, and colours much

of food imagery. The fruit of Eden and the apple given to Venus by Paris have already been mentioned. The flesh of fruit and beasts, the shapes of peaches and pies and nuts and figs and cherries and cucumbers, and virtually every vessel and utensil of the table in every language can bear sexual meaning. It is not for nothing that giant fruits crop up in the central panel of Hieronymus Bosch's *Garden of Earthly Delights* (Museo del Prado, Madrid), where practically everybody and everything copulates. The short-lived strawberries in Bosch's painting seem to stand not just for sex, but for its fleeting satisfaction. On the whole, Bosch's picture of Heaven and Hell and earth scolds man for seeking mortal pleasures instead of eternal bliss, and uses food to make a condemnatory point as well as a sexual one.

Paintings of vendors out of doors or going house to house are particularly open to sexual association – as streetwalkers, selling their wares for consumption. Even a seemingly innocent young woman in a painting by Chardin, who returns from market with some poultry, can be read as salacious innuendo (illus. 35).[21] And it is not only images of women that can imply sexual allusions. Giacomo Ceruti's pretty sales boy (illus. 32), shown with eggs and a lively cock between his legs, and a sidelong glance, is sexually suggestive, as are some of the ragged child street vendors of Bartolomé Esteban Murillo, who influenced Ceruti and many others (illus. 33). Murillo's impoverished gamins sometimes swallow their fruit hungrily as well as offer edibles to the viewer.

Paintings of fowl for sale invite particularly ribald interpretations. Elizabeth Honig found a print by the seventeenth-century Dutch artist Gillis van Breen that depicts a male poultry seller and a female buyer, and which is inscribed with the following dialogue: 'How much is that bird, poulterer?' 'He's sold.' 'To whom?' 'To the landlady, whom I bird all year long.'[22] In several languages the word for bird or birding or flying can mean sexual intercourse or penis or prostitute or several other sexual objects and acts. In Dutch, for example, 'fowls' and related words mean 'fucking'. And the aggressive phallic gesture of thumb stuck between forefinger and middle finger in a fist is called in Italy a 'fig'. I remember seeing a 'taxi-dancing' bar in Detroit in the 1960s, a sort of bordello, with a neon sign at the front that read 'If You Have the Lettuce, We Have the Tomatoes'. It was the perfect picture of marketing and sexuality, of paying greenbacks for luscious ladies, in terms of edibles. Evidently it is not only Freud or linguists who see erotic possibilities in food. In mythological scenes, naturally pagan, sexuality in food as well as story often runs rampant. Long before Freud, Giorgio Vasari in the sixteenth

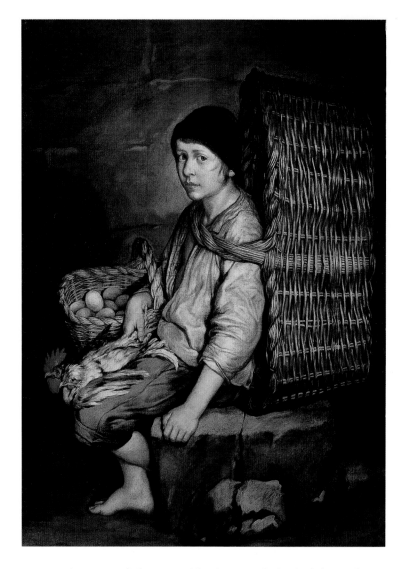

century interpreted the vegetables in a mythological fresco by
Giovanni da Udine in explicitly sexual terms: 'Above the figure
of Mercury in flight he [Giovanni] made a Priapus of a zucchini
with two big eggplants for testicles, passing through a morning-
glory, and near some flowers, he made a cluster of big bursting
figs, and inside an open and ripe one, enters the point of the
flowering zucchini.'[23]

Even images of food offered for sale without figures can imply
sexual gusto. A dead hare and a leg of lamb by Jean-Baptiste
Oudry (illus. 34), hanging against a plain wall, presumably
in a butcher's shop, have an interesting relationship. A stick

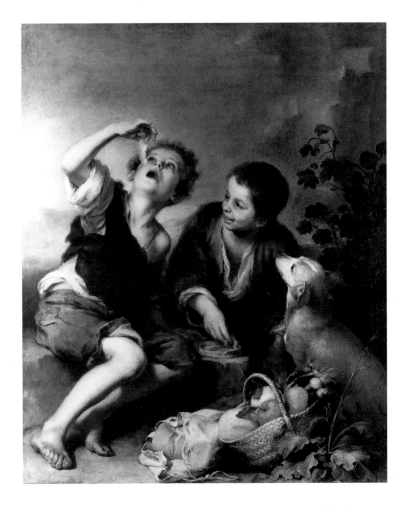

pokes out of the lamb innards, no doubt a pin to hold the
meat in place, but so positioned as to suggest the hare's penis
– and a whole set of amusing narratives about bunny fertility
may be imagined. Phallic-looking fish and sausages – and
vaginal jellyrolls and various tarts – populated numerous food
paintings, including market pictures, for centuries. There is no
end to sexual punning, verbal and visual, in the field of food.
Aertsen's fish vendor (illus. 24), seen in this light, is a riot of
sexual business – maybe.

Gender-related, but very different, is Lilly Martin Spencer's
Young Husband: First Marketing of *circa* 1854 (Metropolitan
Museum of Art, New York), where the woman painter makes
fun of her husband's unfeminine clumsiness in carrying groceries.
A well-dressed young man in the city mishandles his shopping
basket, and lettuce, carrot, tomatoes, eggs and a chicken tumble

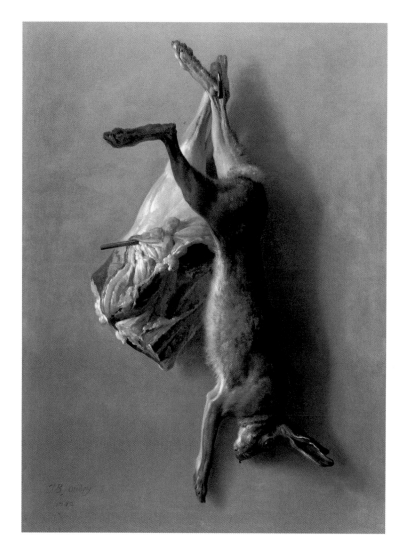

34 Jean-Baptiste Oudry,
*A Hare and Leg of
Lamb* (1742), oil on
canvas. Cleveland
Museum of Art, Ohio.

into the rain-swept street – to the amuseument of passers-by. The
comic image, among other things, suggests that food is affordable
and abundant – and thus continues the long tradition of market
imagery of plenty. Spencer's male shopper is upset by his loss of
dignity, not the loss of the food that has tumbled into the street.
The artist takes it for granted that the husband's anxiety stems
from something other than a desperate need for food.

The whole world of marketing called forth in this American
scene, however, marks a difference from Aertsen and Rembrandt
and Ceruti. Spencer's nineteenth-century provisioning involves
food of all seasons available all year, food-selling organized on
an international scale with long-distance shipping of most edibles.

Canning and refrigeration were already in the ascendant, for while food preservation through salt and sugar and drying had been familiar since ancient times, and such fare was traded over thousands of miles, the nineteenth century bottled and tinned and preserved with a speed and on a scale never before seen. The eggs, lettuce and cucumbers that Spencer's husband fumbles in the city street could all have been grown locally, but the chances are that they were not. Places such as Chicago had already developed organizations by the 1850s to transport by rail or any other means any food in a relatively short time. The modern supermarket was only three or four decades ahead.[24]

Spencer's friendly picture seems in line with Chardin's charming eighteenth-century view of marketing (illus. 35), where a maid returns home with her purchases. But the link is only on

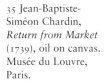

35 Jean-Baptiste-Siméon Chardin, *Return from Market* (1739), oil on canvas. Musée du Louvre, Paris.

36 Telemaco Signorini,
Leith (1881), oil on
canvas. Galleria d'Arte
Moderna, Pitti Palace,
Florence.

the most basic level. The institutions and distributions surround-
ing the selling and buying of food had become infinitely more
complicated in the nineteenth century. Food advertising also
became prominent. Previously, the baker with his horn or a
modest shop sign were the only ads. By the end of the nineteenth
century the cities of the Western world were awash with
posters, billboards and bright containers.[25] Telemaco Signorini in
1881 depicted a modern grocery market in Leith, Scotland (illus.
36). The outdoor market has moved indoors, its goods advertised
not by display on the street but by sign and shop window, and
pasted on the side of the store is a huge, bright advertisement.
This dominates the entire painting, dwarfing the dull reality
around it. Goods are now known by their labels, instead of by
sight, touch, smell and taste. Yet Signorini's painting represents
not London or even Florence, but Leith, the modest port suburb
of Edinburgh. This kind of retailing had spread everywhere in the
Western world.

Commercials eventually infiltrated food painting. In James Ensor's late nineteenth-century vision of modern hell, *The Entry of Christ into Brussels in 1889* (Getty Museum, Los Angeles), Jesus is nearly lost in a garish parade of fools, politicians and advertisements, including one for Colman's Mustard. A few Cubists at the time of the First World War, and a few Precisionists in the 1920s, played with food advertisements, but Pop Art of the 1960s mined such material more vigorously. Warhol's food has become just packaging (illus. 13), and Roy Lichtenstein's vision of a stove with goodies (illus. 74) depends on cheap and tawdry advertising images. Although Pop Art vilified consumerism and capitalism, it is difficult not to like the brightness, visual power and silliness of the movement's food pictures. They could even be thought sexy at times – Tom Wesselman placed canned foods next to sensuous nudes in his collages, and Claes Oldenburg's large sculptures of such items as hamburgers and shoestring potatoes smilingly mimic sexual organs and acts. Somehow Pop Art speaks as much about the vitality of the modern food industry, purveying everything to everyone in a consistent, durable form, as it does about the horrors of corporate marketing.

It is possible that some of the innumerable food still-life paintings in the seventeenth-century Dutch Republic (illus. 30, 42 and 61) were used to advertise provisioners' wares, but this is unlikely. There was no advertising, except for occasional small paper handbills and some insignia on containers. Shops did not have large windows, and outside signs were rare and small. Advertising and food really came together only in the nineteenth and twentieth centuries, and only in the mid-twentieth century did commercial marketing appear widely in the realm of food art.

Not all vendors of food before the nineteenth century presented their goods in open-air markets and stalls. Willem van Mieris's spice-shop painting of 1717 (illus. 37) presents an interior sales space. In this work, however, the store interior seems to be open to the street or some external space. The viewer sees the vendor through a large open archway and on the other side of a counter. These shops were probably not so different from those shown in the background of fifteenth-century Netherlandish religious paintings, where large open doorways with counters separating shop from street represent the selling area.[26] This half-inside-half-outside commercial arrangement appears to echo the structure of ancient Roman selling – as seen at Pompeii.

The van Mieris painting also represents high-class goods for sale. Although some common vegetables appear, the main fare of this shop is spices and sweets. This is a luxury trade – spices

were extremely expensive before the nineteenth century. The money laid on the counter speaks of expensiveness. Indeed, the highly spiced food of the Middle Ages and early Renaissance, it has been claimed, was a major indicator of class distinction.[27] Most spices apart from salt remained costly items. Sugar, and goods made from sugar, were also the stuff of wealth.

37 Willem van Mieris, *Spice Store* (1717), oil on wood. Mauritshuis, The Hague.

The differentiation between food and medicine here is blurred, however. For centuries, many spices – and sugar in particular – were prescribed for a host of illnesses.[28] Candies, fruit in syrup, cookies, cakes and sweet biscuits in the seventeenth century were cure-alls. Before the establishment of sugar plantations in the Caribbean, the Islamic world supplied this costly substance to the West (from sugar cane gathered at great expense in India). The English word 'candy' comes from the Arabic name for Crete (Candia), where around the year 1000 the Arabs had built the largest sugar refinery in the Mediterranean.[29] The spice store depicted by van Mieris should be likened to an apothecary shop, with mortars and pestles and fine scales, and small boxes of rare items on shelves. Indeed, before the nineteenth century apothecaries were the chief sellers of spices in most of Europe. The vendors in paintings of spice shops usually appear dressed in rather fine, urbane clothes. Most vendors of less exalted food in art wear peasant garb or very plain garments.

In the later seventeenth century sugar finally became somewhat less expensive – and more available to ordinary Europeans. Its gradually lower price and spreading popularity stemmed from the European colonization of the West Indies and other sugar-growing regions. The whole system of colonial plantations, worked by slave labour, entwined inextricably with Europe's addictive demand for sweet foods. According to Sydney W. Mintz's Marxist-tinged interpretation of history, sugar, along with rum (derived from sugar) and coffee and tea (sweetened with sugar), were 'drug-foods' that killed hunger, brightened spirits and served to subjugate the European proletariat. Sugar, and tobacco too in this scheme, became the opiates of the masses in the eighteenth and nineteenth centuries. The entire diet of the lower classes changed as medicinal sugar appeared everywhere. Bread and jam replaced porridge as the staple food in England.[30] In van Mieris's spice and sugar shop this whole history appears, neat and satisfying and healthy. Slavery and working-class zombiism do not call out loudly.[31] But the addictive attraction of the goods comes through, as bags and boxes of tempting stuffs tilt towards the viewer.

Food paintings, if one accepts Mintz's historical outlook, participate in the addictive play. And perhaps this helps to explain the unrepentant attractiveness and wilful joy that mark food art in general. The European conquest of the New World for food crops, and the control of peoples both at home and abroad that this entailed, are not really digressions from these little pictures of food vendors. The market theme deals with economics, the

trade of money for goods, the commercial linkage of peoples. The spice shop of van Mieris sells sugar from Dutch colonies in the Caribbean and spices from Dutch colonies in the Far East. And if these products did not come from Dutch colonies, then they came from English or French or Spanish or Portuguese ones with which the Dutch traded. Market scenes display not only humble native produce but also exotic goods, which, as Mintz notes, affected the entire outlook, habits and health of Western man.

By 1800 the familiar porridge of Europe's common people had disappeared from cities and from much of the countryside, and was replaced by potatoes and sweets and coffee and tea. Before 1800 a lower-class family would purchase a large loaf of bread, steep it in water, and eat the resulting gruel for a week. The pabulum was flavoured, when possible, with lard, bacon, butter, onion, oil, milk, cheese or fruit. This is the stuff that Pieter Bruegel the Elder's sixteenth-century peasants slurp and chew during a mealtime break from harvesting wheat, and this was the stuff still consumed by European peasants on the eve of the French Revolution. A traveller in 1789 in south-west France wrote of the bread-based 'soup' or gruel of the common people:

> The bread is all ready in a big wooden dish, with a little knob of butter, and then the boiling water is poured over it. *Voila!* That's the soup. A clove of garlic and a raw onion grated by the cook and sprinkled over the soup – that's the seasoning, the last word in culinary fusion. The soup is served. It's excellent. One eats it with a wooden spoon.[32]

In contrast, Vincent van Gogh's humble peasants in *The Potato Eaters* of 1885 (illus. 39) drink coffee, grown abroad and spiked with sugar. Such a beverage was as common as the potatoes they eat (a New World food that had spread throughout northern Europe by the eighteenth century). Ale and mead, or some other ancient brew, no longer held a high place in the European diet, even in the most impoverished and traditional sections of the population.

Outside Pop Art and a few sexual innuendos in earlier art, there is little evident comedy in market scenes. As noted in the Introduction, humour comes easily to food imagery, but specialists in food painting rarely indulged in it, because their subject matter was already low enough in most estimations. William Hogarth's market painting of 1748, *Calais Gate: O' the Roast Beef of Old England* (illus. 38), is a notable exception. The French authorities at Calais had arrested Hogarth briefly for

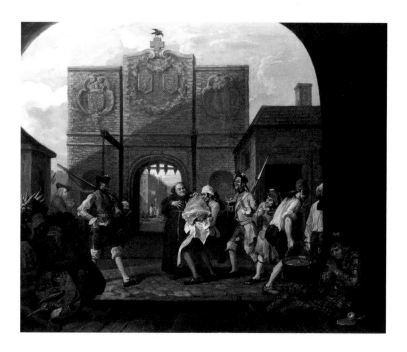

39 Vincent van Gogh, *The Potato Eaters* (1885), oil on canvas. Van Gogh Museum, Amsterdam.

spying in 1747 when they saw him making sketches in the city, and the painter made much of the incident, elaborating his anti-French bias in this work. He especially played up the contrasts of food between the French and English, each of whom had taken possession of the city at various points in history. In the centre of the painting a butcher's assistant carries a great side of beef through the streets, exciting the gluttonous lust of an over-weight Catholic monk. The meat, bloody and bright, epitomizes health-ful, vigorous, no-nonsense food and, as Hogarth's title indicates, is intended to characterize the British nation as a whole. Here more than any other painting, nationalism and nourishment come together.

The time of the year in Hogarth's *Calais Gate* is undoubtedly Lent, because the French street vendor at the lower left sells nothing but fish. Prominent among the wares is a skate, considered a poor breed of fish for eating in England, although evidently Chardin thought it good enough to take centre place in one of his largest canvases (illus. 58). Obviously, the French and English dis-agreed as to the merits of ray as food, and this painting chauvinis-tically plays upon national differences. The monk's delight in the beef takes on the look of corruption or hypocrisy, given the Lenten period – a typical Hogarthian put down of Roman Catholicism. His painting can be taken as a Protestant denigration of a Catholic practice – the observation of Lent. It is impossible to separate reli-gion from politics here. Hogarth was not content to abominate the French and their meagre diet. He also castigated the Scottish sup-porters of the House of Stuart, also Catholic, who had recently rebelled against the English Hanoverian monarch. An expatriate Scot lies miserably in the street at the lower right – too weak to get up after eating nothing but French food for so long.

The mockery of Continental eating habits, and the touting of his own country's most identifiable dish, goes part and parcel with the rest of Hogarth's art – which includes put downs of Catholic superstition and celebrations of John Bull pugnacity. Hogarth's portrait of the Strode family taking tea (illus. 40) seems another proud celebration of Englishness, as well as a depiction of refined family life. Tea drinking in the eighteenth century had become a national characteristic of English high life. Images by the artist who produced *The Roast Beef of Old England* of course invite such interpretations. There may be other images by other painters that similarly focus on national identity through food. The choco-late in the special handled pot in a seventeenth-century still-life by Antonio de Pereda (illus. 41) could very well signify the triumph of the colonial power of his native Spain, which imported the new

40 William Hogarth,
The Strode Family
(1738), oil on canvas.
Tate Britain, London.

41 Antonio de Pereda,
*Still-life with Ebony
Chest* (1652), oil on
canvas. State Hermitage
Museum, St Petersburg.

42 Pieter Claesz., *Still-life with Herring and Beer* (1636), oil on panel. Museum Boijmans Van Beuningen, Rotterdam.

43 Frida Kahlo, *Fruits of the Earth* (1938), oil on masonite. Banco Nacional de Mexico SA, Mexico City.

44 John Sloan, *South Beach Bathers* (1907–8), oil on canvas. Walker Art Center, Minneapolis, Minnesota.

drink to Europe from its territories in the New World. And some art historians have proposed that the herrings that appear so often in Dutch seventeenth-century art (illus. 42) are in part celebrations of the Dutch fishing industry, and a tribute to Dutch trading prowess.[33] This seems likely. In the twentieth century, Frida Kahlo's *Fruits of the Earth* of 1938 (illus. 43) can be seen as a salute to Mexico. She represents specifically Mexican food: pitahaya (a type of red prickly pear), dried chile ancho peppers, black sapote, smooth-skin chayote, prickly chayote and candied tejocote (Mexican haw) as well as maize and local gourds.[34] Later, Warhol's cans of Campbell's Soup are definitely American, but less patriotic than Kahlo's vegetables. On a less critical note, John Sloan's early twentieth-century painting of New York beach-goers with hotdogs (illus. 44) seems to present the particularly American finger food with delight – and the food here characterizes not only the location but also the social level of the people of the scene. Hot dogs belong to the common folk, not the elite. Norman Rockwell's Thanksgiving turkey of 1943 (illus. 45) goes further in sanctifying a national food – as part of wartime patriotism. His painting presents the Last Supper American style as an act of national communion.

Nevertheless, much of the food that appears in paintings from the seventeenth century on, as was noted in the Introduction, is Dutch-inspired. German painters rarely portray sausages; the

45 Norman Rockwell,
Freedom from Want
(1943), oil on canvas.
Norman Rockwell
Museum, Stockbridge,
Massachusetts.

French do not illustrate their glorious desserts; there are very few
paintings of pasta from Italy or anywhere else; and Swiss artists do
not always include cheese in their still lifes.[35]

Here and there, a sense of national identity conceivably
touches paintings of citrus fruits in Spain (illus. 31) or sardines
in Brittany, but this sort of meaning is uncertain. The reason that
paintings of food so rarely take up the theme of nationalism in
any very obvious fashion may be because food primarily represents
privacy and intimacy, and the generally lower rank of still-life
and food paintings would compromise highflown visions. And
surely Hogarth's painting of roast beef is more effective as comic
commentary than pledge of allegiance?

Drinks were less beholden to Dutch tradition than solid food in
art. The mass production and standardization of alcohol produc-

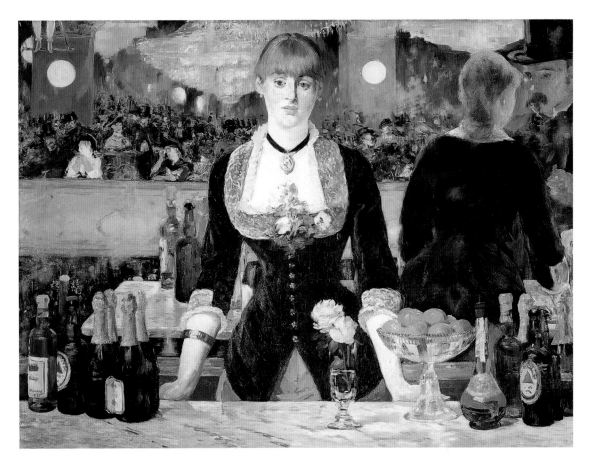

46 Edouard Manet, *The Bar at the Folies-Bergère* (1881–2), oil on canvas. Courtauld Institute Galleries, London.

tion, containers and trademarks in the nineteenth century permitted on occasion some mildly nationalistic political commentary. Much has been written about Edouard Manet's *The Bar at the Folies-Bergère* (illus. 46) – its ambiguous spaces with problematic mirror, its class-mingling setting in a Parisian café-concert and its deadpan expressions. Even the price of drinks in the Folies-Bergère has been discussed with an eye to the economic level of the clientele.[36] But a glance at the bottles of drink in Manet's painting of a bar counter reveals more. The standard gold foil on a number of bottles in the foreground marks them as champagne, and the distinctive bottles of crème de menthe (green with pear-shaped bottle) and claret (light red wine, clear glass, high-shouldered bottle with straight sides) also appear. Perhaps most significant are the bottles of ale – the red triangle on the white label of these brown bottles in Manet's painting clearly identify the company as Bass – it is still this brewer's logo today. Bass Ale was and is an English product. And Manet perhaps showed the bar at the Folies-Bergère serving

47 Damien Hirst, *This Little Piggy Went to Market, This Little Piggy Stayed at Home* (1996), pig, steel, GRP composites, glass, formaldehyde solution. Saatchi Collection, London.

exclusively British ale to express a nationalistic, even jingoistic, sentiment. There are no German beers visible here, even though Germany stood as the most celebrated country of beer production. The Franco-Prussian War had made German products unacceptable in France. The defeat humiliated the French, and since Alsace had been taken by the Germans in the Treaty of Paris, Alsatian beer would no longer satisfy any chauvinistic longings. The prominence of Bass Ale in Manet's painting represents a distaste for Germany, a kind of boycott of the products of France's enemy. Such nationalism in food paintings, however, only rarely disturbed the triumph of Dutch still-life menus.

This market chapter ends with one more butcher shop, but one that is worlds away from Aertsen's and Carracci's. It has a certain humour, but it is not the wit of Hogarth: Damien Hirst's *This Little Piggy Went to Market, This Little Piggy Stayed at Home* of 1996 (illus. 47). Hirst's work displays an actual pig, sliced in half, each side preserved in a transparent glass container. Although not paintings, Hirst's two pig halves resemble paintings. Marketing appears in the *title* of Hirst's work. But there is no real market here, or any delight. Hirst, like other Postmodernists, puts a nail in the coffin of food imagery. For all the carnage of Aertsen's and Carracci's butcher shops, the products are still food – and tempting. But Hirst's pigs are not cut up in the way that pigs are cut up by butchers. They have been dissected – an operating table seems closer than a butcher's counter. The desire to eat disappears. Death rather than food becomes the subject, and in an era when animal rights have assumed new power, Hirst's piggy suggests horror, despite the cute little curly tail and gambolling posture of the poor beast. How happy earlier market pictures seem in comparison!

Preparing the Meal

Meal preparation in art often claims a solemn tone. The creation of a meal from what has been gathered is a grave task, and always involves the transformation of the natural world. The various methods of cooking food – roasting, boiling, frying, smoking, poaching, microwaving, etc. – in Claude Lévi-Strauss's view – describe the fundamental relationship of a society to nature.[1]

Chardin's beautifully simple arrangement of a glass of water, garlic, a sprig of spice and a pot seems filled with these sorts of Lévi-Straussian themes (illus. 48). The pot's pouring lip and side handle suggest that the vessel is for heating liquids. If it had a lid, it might be for coffee or chocolate. But there is no lid, and it is probably for heating and pouring sauces. The food items depicted collaborate with the pot. The water thins the sauce; the garlic and spice heighten its flavour and piquancy. The composition constitutes an architecture of contrast and stability. The two vessels are cylindrical, yet opposites – one wider at the top, the other wider at the bottom. One is transparent, the other opaque. The three cloves of garlic dispose themselves in a gentle curve, as does the plant at the right. One group of vegetables, however, is made of separate items, while the other is a continuous chain. The objects altogether create an informal yet perfectly balanced pyramid, the pot rising highest and most firmly resting on the strong counter. The lightest tones add a buoyant rhythm across the picture, and the garlic and spice modestly push out towards us, engaging our space.

But is the beauty of this group of preparatory things all there is to Chardin's picture? Lévi-Strauss would see, no doubt, a society's understanding of itself, an expression of its differentiation from nature. Raw water and plants have been captured and now await transmutation in the pot and flame. Crushing and liquefaction and heating will turn nature into a man-made thing – just as the glass and pot themselves are raw minerals wrought by heat into objects useful to society. Note how the man-made objects – glass and pot

48 Jean-Baptiste-Siméon Chardin, *Water Glass and Pot* (*c.* 1760), oil on canvas. Carnegie Museum, Pittsburgh, Pennsylvania.

and counter – dominate the water, garlic and spice. Nature here does not threaten or overwhelm. The smallness of the foodstuffs does not indicate sparsity or poverty. These food items act as flavourings and texturizers – accessories of the meal, not the main course. And this role, one might extrapolate, suggests the whole society's relation to nature – the complete domination of nature for even the smallest and most unnecessary of ingestions. Natural things in Chardin's work present themselves for our disposal. These goods add the pleasures of taste, but nothing substantial to human diet – it is all about the icing instead of the cake. That very superficiality, as well as this food's implied alterations by a cook, reveals the extreme refinement and total control of nature of Chardin's eighteenth-century French society. And how sophisticatedly stable that society appears here, represented by a few kitchen goods. They are organized and balanced not by rigid symmetry or drill-parade order, but by subtle similarities and differences of size and tone and texture and placement. The structure of the canvas, along with the nature versus man-made relationship of the meal items, expresses a world where the natural is not just controlled, but altered for consumption with finesse, delicacy and complete transmutation. When the sauce is eventually made, the garlic, spice and water will be invisible. Only the artificial concoction will appear.

Chardin's still-life makes meal preparation seem exquisitely delicate – so much so that one could even believe that Lévi-

Strauss's expressions of social structure in food were not unconscious – at least in Chardin's clever manipulations. But there exist other visions of kitchen activities in Western art that are tougher and more raw, and that depict dismemberment and aggressive decomposition. Such works more powerfully exhibit the fetishistic transformation of animals and plants into edible objects. Pieter Aertsen's mighty cook of 1559 (illus. 49), for example, makes cooking more a wrestling match than a sensitive balancing of taste and form. His woman is one of this innovative artist's newly monumental peasant subjects. She possesses a rude, Michelangelesque vigour, and almost bursts out of her clothes as her muscles and shoulders ripple and swell. The grand Classical fireplace in the background indicates that Aertsen's cook works for some wealthy employer. She is not cooking here for her own family or some peasant inn. Her outlandish robustness conveys a sense of healthy vitality to the subject as a whole, as she handles spitted fowls, a great joint of meat and writhing vegetables. Her equipment also suggests heft and strength – a huge skewer, a large slotted spoon and various buxom pots.

The cook exudes physicality and the healthiness of food and food workers. There is no hint that cooking is fine art. That kind of gourmet appreciation of cooking would arise only in the eighteenth century (when Chardin was painting), and would become so widespread that it could be mocked around 1890 by Jehan Georges Vibert in *The Marvellous Sauce* (illus. 50). There, the artist satirizes the over-refinement of a gluttonous priest. A fat ecclesiastic assesses the cook's work at the stove, savouring the sauce's exquisite flavour, and no doubt explicating the qualities in the sort of language today employed by wine writers and restaurant critics. Vibert gently derides both delicate cookery and the Catholic Church. The conjunction of fine garments and work boots, lower-class cook and amateur chef, ascetic vows and big belly, all contribute to the picture of human foibles.

In the Vibert painting the kitchen is no longer a grave and muscular place, and this lighter tone is not unusual in the nineteenth century. The work of preparation is a pleasant labour. The ample food supply of the nineteenth century, as well as the perception of cooking as a delicate art, may explain the new lightheartedness.

Back in the early years of the seventeenth century a different atmosphere prevailed, although love and gracefulness could still be present. Joachim Wtewael's *Kitchen Scene* of 1605 (illus. 51), slightly later than Aertsen's, adds a dose of Mannerist grace to the subject. Complex artificial postures create a precious beauty. But

49 Pieter Aertsen, *The Cook* (1559), oil on panel. Musées Royaux des Beaux-Arts, Brussels.

50 Jehan Georges Vibert, *The Marvellous Sauce* (c. 1890), oil on canvas. Albright-Knox Art Gallery, Buffalo, New York.

even here, the skewering of fowl and the hacking of slithering fish give the image a sense of tough, powerful muscularity. The kitchen is still a place of hard labour. Like many of Aertsen's food images, this one by Wtewael includes a relatively small biblical subject in the background – the *Parable of the Great Supper* (Luke 14: 12–24). Jesus's parable tells of a rich lord whose invited guests refuse to attend his feast for various reasons. The angered host therefore tells his servants to invite all the crippled and poor folk in the vicinity, and 'none of those men which were bidden shall taste of my supper'. In contrast to some of Aertsen's works, the foreground food relates directly to the background biblical story. Still, there is something amiss or twisted in the concentration on the kitchen, when the parable emphasizes the guests and whether they will sup with the lord (i.e., enter heaven, when offered the chance). Anne Lowenthal, like some of Aertsen's interpreters, sees Wtewael's foreground as a zone of fleshy temptations, which distracts the viewer from the scene of salvation in the background (and she notes the sexual pun of the skewered fowl).[2] Again, however, Keith Moxey's Reformation interpretation could well be applied here, instead of the God-is-hard-to-find point of view. Wtewael's Rabelaisian image seems to put into question the whole concept of religious art. In fact, he appears to enjoy sensuality so much that it is difficult to see this picture as a sincerely moral meditation on the difficulty of salvation.

In any event, Wtewael's kitchen provides a view behind the banquet. The kitchen subject in general acts as a realist space. It reveals the brutalities and constructions that lie behind the artifice of the meal. The people at the banqueting tables in the right

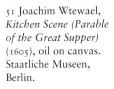

51 Joachim Wtewael, *Kitchen Scene (Parable of the Great Supper)* (1605), oil on canvas. Staatliche Museen, Berlin.

background of the painting know nothing about what happens in the kitchen. The viewers, however, are let into the back room and behold the arduous transmutation of raw nature into manmade food. The foodstuffs and cooking equipment spill and knock about, and children, pets and lovers add to the riot of things and activities in the huge interior. A grand jumble, we are told, lies behind the orderly banquet to come. The painting also shows the stages of food preparation, from dead animal to chopped morsels to pots in the fire. What the scene lacks in sanitation it makes up for in liveliness. The figures and furniture and food items roll across the canvas vigorously. The medical recommendation of a balanced diet exists here too. A hare and fowls hang together at the upper left. These are healthily complementary meats that balance moistness and dryness, and heat and cold. The garlic that hangs nearby will add flavour to the dish. In most kitchen paintings, the foods shown, quite naturally, tend to go together in a meal. The figure with the mortar and pestle in Wtewael's picture further alludes to health – the necessity of thorough mixing is depicted. In the kitchen the lively but tough physical stuff that underlies all of life is shown; it is the workroom of survival.

In Diego Velázquez's *Kitchen Scene with Christ in the House of Mary and Martha* (illus. 52), the world behind the meal, the hard truths beneath the finery, are again depicted. Kitchen labour occupies most of the canvas. An old woman directs a young woman, who sadly grinds food with mortar and pestle. Fish, eggs, garlic and pepper lie ready for preparation. The biblical subject appears through the serving hatch at the upper right, small, but well lit.[3]

52 Diego Velázquez, *Kitchen Scene with Christ in the House of Mary and Martha* (c. 1618), oil on canvas. National Gallery, London.

There is something going on here that is similar to what Aertsen produced in the 1550s, a serious religious subject relegated to the background, while vulgar genre assumes a major role. In super-Catholic Spain, it is unlikely that a similar Reformation attitude toward religious images influenced Velázquez. Here, the foreground subject refines and elaborates the religious episode in the background. The foreground does not oppose the background; it comments on it. By enlarging the genre scene, Velázquez makes his biblical tale more 'real', more relevant to everyday life in seventeenth-century Spain. The story (Luke 10: 38–42) concerns Martha, who complains to Christ that her sister Mary refuses to help with the cooking. Martha must prepare the Lord's meal alone, because Mary devotes herself totally to Christ's words and has no time for such tasks. She feels that it is very unfair. But Christ replies: 'Mary hath chosen that good part, which shall not be taken away from her', and although Martha does well to carry out her good domestic labours, the spiritual path followed by Mary is better. The passage compares the merits of works and faith as roads to salvation, and gives the edge to faithful Mary. Maybe that is why the young cook in the painting seems sad. She toils in the dark kitchen, but never quite attains equality with those who practise the contemplative life. The kitchen remains the zone of the laborious, hard facts of life.

The kitchen is usually depicted as a dour, toilsome place before the nineteenth century – even in Chardin's dappled and smiling eighteenth-century world. The kitchen maid in his *Woman Peeling Vegetables* (illus. 53) appears fatigued, bent-over, sad-eyed, an unenthusiastic worker, as she pares the tubers. The unpeeled vegetables lie on the floor, as do the bowl with cut vegetables and the pan in which they will be cooked. This maid is not so different in expression from the one in Gerrit Dou's *Woman Peeling Carrots* (illus. 54), of the seventeenth century. There, giant vegetables, enormous vessels and dead fowl dwarf the little cook. The carrots alone in this painting are huge affairs, and the woman looks out fearfully from the darkness, a tiny figure in an overwhelming space.

In the seventeenth-century Dutch Republic sober food preparation sometimes takes on a *vanitas* role. In scenes of apple peeling, the unravelling skin seems like a metaphor for life – gradually spiralling downward. In Gerard Terborch's version of this subject (illus. 55), a grave child watches a sad-faced apple peeler, and the bowl of fruit, significantly, rests near a snuffed-out candle. The child learns that he will die – and he responds with a quiet, questioning gaze. Terborch's beautifully attired figures appear with a

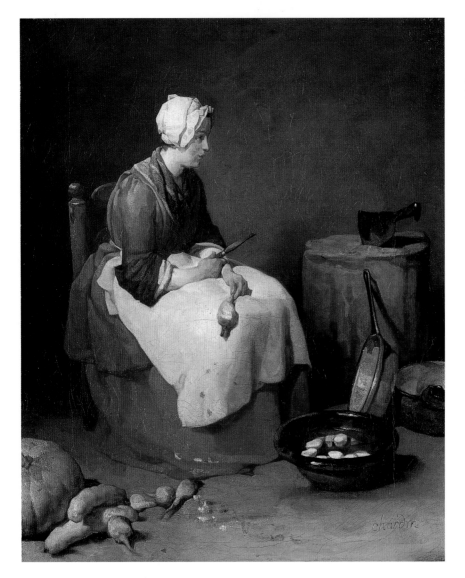

53 Jean-Baptiste-
Siméon Chardin,
*Woman Peeling
Vegetables* (*c.* 1738), oil
on canvas. Alte
Pinakothek, Munich.

richly carpeted table and fine porcelain bowl. Death takes the rich
and powerful as well as the poor and powerless is the moral here.

Such traditional warnings of the material world's mortality right-
ly occupy the kitchens and workspaces of food pictures. They are
yet another dose of the pain and difficulty associated with food
preparation. The death referred to in the kitchen pictures con-
ceivably alludes to the death of animals and plants – the change
from the living to the non-living that is at the heart of food prepa-
ration. But this interpretation seems unlikely. The killing of animals
is, after all, also the stuff of the hunt, noble and exciting. Their

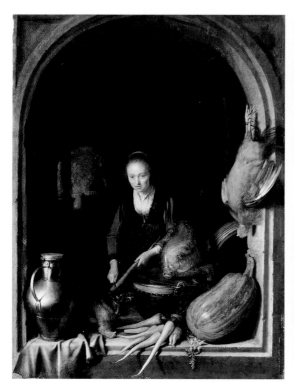

54 Gerard Dou,
Woman Peeling Carrots
(1646), oil on panel.
Staatliches Museum,
Schwerin.

above right:
55 Gerard Terborch,
detail from *Woman
Peeling Apples* (1650),
oil on panel.
Kunsthistorisches
Museum, Vienna.

slaughter for sport or food or any other reason was not distressing to anyone, so it seems, before the middle of the eighteenth century, when works such as William Hogarth's *The Four Stages of Cruelty* (1745) suggested that torturing animals was morally reprehensible and could lead to the abuse of humans. The Society for the Prevention of Cruelty to Animals in England was founded only in 1824. In food preparation, after all, most of the real killing was done before the items reached the kitchen.

It is the sweaty labour needed to transform nature into man-made product that probably underlies the less-than-joyous spectacle of the kitchen. Skulls and mirrors and clocks and burnt-out candles can also be found aplenty in food still-life painting representing meals. But in these works there is almost always a strong counterthrust of cheerfulness as delicacies offer themselves to the viewer's senses. And the implied satisfaction of the meal makes warnings of death acceptable, or only relatively important. The food in the kitchen scenes still attracts and tempts. But all

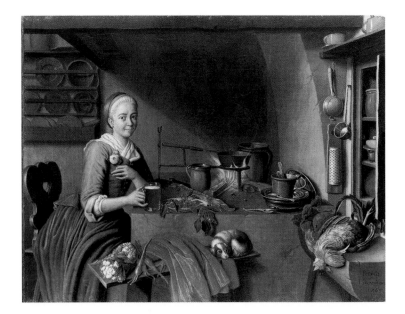

56 Pieter Jacob
Horemans, *The Servant*
(1765), oil on canvas.
Staatsgemälde-
sammlungen, Munich.

that work and harsh surroundings claim too much attention –
and, for once, the fetishistic delight in controlling nature must
reckon with toil and time. The dampened tone of kitchen pictures
had changed by the nineteenth century, when cooking was looked
upon as a fine art, and sensitivity rather than muscularity reigned
in food preparation.

The Servant (illus. 56) by the Dutch painter Pieter Jacob
Horemans handsomely portrays the moment of transition – the
second half of the eighteenth century – in the representation of
the kitchen. Here, the workroom of food no longer appears as
a place of toil and strength. A cook, well dressed, sporting a
decorative flower and sipping a beer, looks out at the viewer
contentedly and at ease. She sits gracefully and gestures delicately.
No longer is there a figure of rude robustness or awkwardness.
The kitchen has become a cozy place, *gemütlich*, the utensils easi-
ly within reach, the dishes neatly racked, the fire under control –
and evidently there is no need to work constantly. The fire irons
hold the cooking pot securely, reducing the cook's physical exer-
tions, and all the objects in the interior appear manageable, not
overwhelming or difficult to handle. The dog, like many of his
forebears, still looks longingly at the dead fowl, but Horemans's
scene as a whole exudes a pleasant air. Even the individuality of
the cook – it is unusual to have a genuine portrait of a lowly
servant – adds a note of humanity to the kitchen. This does not
seem a chamber of dark labour.

57 Martin Drölling,
Interior of a Kitchen
(1815), oil on canvas.
Musée du Louvre,
Paris.

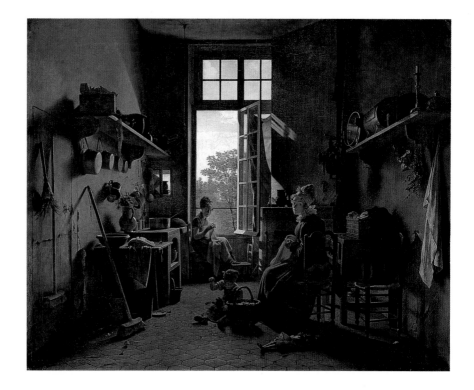

In the early nineteenth century the French artist Martin Drölling depicted another kindly kitchen (illus. 57). Although the room holds all manner of objects in disarray, it remains charming. The workroom, decorated with homely flowers, functions as a chamber for family relaxation. The smiling lower-class group takes its place in the kitchen with calm assurance, and through the open door appears a ravishing glimpse of nature that fills the happy interior with sunlight.

THE KITCHEN STILL-LIFE

Even without people, some pre-modern kitchens appear stressful. Chardin's *Ray* (illus. 58), for example, presents a kitchen counter with a large sting-ray hung from a chain. The ray has been slashed open and its innards spill out, but more disconcerting is its expression of pain. Its face is like a non-smiling smiley face, a caricature of unhappiness. The corners of the creature's eyes turn down in such a way as to suggest tears. The two dead fish on the counter, to a more modest degree, also appear in pain. The cat at the left plays a reversal role, stalking the oysters instead of

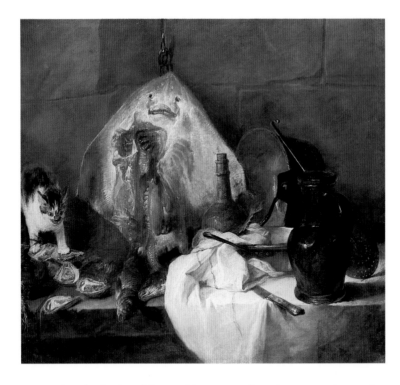

58 Jean-Baptiste-
Siméon Chardin,
The Ray (1728),
oil on canvas. Musée
du Louvre, Paris.

protecting the larder.[4] The cooking pans, slotted spoon, wine and
onions stand ready to make a fish stew. But the atmosphere
hardly stimulates appetite. The dark kitchen scene appears as a
torture chamber, a world gone wrong. The transformative func-
tion of the cook becomes an unpleasant task. Even Denis Diderot,
an ardent admirer of Chardin, found *The Ray* distressing.[5] But
Chardin's image is unusual in his œuvre and in the category of
kitchen still-life painting in general.

Only in Francisco Goya's mutilated animal still-lifes of the early
nineteenth century can one find an equivalent air of distress – and
Goya carries it to a greater extreme than Chardin. Goya's *Plucked
Turkey* of *circa* 1808–12 (illus. 59) constitutes a scene of horror.
José Lopez-Rey made a convincing connection between Goya's
still-life food paintings and his *Disasters of War* etchings.[6] Both
present dismemberment and frailty with a new air of hopelessness,
lack of physical integrity and bleeding distaste. Goya's turkey looks
pathetic and diseased, cruelly strangled, unpleasingly tied up
(and, what is more, from a culinary point of view, it does not go
with the fish in the pan). Even Chaim Soutine's twentieth-century
butchered animals (illus. 20) seem more alive and kicking than
those of Goya. It is fitting that Goya painted his less-than-choice
cuts just when people (in Britain at least) began to outlaw cruelty to

animals, especially domestic beasts. This novel attitude, which viewed these non-humans with the sentimentality and care and passion formerly reserved for human subjects, conceivably underlies Goya's grim still-lifes. He came to know British culture during Wellington's Peninsular campaign, and painted a portrait of the British general (Apsley House, London). Then again, a large number of Goya's images – religious, genre, history and portraits – serve up a sense of displacement, emptiness, terror and eternal death. His food still-lifes conform to his general outlook.

Goya's still-lifes and Chardin's *Ray* stand as rarities. In general, the dour food preparation images of the sixteenth, seventeenth and early eighteenth centuries contain human figures. When devoid of figures, larder and kitchen pictures of these periods are mostly portraits of satisfaction. It is as if the presence of humans in the kitchen and storerooms created a realm of toil, worry and death. But why did that character change in the later eighteenth century? There were not that many new labour-saving devices to explain the new sense of joy in the kitchen in the eighteenth century. The kitchen was usually a lower-class zone, but even in a class-distinguishing society that social designation did not necessitate a dolorous mood. There are plenty of paintings of happy peasants – silly and stupid perhaps – but still convivial. Can the change be explained by that general softening of manners that Elias and Mennel perceive as the great mark of Western civilization around 1700? The matter probably lies more within the bounds of all those tumultuous changes – political, social and artistic – that transformed Western

59 Francisco Goya, *Plucked Turkey* (*c*. 1808–12), oil on canvas. Alte Pinakothek, Munich.

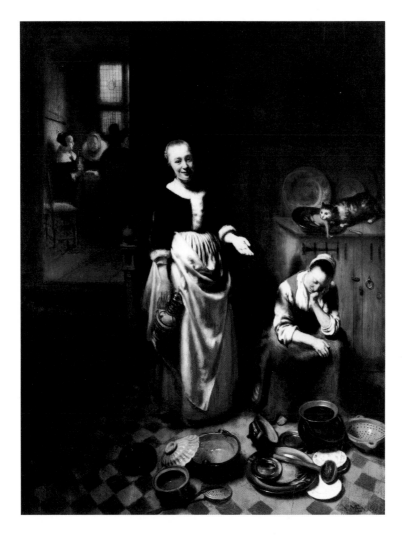

60 Nicolaes Maes,
The Idle Servant (1655),
oil on panel. National
Gallery, London.

culture in the eighteenth century and continued to echo in the
nineteenth. The political revolutions in America and France and
the advent of neo-Classicism in the arts together can be viewed
as an attempt to throw out the stultifying accretions of preceding
centuries and recapture a primitive truthfulness and freedom.[7]

The end of the deadly kitchen in the eighteenth century seems a
kind of liberation of workers and a re-thinking of what it means to
transform the stuff of nature into an elegant meal. The menial
kitchen drudge in the seventeenth century, laughed at and scolded
by Nicolaes Maes (illus. 60), could become an erotically charming
shepherdess type in the eighteenth century in the hands of François
Boucher (e.g., a painting in the Musée Cognac-Jay, Paris). Of
course, Boucher presented most women as pretty coquettes – but

that he did so with a kitchen maid suggests a new appreciation of the kitchen's working. Such a willingness to re-think and reverse oneself lies at the heart of eighteenth-century intellectual life. And in paintings of the most mundane of subjects, the kitchen, one finds the large transformations of the period in concrete terms – the grand social changes and hopes for the pursuit of happiness played out amid pots and pans.

Kitchen still-life paintings without human figures, however, never underwent such re-thinking. They tended toward the joy and satisfaction of most food images long before the eighteenth century. Even the severe still-lifes of the late sixteenth- and early seventeenth-century Spanish master Juan Sánchez Cotán, for example, actually present handsome and tasty food in window-like stone larders.

Some art historians describe Sánchez Cotán's spare representations of fruit and vegetables as abstemious images, and link these works to the artist's late attachment to a Carthusian monastery. They are supposed to express a monastic denial of worldly pleasure and riches.[8] But the apple, lettuce, melon and cucumber in his famous *Still-life with Quince* (illus. 62) are not foods of austerity, and they form a most beautiful ballet-like composition as they wait to be eaten. The melon is already sliced and offered. The items suspended from strings are not death sentences, but the common means in the seventeenth century of preventing fruits and vegetables from rotting.[9] These foods spoil more quickly when left on a stone surface. The Carthusians are vegetarians, but many of Sánchez Cotán's works contain game birds as well as apples, lemons, carrots, apples and a celery-like vegetable called cardoon (e.g., *Still-life with Game Fowl* of *circa* 1600 in the Art Institute of Chicago). He painted most of his food images before becoming a Carthusian lay preacher in 1603.

Balthasar van der Ast's *Basket of Fruit* of about 1632 (illus. 61) presents a situation that may suggest a kitchen larder. Or perhaps it is a table display in living quarters. It is a decorative work, but not so abstract as to neglect entirely a domestic setting. The painting teaches us about the morality of earthly pleasures. Various insects – flies, dragonflies and butterflies – destroy the food, as does a lizard. Holes appear in the leaves, and spots mar the fruit. This work is about as rancid as Dutch seventeenth-century still-life ever got. And it goes beyond Caravaggio's slightly spotted and worm-holed fruit still-life of *circa* 1600 (illus. 5). There is no denying the spiritual *vanitas* message in the van der Ast painting. Yet, it seems, the savoury pleasures of the fruit, still moist, still ripe, still bounteous, still tasty, never quite disappear.

61 Balthasar van der Ast, *Basket of Fruit* (*c.* 1632), oil on panel. Staatliche Museen,

62 Juan Sánchez Cotán, *Still-life with Quince* (*c.* 1600), oil on canvas. San Diego Museum of Art, California.

In showing the transience of earthly satisfactions, the eye and mind and taste buds and appetite are still enticed, tickled – taken note of, at the very least. And there lies the rub. In decrying pleasure, the artist portrays pleasure, and the pleasure seduces the viewer. Contemporary Dutch prints of similar subjects make the expected moral points when accompanied by texts, and sixteenth- and seventeenth-century emblem books in both north and south Europe usually assert the same notion of transience.[10] But if a patron or artist of food paintings truly desired to have us contemplate the emptiness of the material world – as tomb designers had done for centuries, and as Damien Hirst did in the 1990s (illus. 47) – they could have designed visions of brown apple cores, barren grape stems, maggots and putrescence without appeal. This never happens in seventeenth-century Dutch still-life. The note of horror comes dressed with beauty and charm. As the two sides of the coin face us, it seems that the instructional aspect, the *vanitas* theme, merely gives a superficial sheen to the image – pays heed to the polite moralities of society. But the real pleasures of the table take a more prominent role. The patron no doubt wanted to enjoy the pleasures of food vicariously and sense the opulence of the good earth. And yet, he (or she) also felt compelled to moderate his ardour, admit the superficiality of his desires – to keep up appearances of decency, one might say. Yet this is conjecture, based on assumptions of why people buy paintings to decorate their houses. The interiors represented by De Hooch and Vermeer, strictly clean and orderly, but also filled with comforts and delight, dispense a kindred vision of rectitude and indulgence. The title of Simon Schama's book on seventeenth-century Dutch culture, *An Embarrassment of Riches*, seems to express the situation perfectly: a fine appreciation of earthly blessings – and some self-deprecating embarrassment about one's enjoyment.[11] That is the character of the van der Ast painting and of much of Dutch still-life in the seventeenth century.

When tough and mildly unappetizing foods appear in kitchen still-lifes, the reason usually involves class identity. In such subjects as Claude Monet's *Still-life with Beef* (illus. 64), to cite a late example, we see a picture of lower-class food, the sort of beef used for making Swiss steak. It is accompanied by a clove of garlic – for flavouring – and a humble pottery mug – probably to hold beer as a cooking medium. In all, the dark and husky still-life represents the preparations for a working man's solid meal in mid-nineteenth-century France. Even the poor could afford beef by this time. Monet's subject specifically bears the imprint of Realism, the nineteenth-century art movement often associated with the portrayal of

63 Henri Fantin-Latour, *Still-life with Fruit and Book* (1866), oil on canvas. National Gallery of Art, Washington, DC.

64 Claude Monet, *Still-life with Beef* (c. 1864), oil on canvas. Musée d'Orsay, Paris.

the ugly and common. The painting reveals the unrefined world of common people, gives a glimpse of the seamier side of modern life favoured by those artists who considered themselves unflinching documenters of reality.

The leading French realist, Gustave Courbet, a major influence on Monet, gave a plebian tone to many of his subjects. His paintings of apples, for example, present the fruit as wonderfully crude, bumpy, calloused and earth-bound – real peasants of the plant world, so different from the refined fruit that decorate the middle-class tables of Henri Fantin-Latour's contemporary paintings (illus. 63). Fantin-Latour also included such class-associative accessories as a delicate porcelain teacup with his fruit. A great deal of social consciousness resides in food imagery. It is especially strong in the setting and eating of food, but makes its way also into pictures of food preparation. The working classes do not eat caviar or pheasant. They eat the inexpensive, tough stew meat that Monet painted. And the rich and powerful do not usually make a meal of cabbage and onions. Sometimes just one item of dinnerware suffices to identify a social level. In Diego Rivera's 1920s indictment of capitalism, *Wall Street Banquet* (illus. 65), the champagne glasses, if not the clothes and the money bag, single out these people as the dissolute rich. The stemware alone offers a clear reference to a particular class and a particular way of life. Monet's little clay mug and Fantin-Latour's teacup similarly speak of specific social levels.

In still-life representations of food preparation before the twentieth century, one most often finds objects that go together to make a handsome meal. Most of Chardin's kitchen still-lifes fit this mould. The ingredients and cooking equipment respond to each other to form a healthfully balanced subject. Edouard Manet, an admirer of Chardin, continued this tradition in the nineteenth century. His *Still-life with Carp* of 1864 (illus. 66) typifies the genre. A carp lies on a table next to a copper cooking pot, and nearby stand oysters, an eel, red mullet, a lemon and a knife. Were this a picture from the sixteenth or seventeenth century, periods when enthusiasm for Classical culture animated the world of art, the red mullet would have possessed allusions to ancient Rome, when fish was the greatest culinary delicacy and famous gastronomes paid fantastic sums at auction for huge red mullets – as reported by Suetonius and other ancient authors.[12] But by Manet's day the fish he represented probably referred only to the fresh catch available in French markets. Nevertheless, the artist carefully selected his still-life objects to make a fine dish. He presented the varied fish and a cauldron for a seafood stew

65 Diego Rivera,
Wall Street Banquet
(1923–8), fresco.
Ministry of Education,
Mexico City.

66 Edouard Manet,
Still-life with Carp
(1864), oil on canvas.
Art Institute of
Chicago.

or *bouillabaisse* – seasoned with a lemon, ready to be peeled or sliced with the knife.

In part, of course, Manet deliberately recalled still-life history – Chardin and, before him, the seventeenth-century Dutch masters. But still, he offered these constituents of a particular dish as if in presentation to a chef. Not only is it probable that Classical allusions have disappeared, but so too have those ancient medical concepts of the four elements proposed by Galen and others, which were so important for pre-modern medicine. There is very little to balance the cold and watery menu proposed in Manet's fish painting. Manet and his viewers found themselves in a world where fine taste counted more than anything, especially in France, which had come to be regarded as the centre of culinary grandeur. But along with delicacy of appreciation came matters of social rank, and one need only compare Manet's fish paintings with Monet's humble cut of beef (illus. 64) to realize that Manet's proposed meals have the fragrance of high-class life.

The exhibition of food on a sideboard – an in-between stage of meal preparation just prior to serving – frequently appears as a subject in seventeenth-century painting. The German artist Georg Flegel's *Large Food Display* (illus. 68) exemplifies the genre. The tiered piece of furniture in this painting, covered in cloth, looks like the display cupboard that appears in medieval and early Renaissance meal scenes (illus. 17 and 67). In those earlier images, the furniture functioned primarily to display the host's wealth and prestige, the costly plate and precious vessels of the household. But in the Flegel painting, this furniture serves to display the food as well as the rich possessions. Actually, the fine crystal and metalwork act as relatively minor objects in the painting. Instead, food, ready to serve and eat, crowds the steps of the furniture. The victuals in fact also express wealth. Expensive sweets dominate the scene. Although some common fare such as bread appears, the rich fruits and nuts and delicate pastries suggest a well-to-do house. A parrot and flowers add colour to the

opposite:
67 The Limbourg Brothers, *January*, from the *Très riches heures du duc de Berry* (1413–16), watercolour on vellum. Musée Condé, Chantilly.

68 Georg Flegel, *Large Food Display* (c. 1630), oil on copper. Alte Pinakothek, Munich.

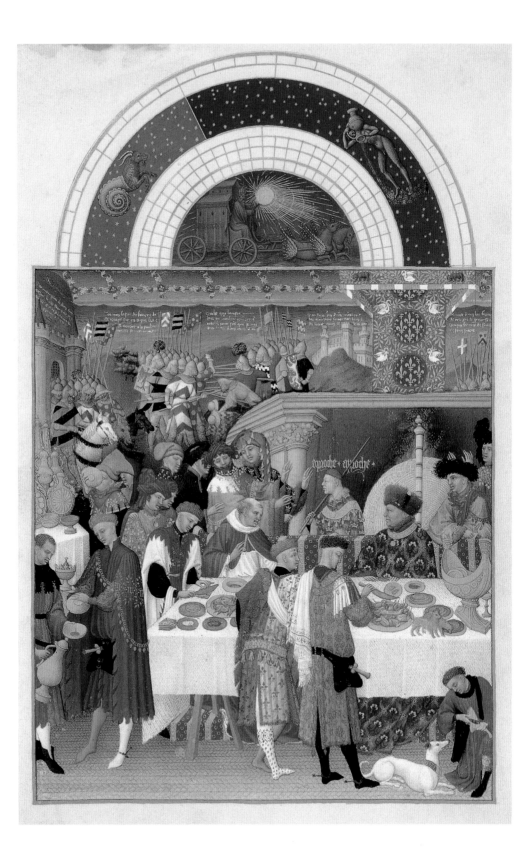

ensemble – and the bird probably also gives an exotic and costly glamour to the arrangement.

As is so often the case, Flegel's proud display of worldly possessions includes an apologetic note of *vanitas* – a butterfly, a fly and a wilted flower indicate the ephemerality of these showy stuffs. But only slightly. The glow of earthly delight outweighs evidence of mortality in this food picture. Overall, the charms of artistic manipulation assist the fetishistic sense of control. The artist and the viewer govern and dominate the symbols of decay and extinction. Everything is a small object at our disposal. Ultimately, and most profoundly, such seventeenth-century images imply that we can even control death. The insects, the flowers, etc., are not giant obstacles, but little things, like the candies and fruit nearby, to be handled and treated as one wishes. The happy world of food paintings constantly declares humanity's domination of nature and adds to the joyful mood by putting death itself into our controlling hands.

Antonio de Pereda's *Still-life with Ebony Chest* (illus. 41) can serve as a Spanish example of the Baroque sideboard image, with fine pottery, expensive cookies, candies, the New World sensation – chocolate – in a special handled pot, all placed round a richly wrought chest of exotic wood. The sideboard image again offers an excuse to show off, and because it represents food just before the actual eating begins, it also offers that important gustatory and medical aid – the stimulation of the appetite.

The paintings by Flegel and Pereda, like other works discussed, can serve to stimulate the appetite. Chardin's *The Brioche* (illus. 69) more delicately makes the same appeal to the salivary glands. The opposite of the luxurious Flegel sideboard is William Michael Harnett's painting of turnips (illus. 70). Here are the poor man's prospects – a few pathetic turnips, a stoneware pot of wine and half a loaf of bread. This American painter worked in Munich for several years, and the picture presents impoverished life in the new Germany – unified a decade before. A German newspaper lies on the plain wooden table. Torn posters appear on the rough walls along with a rude caricature of a drinker. The burnt-out match and unlit pipe, like Flegel's insects, speak of things dying. But in Harnett's case, the dead match probably refers not to man's mortality but to the burnt-out economic state of the householder. Like Monet's picture of a cheap cut of beef of the 1860s (illus. 64), this image smells of lower-class life.

Nineteenth-century realists such as Harnett took the seventeenth-century vision of food and lowered the social class to give a hard edge of truthfulness to their works. Realists often sought subjects

69 Jean-Baptiste-
Siméon Chardin,
The Brioche (1763),
oil on canvas. Musée
du Louvre, Paris.

70 William Michael
Harnett, *Munich Still-
life* (1882), oil on
canvas. Dallas Museum
of Fine Arts, Texas.

among the lower ranks of society – to escape idealism and artificiality. Ugliness, unpleasantness, unseemliness represented unadulterated truth. They did not always succeed. Monet presented meat in a poor man's larder and thereby tells us about the nineteenthcentury's bountiful food supply and enriching diet – despite the painter's intention to exhibit the underside of the modern world in still-life terms. Harnett, however, managed to present a properly bleak vision. The worn posters suggest lack of success in a musical career, and the references to drink indicate alcoholism. Turnips here do not necessarily represent Germany (they appear in Harnett's American subjects too). Rather, the turnips are the food of the poor – they even sometimes served as animal fodder. The match and the pipe and the newspaper might have been metaphysical references in the seventeenth century. In the nineteenth they became mundane statements of physical condition. Realists wanted to diminish the otherworldly meanings of earlier art, and one sees this clearly in such reworkings of seventeenth-century symbolism.

To appreciate the Harnett picture fully, one needs to see his work as antagonistic toward the whole history of food paintings. He denied the salivary appeal of traditional sideboard images, and worked against the history of delightful food pictures, in order to depict the bitterness of poverty more acutely. To appear real, one must reject convention, and Harnett applied that realist instruction in the representation of food.

Artists had depicted poverty in terms of food before the nineteenth century. In the sixteenth and seventeenth centuries a subject called the 'fat kitchen and the thin kitchen' appeared in northern European art. The theme comically posed plenty and scarcity side by side, but ultimately presented social inequity as meaningless in the larger scheme of salvation. Hefty people and glorious mounds of meat and comestibles crowd the 'fat kitchen'. The emaciated folk in the 'thin kitchen', on the other hand, have little to eat but a few onions. The subject usually appears in prints and drawings and only rarely in the more serious and august art of painting – the comic master Jan Steen was one of the few fine artists to represent the paired kitchen subjects in paint.[13] Like pictures of people actually putting food in their mouths, the contrast of fat and thin belongs to the graphic arts. The subject makes a point about the inequality of the world, but it is basically concerned with amusing and grotesque contrasts, and hardly rates as a moral outcry. The fat and thin kitchen theme does not lie behind the social concerns of Harnett.

Late nineteenth-century food pictures consider real social problems that require alleviation. Sixteenth- and seventeenth-century

71 Edvard Munch, *Self-portrait with Wine Bottle* (1906), oil on canvas. Munch Museet, Oslo.

pictures of plenty and poverty do not demand changes in social policy. Then, artists merely described the imperfect state of man on earth. The rarity of paintings of the 'thin kitchen' underlines the overall mood of abundance and satisfaction that mark food paintings as a whole. Even the nineteenth-century social commentators are odd men out in the realm of food depiction. An equivalent sense of sadness, emptiness and concern in food subjects is found only in the work of later artists such as Edvard Munch, who sought to describe their despair and anxiety. The alcoholic artist's lonely self-portrait of 1906, in a restaurant facing nothing but an empty plate and a bottle of wine, admirably represents this late category of food subject (illus. 71). Edward Hopper created similar expressions of depression through food (illus. 72, 106). Yet in any overview of food paintings since 1400, such bleak picturings of food must be regarded as unusual. Food provides an incisive vehicle for those who want to represent distress in immediately understandable physical terms. Food figures prominently in scenes of charity – but as an antidote for deprivation. Food –

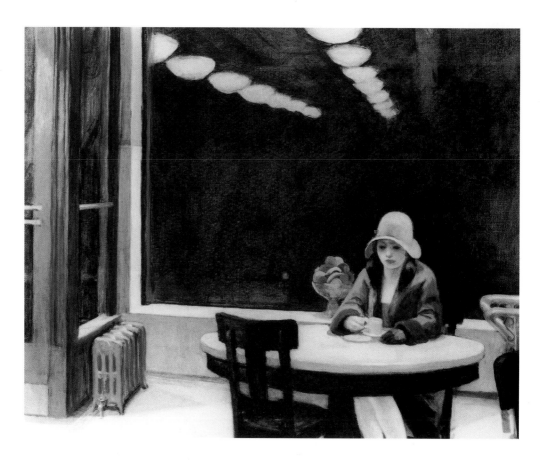

72 Edward Hopper,
Automat (1927), oil on
canvas. Des Moines Art
Center, Iowa.

even plain food in dark chambers – almost automatically means satisfaction, and it is only by extreme reversals that the artist with a negative bent can make his point. A painting of truly rotten food, covered in maggots, or green with sickening mould, or entirely unappetizing, is rarely – if ever – to be found.

Still-life paintings by definition describe objects, manipulated things that can be bought and sold, chattels. These function very well as testaments of social standing. Food, like jewellery, plate, clothes and furniture, can be accumulated, altered and displayed, and it functions as an indicator of social value. In modern America, for example, quiche ranks higher than ribs, and wines with twist-off caps stand far below wines with cork stoppers. Of course, in the subtle world of class distinctions, reversals of expectations can arise – sophisticated, ironic plays to create greater exclusivity. Thus privileged youths at Ivy League colleges might dabble in cheap liquor, pretend to be street louts and look askance at some nouveau riche classmate who drinks only rare and expensive spirits. And in a democracy, the need for politicians

and those in high office to present themselves as men of the people often requires indulgence in lower-class foods. George Bush favoured pork rinds; Ronald Reagan made much ado about jelly beans.

To correlate food and eating utensils with social class, one needs to understand that the scene depicted represents a household, a family celebration, some naturalistic arena in which food is consumed or displayed or handled. Even the largely decorative fruits and costly ceramics displayed in many seventeenth-century still-life paintings imply a social situation. The precious objects in Flegel's and Pereda's still-life paintings (illus. 68, 41), for example, can still be understood as domestic scenes, as sideboard displays before a meal. But in Western art after Paul Cézanne in the 1870s and '80s, the rationale of foodstuffs as objects to be eaten was dissipated. Food no longer always fits into some normal scheme of dining at home or restaurant or picnic or any other situation. And consequently the overt connection between society and food no longer operates all the time.

Cézanne affected twentieth-century art deeply, and the character of his art transformed a good deal of food imagery – so much so that a painter in the twentieth century could rarely depict an apple, the fruit most frequently portrayed by Cézanne, without having this artist in mind. The apple's longstanding association with Adam and Eve and the Judgement of Paris thus acquired a competing meaning in the visual arts. The apple became a homage to Cézanne and all he represented as a modern artist. Yet the distinctions became blurred.

More important for later art, Cézanne's still-life paintings present food items such as apples, pears, cherries, onions, ginger pots, food bowls and teapots in odd, unnatural, unsocial circumstances (illus. 6). The setting most often seems the artist's studio – not a kitchen, or a market, or a dining area, or a boudoir, where snacks might be eaten. Furthermore, the onions and teapots and apples and ginger pots tumble together without meaningful relationships. These objects do not go together easily as part of some meal or shopping expedition or even in a larder, and they usually lack appropriate accessories. The same qualities can be found in other arts and other media and subjects from the late nineteenth century through the twentieth. The movement is called Modernism, and, in painting, Cézanne was a prime mover.

In Cézanne's *Still-life with Coffee-Pot* of 1870–72 (illus. 12) several objects are shown on a shelf or sideboard. There are an isolated apple, two onions and two eggs and a knife resting in the folds of a bunched-up white tablecloth, a ceramic jar, a metal

coffee pot, and what is probably a mustard pot. The items are not arranged in readiness for a meal, nor do they seem likely inhabitants of a larder – why put a knife and a tablecloth on a larder shelf in such a manner? Do the assembled goods make up the ingredients and preparatory tools of a specific dish? It seems unlikely. It is a mystifying group – if the objects are looked upon as food to be eaten.

The food in Cézanne's art seems detached from meals, kitchens and storerooms, and the food and utensils do not seem to represent the aftermath of a meal. Many art historians have interpreted Cézanne's apples and other items as purely decorative elements. Meyer Schapiro may be right to perceive the apples as sublimated embodiments of the artist's sexual anxieties, but for most art historians and artists in Cézanne's wake, his food items are purely decorative elements, studies of form and colour.[14] In either case, Cézanne destroyed social coherence in the food still-life. Perhaps that very incoherence represents a psychologically rich matter of social significance – an escape from home and family and ordinary life into a private world of art where normal relationships cease to exist. Does the twentieth-century's adoption of Cézanne's disengaged vision of food therefore express a general derailment of domesticity and social relationships? It would seem so. Innumerable modern novels of the twentieth century similarly portray a pervasive anomie, a lack of community, a world without sure meaning. What has Cézanne's coffee pot to do with the rest of the objects in his still-life? Nothing much from the point of view of consumption. If the connection between these items is just a matter of visual form, then that ideal too should be understood not just as a positive emphasis on the artist's inventive beauty, but also as a destructive force that withers the social significance of the subject.

Cézanne's approach influenced hundreds of artists at the end of the nineteenth century and throughout the twentieth, and presumably his disengagement struck a responsive chord, expressed some aim or feeling about the nature of food and eating and the social world it represented. Even a twentieth-century artist such as Henri Matisse, who frequently portrayed domestic life with warmth and delight, often created Cézannesque food pictures – edibles that go together only visually. In one of his paintings of 1914, *Goldfish and Palette* (Museum of Modern Art, New York), for example, a lemon rests next to a goldfish bowl. It provides a handsome contrast to the orange fish and blue interior. But what is a lemon doing with decorative pet fish? The animals are surely not to be eaten, and the fish do not get to eat the lemon.

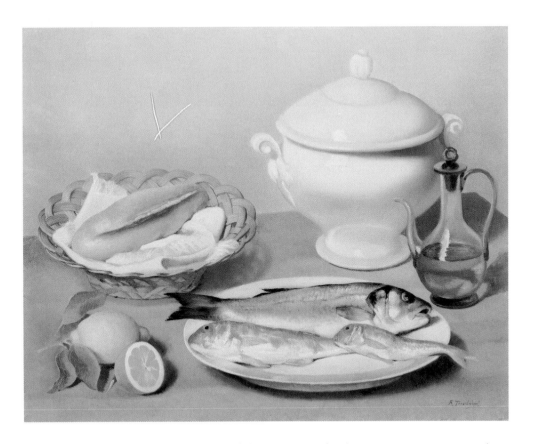

73 Francesco
Trombadori, *Still-life*
(1935), oil on canvas.
Galleria Civica
d'Arte Moderna
e Contemporanea,
Turin.

The sense of dislocation in food imagery occurs even in the
art of the most conservative painters of the twentieth century.
Francesco Trombadori's *Still-life* of 1935 (illus. 73), for example,
seems straightforward enough, but really hangs in limbo. It is not
clear whether it is a scene in the kitchen or in the dining room,
or whether the objects go together. It looks like a meal set before
a diner. The disposition of objects accords with what might be
expected at a restaurant table. On the plate lie three fish, with a
lemon to the side. There is a basket of bread to the left, and an
easily reachable tureen at the right. The oil in a glass dispenser
might be part of some cruet set permanently placed on the table.
But there are no eating utensils, or napkins, let alone beverage
glass. Three fish also seem too much for one diner. Maybe the
platter is a serving dish, rather than a plate from which to eat –
that might explain the lack of fork and knife. And, looking
again, perhaps the whole assemblage constitutes the preparations
for a meal, rather than the meal itself. That would also explain
the presence of a whole lemon with leaves at the left side of the
painting. It is not the sort of item usually found on a dining

table, but perfectly appropriate on a kitchen counter. What about the tureen? Does this hold sauce to accompany the fish? Or does it hold soup, or some starchy food? Maybe the fish are to be cut up and become part of a seafood bisque or stew and placed in the tureen. It is not the tureen that is a problem, just the uncertainty as to what is inside. But the oil is a problem. Would one use the oil with the fish? Not during the meal – but perhaps when cooking them? On the other hand, the bread is present as if to accompany food already prepared. What stage in the preparation of a meal is shown? It is a little unclear. One cannot assume that the oil is for flavouring the bread as a dip. The substitution of olive oil dips for cholesterol- and calorie-ridden butter on bread did not come about until fifty years after Trombadori had completed his painting. The oil is a discordant element in this image. Unlike the lemon – a normal complement of the fish – it is not a a flavourful accent and de-greaser. Maybe the oil is really wine – or is just waiting for the vinegar and salad to appear. The point here is that there is no true coherence of objects in this food painting. No matter how staid and traditional it might seem, Trombadori's image bears the dislocated character of twentieth-century modernism. It is unlike Manet's fish painting of 1864 (illus. 66), a picture of meal preparation where everything works together to suggest an imminent repast.

Trombadori, like Cézanne, may have chosen his objects for their formal properties. The broad patches of light and delicate shade in the crockery, bread, lemon and fish help to create the sculptural severity favoured in much of 1930s art. And the series of rounded shapes gives formal coherence to the picture. But such arrangements produce a vision of our rites of consumption and domestic condition that appears dysfunctional and meaningless.

Such paintings are introduced into this chapter on food preparation in order to bring out the anomalous character of these images that might, on some rudimentary level, be considered items in a kitchen or larder waiting to be used. Although they could have been saved for the final section on symbolic and decorative representations of food, here they illustrate a significant development in food imagery that occured in the late nineteenth century and throughout the twentieth century – modernism. One must consider food pictures in these periods differently from those of preceding centuries, because an additional game was afoot. The modern world's sense of displacement, or alienation, or meaninglessness, or individuality without context rises up to challenge some simple explanation of foodstuffs in paintings. It is not a matter of a change in eating habits, but one of the entire understanding of self

74 Roy Lichtenstein, *Kitchen Stove* (1962), oil on canvas. National Gallery of Australia, Canberra.

and universe. Food pictures are the perfect vehicle for expressing such a *Weltanschauung*. They depict the daily stuff of human life, the ordinary world of experience, the things we must deal with. And when they become deranged, divorced from explicable circumstances, they touch on the most basic outlook of people, the viewers and the painters.

The disengaged vision of food makes it difficult for an artist to make pointed social criticism, because that kind of art seems

outside the bounds of normal social contexts. Most Pop artists in the 1960s gave up 'purely decorative', 'aesthetic' depictions of food because they wanted to criticize American society. Roy Lichtenstein's *Kitchen Stove* (illus. 74), for example, presents food as seen in a throw-away newspaper advertisement, in a tacky piece of suburban kitchen equipment (and with the unlikely and distasteful combination of meat and dessert pies in the same oven). Edibles are seen only at a distance, through the vision of some hack commercial illustrator. The dreary banal style – slick but pathetic – as well as the purportedly shiny subject wittily depict the crassness and dehumanization of industrial society. The new stove, overfilled with goodies, stands on a blank page in the middle of nowhere. Modernity never looked so bad.

THREE

Meals

The meal is the crux of the food cycle and naturally occupies an important place in food imagery. Paintings from the early Renaissance to the Postmodern period depict every kind of eating occasion from snacks at an outdoor stall to multi-course coronation banquets. The settings range from forests (where picnics take place) and cottage hearths to restaurants (which arose in their modern form in Paris in the 1760s) and elegant home dining rooms (which, as chambers devoted exclusively to eating, rarely existed before the late seventeenth century). Meals also appear in sickbeds and automobiles, on sidewalks and boats, and in every season.

The food shown in meal paintings was often obtained from public cook stalls, bakeries, taverns or caterers. Guilds in the Middle Ages usually separated cooked-food providers from grocers and butchers, and designated specialist meal makers. Just as bread was bought from a baker, rather than baked at home, so, too, hot foods were purchased from various purveyors, often situated in the market areas, where raw foods were also sold. The difficulty of cooking at home, with limited or non-existent ovens, encouraged the catering trades in the larger towns and cities. For centuries, many people, especially those who lived in towns, did without the expense and burden of kitchens and cooking equipment, and bought their food in the street. In New York and other major cities today, despite the ease and efficiency of cooking at home, things have not changed that much. Take-away places, as well as delicatessens and gourmet food shops fill the streets. Discussion of meal paintings here, however, begins with images of the grandest sort of home cooking – aristocratic and royal dinners.

The Limbourg brothers' depiction of the feast of Jean, duc de Berry (illus. 67), which illustrates the month of January in the *Très riches heures du duc de Berry* (1413–16), represents the height of aristocratic dining. The duke, brother of the French king, was probably the richest man in Europe, and the 'book of hours', which this scene decorates, was a rich man's article of conspicuous consumption. Such books of devotion for the home were the equivalent of Rolls-Royces, statements of prestige. In the feast illustration, the duke sits at his table, surrounded by retainers and courtiers. The colourful tapestry adorning the walls depicts knights in battle, and was another testament of economic power. Such a hanging was among the most expensive luxury items of the time, carried from château to château as the peripatetic duke visited his numerous residences. The table too is a knock-down affair, a board on a trestle or sawhorses assembled and dismantled as needed, and covered with rich cloth when used for dining. The room itself could serve any number of purposes. Only monasteries had permanent dining rooms – refectories – where the contemplatives ate together. Leonardo da Vinci's *Last Supper* at Santa Maria delle Grazia in Milan pointedly decorates just such an eating hall.

At the largest banquets, nobles took their food in the great hall of a castle or palace, a very public space, on a temporary podium, above the many people in the hall, with just a few select visitors and family members at the lord's table. Usually, however, such powerful people would eat in an inner chamber, or one on the second floor, and by the seventeenth century a noble family would often prefer to take its meals in smaller, more modest rooms, even further removed from the public glare. There were also all kinds of hunting lodges, roof chambers and recreational spaces where snacks, hunting refreshments and sweets might be served on a great estate. The roofs of many of the great country houses in sixteenth-century England possess little turret rooms and covered nooks where eating took place.[1] In the left foreground of the Limbourgs' illumination is a cloth-covered multi-tiered piece of furniture. This was a standard feature of great people's banquets, a cupboard to display the richest plate of the household. The meal has not fully begun yet, and two retainers select several gold plates or trenchers for the meal. They also carry a covered bowl and flagons of wine. A boat-shaped metal vessel already decorates the table. This is a great salt container, mentioned in the duke's inventories. Large and elaborate salts

usually figured as the primary table decoration in the Middle Ages and Renaissance. In platters on the table lie heaps of rabbit and fowl, as the carver approaches with a knife. Bread has been placed on the flat discs called trenchers, and what is probably soup appears in shallow bowls set before the duke and the priest with whom he converses. Dogs appear not only on the floor, where they are fed scraps, but also on the table itself.

To modern eyes it would seem that the finely garbed courtiers behind the table are milling about before sitting down to eat. The duke's right-hand man, with a staff, says to the newcomers 'approach, approach', as inscribed on the manuscript page. The men are certainly aristocrats, but in all likelihood they are the servers rather than the eaters. Only the ecclesiastic dines with the duc de Berry. Noblemen performed the duties of table servants in the highest courts, signalling their obedience to the lord. The meal declares feudal rank. One's place in the social firmament became clear during great banquets, such as this holiday affair in January. The remains of the lord's table would be given to lesser humanity (just as his dogs are fed scraps), an act of generosity that denoted his superior position as much as his dedication to Christian charity. A visiting noble might sup with the lord and his priests at a feast in the fifteenth century, but the lord's vassals routinely did not. All those grand titles of royal servitude still doled out to aristocrats by the British monarch continue the tradition seen in the *Très riches heures*, even though the title-holders today no longer perform their titular functions. The grand meal described by the Limbourg brothers is strictly a male affair, a matter of power relations, and not an occasion to engage in courtly love or family togetherness.

No silverware appears on the duke's table. On most occasions the eater would provide his own knife, and sometimes a spoon as well. Forks were very rarely part of any table equipment before the eighteenth century. They were supposedly used outside the kitchen, at the dining table, by the fourth century AD in Byzantium. And there exists an eleventh-century version of a seventh-century manuscript that includes a fascinating drawing: two men eat with forks and knives in a modern manner (although the forks have only two tines). There are reports that forks were sometimes used in Italy in the sixteenth century, and in England in the seventeenth. Small two-tine forks from several European countries, which can be dated stylistically to the sixteenth and seventeenth centuries, exist in a number of museums, but whether these utensils were employed at table, rather than in the kitchen, is debatable. One of the occasional functions of a fork before the

eighteenth century was to extract fruit preserved in syrup from small-mouthed jars. This makes the fork equivalent to a can-opener, and still not a true eating utensil of the table.[2]

Paintings indicate strongly that forks were virtually unknown at the dining table between 1400 and 1700. They rarely – if ever – appear at all in images of this period. In Bartholomeus van der Helst's painting of *circa* 1649 of a banquet (illus. 75), one diner eats from a pie with two utensils – but it is uncertain that one of them is a fork. He might be using two knives. The other diners in the painting use knives for paring, eating, picking teeth, etc. Only knives and the occasional spoon appear. Most people of all classes in all countries of Europe during these 300 years ate with their fingers most of the time. The carver cut up the meats into manip-ulable pieces before and during the meal. If necessary, the diner would use his own knife to cut the piece smaller, or to remove unwanted portions. Even soups and semi-liquid dishes did not always require a spoon. Pieces of bread or other absorbent edibles, called sops, were usually provided with such dishes to soak up the food, and the diner could easily lift the liquid to his mouth by such means.

The wooden or metal trenchers, whether flat or slightly depressed in the centre, whether circular or rectangular, were not always needed either. Hard, flat bread often acted as a trencher, an eating surface that absorbed sauces and drippings and could be eaten after the main food had been consumed. The gold plate on the duc de Berry's table is largely there for social display, a testament of wealth. When eating with hands and knife alone, messiness was unavoidable, and napkins and hand washing were common. At a great table, napkins or towels were usually offered to the diner at various points in the meal, and accompanied by

75 Bartholomeus van der Helst, *Banquet in Celebration of the Peace of Münster of 1648* (*c.* 1649), oil on canvas. Rijksmuseum, Amsterdam.

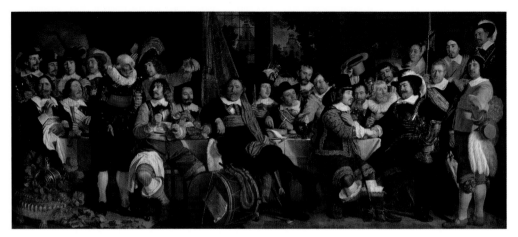

water poured over the hands. They were not placed on the lap or under the chin.

About a hundred years after the Limbourgs' illustration of January, Gerard Horenbout represented another nobleman's meal, but things have not changed much (illus. 17). In this manuscript illumination there is a scene of knightly warriors above the fireplace (subject matter similar to that of the duc de Berry's tapestry, and an equally showy piece of decoration). As in the earlier manuscript, fine plate is displayed on a tiered piece of textile-covered furniture at the left – the cupboard. Dogs are fed; fowl is for dinner. A great boat-shaped object, probably a salt holder, again appears and there is also a covered gold-and-crystal vessel on the table. Bread rests on the table too, and the only eating utensil is a knife. A simple, fine cloth again covers a board on a trestle. In the Horenbout illumination, the superiority of the lord over his vassals is even more apparent. On this occasion the rich nobleman dines alone at table. The servant with a towel over his shoulder near the ship ornament stands ready to wash his hands. And maybe the ship contains not salt but water for washing hands. The nautical theme would be more appropriate – although it seems likely that the similarly shaped vessel in the *Très riches heures* is a salt container.

It appears that Horenbout imitated the scene of January from the *Très riches heures* directly. Like the Limbourg brothers, he placed a fire screen behind the chief diner, which acts as a kind of cloth of honour for the noble figure. At the left, men bearing trays of food enter the curtained dining area. The eleven figures who attend the lord but do not eat with him inform us what a grand matter this meal is as a show of authority, as an indicator of superiority. And as in the *Très riches heures*, the dress and jewellery of the dinner servants clearly show aristocrats at work. Again, this feast is not a communion of peers, but an expression of individual power. These nobleman of the fifteenth and sixteenth centuries must declare their stature, as if it were in question.

The Horenbout picture and the Limbourgs' image may tell us something about the upper classes clinging brazenly to their feudal status as the Renaissance and developing capitalism began to alter society. But beyond the historical moment illustrated here, this early sixteenth-century manuscript illumination displays the social importance of eating in general. What one eats, and in what setting, and with whom, create statements about the host and the diners and where they figure in the community. Eating in the Horenbout picture is very obviously a ritual, an orderly affair of obeisance and economic display and the affirmation

of social relationships. In the modern world, where personal servants are rarities, experience of waiting attendants, who serve our pleasure with attitudes of humility or even obsequious obedience, is limited to restaurant meals. Does the modern restaurant attempt to give the diner the feeling of feudal power? Do we re-enact the rituals shown in the paintings by Horenbout and the Limbourg brothers when we visit a fine restaurant? Before answering that question, a few later pictures of noble dining must be examined.

Although it is a pretend historical epic, with the artist and his family as the players, Jan de Bray's *Banquet of Anthony and Cleopatra* of 1669 (illus. 76) nevertheless reveals the Baroque conception of a royal meal. Apart from the gesture of Madame de Bray, who, like Cleopatra, removes an earring to dissolve in wine – the epitome of extravagant consumption – and the laurel wreath crown of de Bray–Anthony, and perhaps some of the antics of the de Bray children, who act as servants, we see a representative royal repast. The military atmosphere of the noble setting, previously presented by the Limbourgs' tapestry and Horenbout's fireplace ornament, continues in the de Bray picture with the guard at the left, who holds a large pike. As in the earlier two works, a dog takes a prominent place. The oriental carpet and large plate in the foreground testify to the same thing as the duc de Berry's tapestry and array of gold: wealth.

The more casual placement of the costly luxury items in the de Bray painting, however, tells us of a new, seventeenth-century ideal of nonchalance in noble behaviour. A similar vein of sophisticated informality appears in the English aristocratic and royal portraits of Anthony van Dyck in the same century. The less rigid order extends to the arrangement and gestures of figures, although a great cloth of honour and a canopy surround the chief diners – ancient signs of importance. Porcelain and glass vessels appear in the de Bray picture – and this is a change from the previous two paintings. These are new sorts of materials and objects to indicate richness and elite status. Gold and silver no longer have exclusive rights to swagger. The marble of the foreground parapet is another novel substance of stature. The foods here are also different – not just any old fowl, but a peacock, made into a great feathered table ornament, and a pig's head along with fruit have been served to the royal couple.

Although this is not discernible in the de Bray picture, by the seventeenth century noble eating no longer involved all the spices that had marked aristocratic cuisine in the Middle Ages. In great houses, food in the Middle Ages and in much of the

Renaissance was coloured and flavoured strongly with very
expensive spices – imported from the East. Indian cookery
today, it seems, is the equivalent – lots of almond milk dishes
and curries covered with stinging spices and bright colours. But
in sixteenth-century Italy, the kitchens of the rich, probably
inspired by what were believed to be the habits of the ancient
Romans, turned to simpler, less spicy cuisine, in which sauces
were made from meat drippings. From Italy, it is believed, this
newly mild cuisine spread to France, probably through the
influence of Catherine de' Medici and Marie de' Medici. Both
of these powerful women became Queens of France, and that
country became the *ne plus ultra* of fine cookery.[3]

The ancient Roman subject of de Bray's painting, no matter
how half-serious and historically inaccurate, reveals how com-

mon the Renaissance appreciation of Classical culture had become by the seventeenth century. As with the new simple cuisine, almost anything evocative of the ancients found favour among the wealthy and powerful.

A representative painting of aristocratic dining in the eighteenth century depicts a supper given by the prince de Conti in the Temple, a vast complex of medieval buildings in Paris (illus. 77). The Temple enclosure included a royal prison, a church and various living quarters.[4] Barthélémy Ollivier, a minor painter, produced this picture of elite eating in 1766. A harpist entertains the diners at the candle-lit meal, and a guitar and sheet music rest on a table at the right. Although musical accompaniment to eating does not appear in the noble meals discussed above, it is frequently depicted in eating scenes after *circa* 1400.[5] Dogs still lounge about in Ollivier's eighteenth-century dining area – for centuries, hounds signified an aristocratic household, and probably allude to the privileges of hunting. The perpetual presence of hunting dogs also refers, however subtly, to the upper-class associations of meat

77 Michel-Barthélémy Ollivier, *The Supper of the Prince de Conti in the Temple* (1766), oil on canvas. Musée Nationale du Château de Versailles.

eating, the reward of the chase. The reminder of the hunt additionally brings forth, however subliminally, the fetishistic transformation of nature into food, that what is being consumed here was living stuff turned by man into inanimate objects.

In the Ollivier painting a breakdown in noble domination seems to have occurred. One is not sure where the host, the chief person of rank, is seated. Hierarchies have blurred. Two tables are shown, but which is superior? Aristocrats, it appears, no longer declare their power emphatically. A new subtlety has crept into the image. The leisurely gestures, postures and conversational air are even more notable than in the de Bray painting of the seventeenth century. The prince de Conti chooses not to mark out his superiority in any crudely bold manner.

The grand display of plate, with all its connotations of wealth and power, has also mostly disappeared. Glass appears everywhere, even in the wine containers. Fruit looms larger than before, both as table ornament (beautiful pyramids of oranges decorate the table) and as the stuff of fine dining (one woman holds the fruit). Although Madame de Bray – as Cleopatra – played an important role in her husband's seventeenth-century painting, the presence of women in the eighteenth-century work by Ollivier takes on a greater importance. Females fill the chamber, most paired with men, and turn the supper into an affair of delicate *tête-à-têtes*, in contrast to the meal scenes of the Limbourg brothers and Horenbout. Perhaps most telling of all in suggesting the new gentility and avoidance of brazen exhibitions of power is the scale relationship of people to chamber. The figures remain small within the high panelled room. They do not proclaim their presence. It is not that these powerful people in the eighteenth century did not feel superior to others and to nature. Rather, they felt so sure of themselves that they felt no need to demonstrate rank and prestige – it was understood.

The details of the table setting in Ollivier's painting are small and at points difficult to determine. No forks or other silverware are visible, but they were surely present, for these utensils appear in most eating images – certainly those of the upper classes – by the early eighteenth century. In an eighteenth-century painting of a drinking party by Nicolas Lancret (illus. 78), for example, with ham and bread as mere accompaniments, forks appear among the tableware. That such an informal outdoor wine fest should include forks indicates how ubiquitous these dining tools had become.

A nineteenth-century example of a noble dinner is Adolf von Menzel's *Supper at the Ball* of 1878 (illus. 79), where some of the

79 Adolph von Menzel, *Supper at the Ball* (1878), oil on canvas. Staatliche Museen, Berlin.

novelties of the eighteenth century have increased in power. Menzel depicted two rooms in the Royal Palace in Berlin during a buffet and dance. Informality has moved forward measurably so that the diners eat without tables, standing or sitting. Compared to the earlier works, there is a total breakdown of formal order and all the hierarchies implied by regimented positioning of guests and host. The de-emphasis of the host has also spread to such a degree that the royal or aristocratic giver of the feast is invisible. A military atmosphere still rises amid the swarm of diners, talkers and dancers. The numerous uniforms of various officers stand out in this ocean of diverse individuals in the palace.

Of course, Menzel was depicting a particular kind of meal – a buffet – and table meals did not disappear in the nineteenth century, but even the advent of such a repast in a European court reveals a new sensibility, where noble distinctions and clear definitions of rank and an orderly comprehension of society disintegrate. The Menzel portrays a world where a person's significance, whether hereditary or not, is not a given, is not apparent, is not absolute, and is something that must be fought for, apparently, in a society in constant flux. In stately dinners, food brings together the powers of society, and Menzel tells us that, in the nineteenth century, those powers are uncertain, a tangle. There is not even a dominating current in the sea of lavishly dressed people in the Berlin palace. The viewer's eye swims about without guidance,

opposite:
78 Nicolas Lancret, *Luncheon Party with Ham* (1735), oil on canvas. Musée Condé, Chantilly.

distant from the mass of moving humanity, and unable to grasp it visually. It is a world of individuals related only by proximity in a fluid physical space.

Even more than in the Ollivier painting, the Menzel picture presents figures dominated by their environment. For all that, the joy and excitement of food still flows, as it did through the market scenes. The ebullient swarm is indeed like the overflowing fruit and vegetables in an Aertsen painting, a vision of abundance, energy, happiness. Whatever has happened in society, the satisfactions of eating remain.

For the twentieth-century representation of an aristocratic or royal meal, a picture of actual nobility would prove unrepresentative of true social weight. Power by birth atrophied as the nineteenth century progressed and fell into complete decrepitude after the First World War. Noble dining events in palaces no longer described the attributes of those in control of the world. At first sight, Diego Rivera's *Wall Street Banquet*, executed between 1923 and 1928 on the walls of the Mexican Ministry of Education (illus. 65), might be a model dinner of social potency. In this mural, John D. Rockefeller and fellow capitalists, the new elite of the world, sip champagne. (This wine and the specific glasses in which it was served had come to signal wealth and status by the later nineteenth century: virtually all wines and their identifying vessels and rituals had become codified and regimented during the nineteenth century as part of the general industrialization of food production.) But the communist Rivera's image indulges in castigating symbolism and does not document the true appearance of power banquets. The money vault, stock ticker-tape machine and ironic Statue of Liberty lamp on the table are caustic attributes of capitalist hegemony, and do not describe the real rituals of elite eating.

The less programmatic painting by Jules-Alexandre Grun, the *End of the Supper*, made in 1913, just before the outbreak of the First World War, gives a more accurate view of privileged dining (illus. 80). Women here continue to dominate the dining room and express most powerfully the status of the event. They form the bright and colourful monuments of a fancy but routine supper party in France, where their jewels and costly dresses overpower the refined chamber. The men, all dressed in black, play supporting roles in the light conversations at the close of a meal. Unlike the Menzel picture, there are no uniforms or military presence to give them prominence. Grun, who made a considerable success as a graphic designer of posters and elegant menus for the great restaurants of Paris, knew the rituals of dining intimately.

80 Jules-Alexandre
Grun, *End of the
Supper* (1913),
oil on canvas. Musée
des Beaux-Arts de
Tourcoing.

Elegant informality reigns in this painting of moderate opulence.
Grun portrayed the finishing up of coffee, the putting on of gloves,
the gradual removal from the table – not in unison as in a reces-
sional, but one by one, or in pairs, half of the figures leaving the
remaining coffee, half coming back for further talk. The moment
chosen for depiction illustrates a time of fulfilment, repletion,
satisfaction, in which digestion and delicious fatigue rule. All
seems informal – leaning with elbow on table, fixing hair, slouching
in one's chair. All the strict etiquette of dining slips down in this
painting of the end of a meal. The artist's view of the table too is
offhand, a glimpse from a corner vantage. The sparkling silver
coffee service, flower-decorated lamps and table ornament with
celebrant female nude are asymmetrically placed, delicately
sprawled, like the diners. Glimpses into other rooms provide
breathing space, room to expand, so that the meal does not
become a claustrophobic, hothouse experience.

The whole meaning of coffee as a social gatherer and finale to
a meal (which will be elaborated below) comes through here, and
this twentieth-century image, like so many earlier ones, expresses
the satisfaction of eating. The relation of people to each other,
however, remains unclear. Partners, parents, families, let alone the
hosts and the identity of the most powerful people in the room,

do not declare themselves loudly. As in the earlier paintings by Ollivier and Menzel, individual rank and superiority are not displayed. The dinner table as a whole indicates a social class, but the social value of each diner is largely hidden – told only, perhaps, by details of the women's clothing and jewellery. Even the lady at the 'head' of the table, at the left side of the painting, may not be the hostess of this affair. This is a world where strict delineations of status do not count. The atmosphere does not suggest a statement of social discrimination at all – the figures are all too shoulder-rubbing, *au pair*, unstuffy for that tradition of social demarcation. But the meal as a whole and its setting speak of elitism, where only the 'right' people are invited. Notable here is the lack of servants. No lackeys hang about. No maids clear the table. That whole system of servitude in the course of a meal has disappeared from view. The help will appear later – after everyone has left. Attendants may have served the various courses, but their absence from the painting signals a new, slightly more democratic world – at least as far as social graces are concerned. To lord it over others at the great social gathering point called a meal no longer seemed good manners.

In chapter Two it was noted that painters do not emphasize the nationalistic aspects of food, because the subject is essentially private, and because food has long been held as a low-ranking subject in art. It was also pointed out that one of the few kinds of food paintings to make grand public declarations are banquet images, pictures of social import. The banquet scenes already considered

81 Jacob Jordaens, *The King Drinks* (*c.* 1650), oil on canvas. Musées Royaux des Beaux-Arts de Belgique, Brussels.

possess that character. They declare the solidarity of the participants. The feast glues the group together. But it is notable too how little visual power is held by the food in these scenes. One hardly notices the edibles. The comic element of food would rise too high if one of the prince de Conti's guests were to wave a giant *crêpe* over his fellow diners as a kind of nationalistic symbol. That sort of amusing emphasis on food would give Ollivier's painting the character of Jacob Jordaens's drunken Twelfth Night parties (illus. 81), entertainingly condemnatory scenes of silly people engaging in disreputable activities. Food is a little too materialist, too commonplace, too long ranked at the lower end of subjects for art, to be raised up as a grand social statement in a public space.

INFORMALITY

Like Grun's meal scene of 1913, many paintings dwell on the close of the meal and project a sense of repletion. The artists portray the satisfaction of a filling repast as diners sip coffee or liqueurs, or nibble fruit, nuts and dessert. Figures relax, and still half-filled dishes and decanters on the table signify an overabundance of food. Renoir's *End of the Lunch* of 1879 (illus. 82), for example, depicts the after-meal smoke – a routine developed in the nineteenth century and alive with all sorts of social meanings. Smoking was for men only, and if women were present, it suggested that they were not proper ladies. The painting shows a less-than-refined moment of social détente. It speaks of breaking strict social conventions, since the artist captured the typical bend of the head when the smoker lights up.

This is not a condemnatory image. Rather, it is the triumph of informality. This middle-class smoker has probably picked up these young women, and fed them at one of the less-than-formal eating houses in déclassé Montmartre.[6] Renoir and his fellow Impressionists also painted many such scenes of modern life in the outdoor restaurants along the Seine, in the suburbs of Paris. The painting of 1879 does not depict a family affair, a business lunch or a holiday celebration. Instead, it shows the way of life of a racy youth in the French capital. The smoker pays no regard to the social niceties, not because he does not know them, but because they do not suit his modern sensibility or these particular circumstances.

Edouard Manet's *Luncheon in the Studio* of a decade earlier (illus. 83) possesses a similar tone. Over coffee and an after-

82 Pierre Auguste
Renoir, *The End of the
Lunch* (1879), oil on
canvas. Städelsches
Kunstinstitut,
Frankfurt-am-Main.

meal drink, a smoker lounges in what appears to be an artist's
studio. He wears his hat indoors – an offence in polite circles –
and epitomizes the leisurely eater, the well-dressed, nonchalant
diner in modern Paris. In the foreground a young man leans
against the table. He is dressed in fashionably casual clothes,
and like the smoker reeks of languid informality. Both figures
relax in ways frowned upon in etiquette books, sprawling on
the furniture with a careless air. The maid with the coffee pot
further indicates the late stage of the meal. The artist's props –
swords, helmet and other accoutrements of a history painter –
possibly act as a contrast to the utter modernity of the rest of
the composition. But these props also link this informality to
the life of artists, to a way of existence less strict than that of
other professionals. The artist's world appears dandified and
sophisticatedly casual.

83 Edouard Manet,
Luncheon in the Studio
(1869), oil on canvas.
Bayerische Staats-
gemäldesammlungen,
Munich.

Meal scenes often possess the qualities of a vignette from a novel.
Some of these works have general similarities in spirit to a scene
from Leo Tolstoy's *Anna Karenina* (first published 1875–7):

> When Levin went into the restaurant with Oblonsky, he could
> not help noticing a certain peculiarity of expression, as it were a
> restrained radiance, about the face and whole figure of Stepan
> Arkadyevitch. Oblonsky took off his overcoat, and with his hat
> over one ear walked into the dining-room, giving directions to
> the Tatar waiters, who were clustered about him in evening coats,
> bearing napkins. Bowing to right and left to the people he met, and
> here as everywhere joyously greeting acquaintances, he went up to
> the sideboard for a preliminary appetiser of fish and vodka, and
> said to the painted Frenchwoman decked in ribbons, lace and
> ringlets, behind the counter, something so amusing that even that
> Frenchwoman was moved to genuine laughter. Levin for his part
> refrained from taking any vodka simply because he felt such a
> loathing of that Frenchwoman, all made up, it seemed, of false
> hair, *poudre de riz*, and *vinaigre de toilette*. He made haste to
> move away from her, as from a dirty place. His whole soul was
> filled with memories of Kitty, and there was a smile of triumph
> and happiness shining in his eyes.

'This way, your excellency, please. Your excellency won't be disturbed here', said a particularly pertinacious, white-headed old Tatar with immense hips and coat-tails gaping widely behind. 'Walk in, your excellency', he said to Levin; by way of showing his respect to Stepan Arkadyevitch, being attentive to his guest as well.

Instantly flinging a fresh cloth over the round table under the bronze chandelier, though it already had a tablecloth on it, he pushed up velvet chairs, and came to a standstill before Stepan Arkadyevitch with a napkin and a bill of fare in his hands, awaiting his commands.

'If you prefer it, your excellency, a private room will be free directly; Prince Golitsin with a lady. Fresh oysters have come in.'

'Ah! oysters.'

Stepan Arkadyevitch became thoughtful.

'How if we were to change our programme, Levin?' he said, keeping his finger on the bill of fare. And his face expressed serious hesitation. 'Are the oysters good? Mind now.'

'They're Flensburg, your excellency. We've no Ostend.'

'Flensburg will do, but are they fresh?'

'Only arrived yesterday.'

'Well, then, how if we were to begin with oysters, and so change the whole programme? Eh?'

'It's all the same to me. I should like cabbage soup and porridge better than anything; but of course there's nothing like that here.'

'*Porridge à la Russe*, your honour would like?' said the Tatar, bending down to Levin, like a nurse speaking to a child.

'No, joking apart, whatever you choose is sure to be good. I've been skating, and I'm hungry. And don't imagine', he added, detecting a look of dissatisfaction on Oblonsky's face, 'that I shan't appreciate your choice. I am fond of good things.'

'I should hope so! After all, it's one of the pleasures of life', said Stepan Arkadyevitch. 'Well, then, my friend, you give us two – or better say three – dozen oysters, clear soup with vegetables . . .'

'*Printanière*', prompted the Tatar. But Stepan Arkadyevitch apparently did not care to allow him the satisfaction of giving the French names of the dishes.

'With vegetables in it, you know. Then turbot with thick sauce, then . . . roast beef; and mind it's good. Yes, and capons, perhaps, and then sweets.'

The Tatar, recollecting that it was Stepan Arkadyevitch's way not to call the dishes by the names in the French bill of fare, did not repeat them after him, but could not resist rehearsing the

whole menu to himself according to the bill: – '*Soupe printanière, turbot, sauce Beaumarchais, poulard à l'estragon, macédoine de fruits . . . etc.*', and then instantly, as though worked by springs, laying down one bound bill of fare, he took up another, the list of wines, and submitted it to Stepan Arkadyevitch.[7]

In novel-like narrative paintings, the slouching postures and informal glances, as well as the setting and food itself, can take on dramatic meanings; they are clues to the characters' state of mind, or moral commentaries, or references to the themes of the tale. Hogarth pioneered this literary-like visual art, and sometimes employed it in food scenes, but in his works the characterizations and story-telling become obvious. In a later painting of modern life, William Quiller Orchardson's *Mariage de convenance* of 1883 (illus. 84), a somewhat more subtle characterization through gesture, glance and table appears.

Orchardson presents his story in a series of separate canvases. In the one shown here, the beautiful young wife, who married for money, is tired of her life. The enormous distance of the marriage partners from one another, at either ends of the table, describes the couple perfectly. One mate is bored, the other aware of the other's boredom. The elegant tableware depicts the wealth and

84 William Quiller Orchardson, *Mariage de convenance* (1883), oil on canvas. Glasgow Art Gallery and Museum.

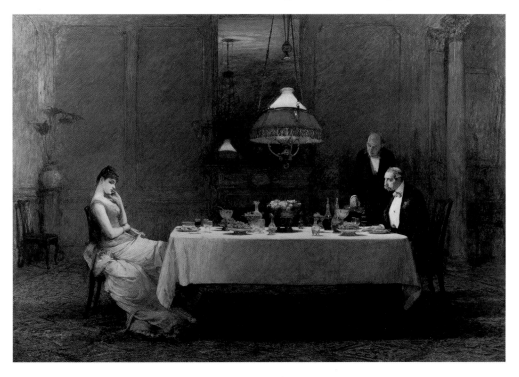

comfort that underlie this marriage. Food here means social standing and money – as does the servant at the right. The well-appointed dining chamber, however, means more than this. The artist used the enormous room to express the loneliness and emptiness of the couple's existence. The table abounds with food and drink but the wife partakes of nothing, indolently removed from the meal, and her attitude toward the table reveals her state of mind and the sad story.

Most other depictions of informality in dining promote an air of carefree indulgence. Pleasure increases. Restrictions can be relaxed. Satisfaction can be experienced without stiffness or authoritarian control. The attitude and actions of the figures in these eating scenes seem related to the disarray of market pictures. The eaters, like the goods for sale, sprawl around in their environments, and this is a quality also found in many meal still-life paintings.

DUTCH STILL-LIFE

Dutch painting of the seventeenth century established the most potent conventions of the food still-life. Haphazard piles of vessels and edibles, the tablecloth pulled aside to form a mound of folds, the angled table knife (handle toward the viewer), the spiralling lemon peel, half-eaten pastry, shining metal decanters and half-filled glasses of wine are a few of the standards of the genre. Pieter Claesz., Abraham van Beyeren, Jan Davidsz. de Heem, Willem Claesz. Heda, Willem Kalf and others devised and elaborated these elements, which would become mainstays of food imagery for 200 years. These Dutch still-lifes often suggest a meal – the viewer sees the food as a diner would, and the deranged dinnerware and victuals seem to have been left just moments ago by the eater.

The most influential Dutch still-lifes of the seventeenth century are marked by a roughly pyramidal heap of food and tableware. Spanish still-life painters of the same period separated their objects more, or arranged them in squarish compositions or in just a line (illus. 31, 41). The silvery highlights of Dutch still-life are also distinct, piercing the dark- or light-grey spaces with dancing movement. The kinds of food represented in Dutch seventeenth-century still-lifes remained the standard fare in the genre for centuries: fruit, fish, shellfish, ham, wine in glasses, bread, pies, fowl, olives, nuts and sweets. Cheese is frequently present up to about 1725.[8]

Cabbages and salad stuffs make their way boldly and repeatedly into Dutch market and kitchen pictures, but rarely appear

on the Dutch table. The carrots and onions that are seen scraped and chopped in the Dutch food preparation pictures by Dou and many others (illus. 54) are absent. German and Swiss still-life painters of the seventeenth century might include some greenery – a few leeks or lettuce leaves – but not Dutch artists.[9] There are large joints of beef and lamb in seventeenth-century Italian still-lifes (and they appear too in Dutch market and kitchen scenes), but not in Dutch meal paintings. Cardoon and celery are notable in Spanish still-lifes, but not in Dutch meal paintings. The Dutch choices, whatever their rationale, determined the menus of the history of art.

Chardin, Cézanne, van Gogh and Matisse may have diverged from the Dutch Baroque path in some ways, but they did so in full awareness of the earlier masters, defining themselves as still-life painters in relation to them. When a post-seventeenth-century still-life painter chooses to represent food differently from the Dutch canon of food or table decoration, it immediately suggests a special meaning. Thus Frida Kahlo's *Fruits of the Earth* of 1938 (illus. 43), noted previously, presents obviously un-Dutch items, and her purpose was evidently to salute Mexican nationalism.

It was no doubt their sheer numbers that partly explained the long-lasting influence of Dutch still-life. The thousands of Dutch still-life paintings in the major museums of Europe and America provided a blanket of familiarity and authority. The more varied fare of Italy and Spain could not rival the Netherlands in numbers of works or in fame. All this is amusing in its way, because Dutch cuisine has hardly been celebrated over the centuries. The lowly stew known as hotchpotch is the chief Dutch claim to gustatory distinction – but it does not appear in Dutch still-life painting.

Dutch seventeenth-century still-life is crucial to an understanding of the broad history of meal paintings. Pieter Claesz.'s painting of a herring (illus. 42), illustrated above in relation to Lenten subject matter, is an astonishingly barren yet beautiful work of an abstemious meal. There is nothing here but a large glass of beer, the cut-up fish, a small bread, a plate of what is probably caper sauce, and the broken shell of a single hazelnut. Even in this Spartan work, however, there exist hints of refinement and wealth. The knife appears to be a sumptuous piece of metalwork, and the glass is decorated and probably expensive. The bread is not humble black bread, but elegant white – an insignia of high economic status (spoilt children of the rich were called 'white bread kids' in the seventeenth-century Dutch Republic). Dutch still-life paintings always manage to include

some notes of ease and pleasure and richness, even as they speak of abstention or death or sin.

Another painting by Pieter Claesz., who stands here as the chief representative of Dutch still-life painting, is of a type now called a 'breakfast piece', a modest display of cold food in a generally monochrome atmosphere, and with not-too-pretentious dinner-ware (illus. 85). But this name is a misnomer. Few people before the nineteenth century ate any breakfast to speak of. The first real meal of the day was luncheon (or dinner as it is sometimes called), eaten between 10 am and noon. It is also uncertain that the paint-ing depicts a meal at all. It exemplifies the problem of much Baroque Dutch still-life – is it a meal that is represented or some-thing other than a meal? Its disorder goes against the centuries-old conventions of meal settings. From food literature – including plans of banqueting tables – it is known that in England and the rest of Europe from at least the fifteenth century through to the nineteenth, and often beyond, the dishes of a meal were to be arranged in a strictly ordered and usually symmetrical configura-tion, and placed on a cloth-covered table.[10] Frans Hals's painting of a banquet of the civic guards of the Company of St George (illus. 86) shows a well-laid table with trenchers set neatly before each diner, as etiquette books recommended. The arrangements of most seventeenth-century still-lifes, however, are different. The disorder suggests, among other things, ongoing action.

On the table in the Claesz. painting (illus. 85) is a knife, placed at a slight angle pointing away from the viewer, and also its scab-bard with a blue sash that hangs sloppily over the front edge of the furniture, echoing the spiral lemon peel. The knife in its scabbard was evidently worn by an eater. (Before the eighteenth century, before forks and other utensils were set out on the table by the host, the diner would bring his own knife to the table.) Someone has been slicing or paring or picking at food, and it is unlikely that a cook would remove his scabbard, place it on the table and then proceed to prepare the food for eating. Someone has been eating at this table. It does indeed appear to be a meal. Yet the food is in such disarray. We see bread, a crab, a lobster, a dish of caper sauce for the seafood, two lemons, a romer of wine, a tall pass glass of wine or beer, a watch and a decanter. All the food rests on metal platters, except the sauce, which is in an oriental-style porcelain dish. The white tablecloth covers only the right side of the wooden table, and it bunches into folds, as if someone has swept it aside. The plates seem deranged, piled half-atop each other, and although the objects altogether form a handsome pyramidal composition, as a setting for a meal they appear haphazard.

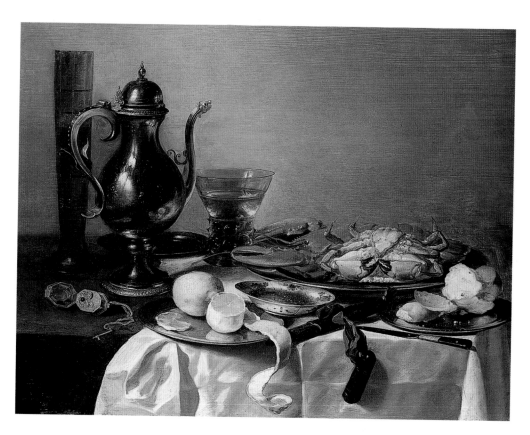

85 Pieter Claesz., *Still-life with Crab and Lobster* (1643), oil on panel. Minneapolis Institute of Arts, Minnesota.

Perhaps, as Anne Lowenthal claims, such still-lifes do not depict meals at all, but are just arrangements of precious things and delectable items without any naturalistic justification.[11] She sees many Dutch still-lifes as primarily *pronk* pictures, pictures of wealth, of precious objects denoting social level. Yet signs of eating animate most of these still-lifes, including the one illustrated here. The knife in the Claesz. painting suggests the process of eating. Numerous still-lifes show food half-eaten, and the viewer is placed where the diner would be. It is as if we witness a temporarily suspended meal. Who would leave his scabbard and knife on the table if the meal were over? The food goes together as a meal, but if it is a meal, why is it so cluttered and disordered and unlike most meals recommended in the literature of the day? Maybe it is not just a *pronk* picture, but a symbolic arrangement. After all, the watch – not a necessity at a meal – clearly seems a *vanitas* symbol. It is possible that many of the items represent bodily delights or the soul or the Eucharist or the disordered household or any number of other ideas or themes, of the sort found in emblem books. It seems more likely, however, that in this

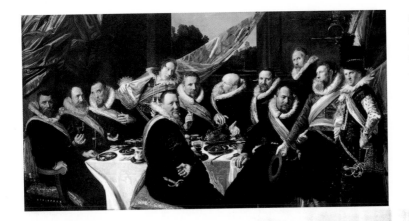

86 Frans Hals, *The Company of St George Banquet* (1616), oil on canvas. Frans Hals Museum, Haarlem.

and similar works from the period there is an expressive vision of eating. Such pictures probably do suggest a meal – but a meal without restraint or stricture, a fully indulgent vision of one. This disorder is the same sort that is found in market paintings from the very beginning of that genre, and again in the meal scenes with figures just discussed – celebrations of informality. Disarray in the still-life suggests abundance, non-rationing, expansiveness, no need to conserve or order or count, but, instead, a complete surrender to needs and desires.

Although plenty of Dutch seventeenth-century paintings condemn the disorderly home – most notably those by Jan Steen – it is less certain that this is what is going on in the Claesz. painting.[12] The sloppy household paintings make the subjects look ridiculous – they are comic visions of a world turned upside down. But the sloppiness here seems to represent unrestricted indulgence – even if a watch refers to the transience of such pleasures. There is nothing obviously humorous or satirical. In a contemporary painting by Bartholomeus van der Helst of a banquet of militiamen celebrating the Peace of Münster (illus. 75), a certain disorder reigns. Food and drink crowd together and the table certainly lacks the order prescribed in books on etiquette.

Although all this rigorous decorum of the table was fine in theory – and could appear in some formal group portraits such as Hals's *The Company of St George Banquet* (illus. 86) – it seems rarely to have been practised rigorously, as is suggested by the free and easy atmosphere of these civic bowmen of Amsterdam. The disorder of Dutch still-lifes bears some similarity. It may be that all this disorder suggests a *vanitas* theme – all is unstable. But this seems doubtful. The irregularity of Dutch still-life at the very least enhances the general Baroque taste for action, things in transition, the momentary. A perfectly laid table, ready for dining, would

be a static affair, unartistic, limited and dead by the standards of Rembrandt, Bernini and other seventeenth-century artists. People in paintings of the period consistently appear in transient postures, with mouths open, heads just turning, caught off balance, while buildings thrust and pull and writhe in light and shadow. A sense of ongoing action in still-life should therefore be expected as well. And a meal left half-eaten, the diner about to return, as perhaps the Claesz. painting and similar works imply, fits well with the Baroque outlook. The peeled fruit and half-drunk wine, however, also make the meal more inviting, more appetizing, more effective as a picture of pleasure. Still, there is no empty trencher or plate on which to place the food as it is eaten. If this is a meal, the edibles apparently will have to be plucked from the serving platters and popped directly into the diner's mouth.

It was not only in the Dutch Republic that this irregularity of arrangement and problematic meal-like presentation were found. The Flemish painter Osias Beert, who spent his career in Antwerp, laid out a handsome cold collation in *Still-life with Oysters* of 1610 (illus. 87). This early northern European still-life has a similar kind of asymmetry and half-activated character as the later work by Claesz. and other Dutch painters. The dishes lie haphazardly on a bare tabletop, again unlike the prescribed meal settings of the day. Furthermore, a lemon and lemon slice lie directly on the table without any dish, rather unexpected in a household able to afford such expensive fare as candy. A plate of oysters and a dish of olives in brine, sprinkled with what is probably salt, seem untouched. But the dish of dried figs and raisins

87 Osias Beert, *Still-life with Oysters* (1610), oil on panel. Staatsgalerie, Stuttgart.

has evidently been toyed with and pieces of the food have landed on the table. A piece of chestnut shell also lies near the bowl of chestnuts at the upper right, and broken bits of candy rest at the edge of the table, near a compotier filled with the sugary goodies. On the other hand, the two glasses of wine, one red, one white, seem untouched. Someone has been nibbling – but is it a meal interrupted, or items ready for serving, or just a line-up of victuals without any real-life context? Again, it is as if we are facing an opulent set of snacks in a particularly informal manner. Perhaps this disorder adds a note of privacy to the imagined meal. The food is not laid out as if this were some public banquet or even an ordinary social situation, but rather an individual meal, alone. In such circumstances, the strictures of polite society could disappear. One is reminded of a policeman character in the twentieth-century crime novels of Lawrence Sanders: the policeman has recently separated from his wife, and now in charge of his own private meals, he indulges his lust for giant sandwiches. They are so oozing and sloppy in their ingredients that the man eats the sandwiches bent over the kitchen sink, so as not to dirty a plate, table or anything else. Privacy frees one from propriety.

The intimacy of seventeenth-century Dutch meal-like still-life paintings engages the viewer, and makes him (or her) part of the painting. The viewer is the diner, hence all those knives with their handles directed outwards – they are invitations to join the meal. This persistent engagement goes hand in hand with the viewer relations of Baroque art in general. Seventeenth-century art frequently reaches out to the viewer and drags him into the painting, or sculpture or architecture. In the context of food images, the viewer becomes more physically involved with the meal. He becomes a diner, and the food takes on a more powerful presence.

The relation of viewer and meal in these still-lifes differs greatly from most fifteenth- and sixteenth-century meal scenes. In Jaime Huguet's *Last Supper* of around 1470 (illus. 88), the viewer is a little above the table, which makes the grand event remote. The sacred meal lies at a distance, rather as a church altar remains separate and distant from the laity. The subject is too important, too holy, for us to approach too close. Leonardo's *Last Supper* is above rather than below the viewer, but it too is separate – even from the monks eating in their refectory. The viewer never really participates in a *Last Supper* – not even in the seventeenth century. Aristocratic meals in the fifteenth century also present themselves at a decent remove, even as they clearly describe the food on the table. The ducal meal of the Limbourg brothers (illus. 67) presents a table of food in this remote manner, seen from above. The viewer

88 Jaime Huguet, *Last Supper* (c. 1470), oil on panel. Museu Nacional d'Arte de Catalunya, Barcelona.

must always keep a distance from the main event, whether it is a holy or an upper-class one. Horenbout's sixteenth-century meal (illus. 17), so exclusive that only the prince can eat, also keeps us high and far away. The dinner table in these works serves as an unapproachable altar for all but the anointed, and tells us generally about the importance of ritual eating, of gatherings of diners where rank is enforced and great history unfolds.

The seventeenth-century Dutch still-life offers a different world, secular and sensual and private. It makes the viewer comfortable, brings him down to earth and puts him in front of the food. Aristocratic meals gradually became much more informal – beginning in the seventeenth century – and the Dutch still-life participates in that same tendency in the representation of food. Its viewer-as-diner implication led to numerous later visions of easy dining with the personal participation of the spectator – and this mode became particularly prevalent in the nineteenth century. In Monet's *Déjeuner sur l'herbe* of 1865–6 (illus. 89), there is a place for us at the picnic blanket, a space in the foreground, as the

hostess sets out the elegant porcelain plates. In still-life form, Manet's *Oysters* (illus. 90) presents a seafood snack as the Dutch did in the seventeenth century – at our disposal. We sit before the oysters, with a fork available and a sauce dip at the ready. Albert Fourie's painting of a marriage feast of the 1880s (illus. 91) makes us one of the guests, amid the food and celebrants. The Dutch still-life, more than any other food picture, made the picture of food a matter of intimate personal experience.

There was a return to the overhead food picture in the late nine-teenth and twentieth centuries. The art of Cézanne and his admirer, Matisse, became particularly influential models in this regard.

90 Edouard Manet, *Oysters* (1862), oil on canvas. National Gallery of Art, Washington, DC.

91 Albert Auguste Fourie, *Marriage Feast at Yport* (1886), oil on canvas. Musée des Beaux-Arts, Rouen.

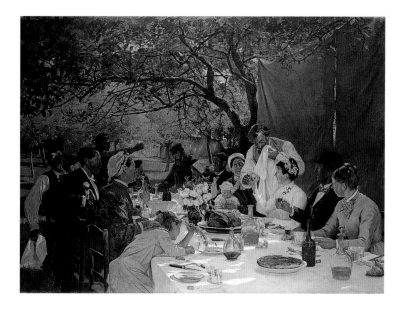

In both these painters' works, the exact position of the viewer remains uncertain or unstable, as the painting plays back and forth between two-dimensional emphasis and three-dimensional illusion. But an overhead view frequently predominates. These images differ strongly, however, from the overhead views of earlier centuries. The food is now presented close up. The opposite of remoteness prevails. An early Matisse painting of about 1898 (illus. 124) offers coffee and fruit to the spectator as if he (or she) were bending over the table. A late one of 1940 (illus. 92) pushes its offerings even further under the viewer's nose. The overhead view invites the intimacy of the private meal in these modern visions of food. Pierre Bonnard presented perhaps the most succulent overhead views of food on tables of the twentieth century. In a painting of 1924 now in the Metropolitan, New York, for example, the articles of dinner array themselves before our noses, close to us – and the whole history of a remote, untouchable meal is turned on its head.

The revolution of intimacy began with Dutch still-life and continued for centuries. The personal involvement of the spectator in such paintings conceivably developed from Dutch Protestantism – from a belief in the worshipper's private communion with God as more important than any institutional programme of salvation. Rather than social rank and ritual, one finds a newly private embrace of the meal. Although it is speculative to link august conceptions of man's relationship to God with pictures of eating, the marginal status of food imagery permits the painter to explore

the feelings and meanings of experience more freely than subjects of grander import. One's relation to others, and to the world at large, and to God, no doubt affected the artist's perception of his and our relation to the stuff of earthly survival that we all face daily.

92 Henri Matisse, *Still-life with Oysters* (1940), oil on canvas. Offentliche Kunstsammlungen, Basel.

OYSTERS

Some foods of the seventeenth-century Dutch meal painting carried specific meanings that lived on in later art. Oysters are a good example – and the oyster's legendary power as an aphrodisiac certainly infiltrated Dutch and Flemish pictures.[13] Frans Francken II depicted an oyster orgy of cavaliers and prostitutes in the Antwerp burgomeister's house in the 1630s (illus. 93). And

the burgomeister's famous art collection presents some wry commentary on the goings-on. Rubens's *Samson and Delilah*, over the mantelpiece, tells us about the dangers of female sexuality. Jan Massys's painting of moneylenders tells us of prodigality and venality. A painting of St Jerome in prayer tells us of penance to come. None of these warnings, however, dampens the sexy fun. The same can be said of Jan Steen's pretty whore (illus. 94), who smilingly invites us to sample her oysters. She sprinkles salt on the food of love to make her offer even spicier.[14]

In an eighteenth-century painting by Jean François de Troy (illus. 95), an all-male oyster luncheon is watched over by a statue of Venus – revealing that oysters continued to possess libidinous force. The gentlemen eat their oysters juicily directly from the shell – without silverware. (Louis XV commissioned this painting to hang in the dining room of the Petits Apartements du Roi at Versailles.) Manet depicted a more restrained nineteenth-century oyster still-life meal (illus. 90). Quiet, Chardin-like, politely decked out with a special oyster fork and a special oyster dip bowl, this might relate to marital sex. The artist reportedly painted the oysters for his fiancée, and a sexual allusion would be apt.[15] But the shellfish is losing steam. (Incidentally, the special oyster

93 Frans Francken the Younger, *Supper at the House of Burgomeister Rockox* (1630–35), oil on panel. Alte Pinakothek, Munich.

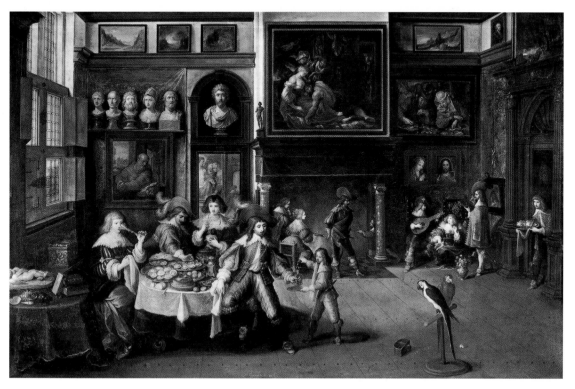

94 Jan Steen, *Girl with Oysters* (1658–60), oil on panel. Mauritshuis, The Hague.

tableware in the painting, typical of the period, played a class-distinguishing role – if one did not know which fork to use, one was obviously ill bred.)

In the twentieth century the sex life of the oyster petered out. Without any obvious licentious intent, Henri Matisse painted a large, handsome oyster still-life in December 1940 (illus. 92). It is significant that the artist probably thought of this canvas as his last major painting. He had been diagnosed with intestinal cancer, and was about to undergo dangerous surgery. He had not painted for months. The Nazi defeat of France, and Mme Matisse's deci-

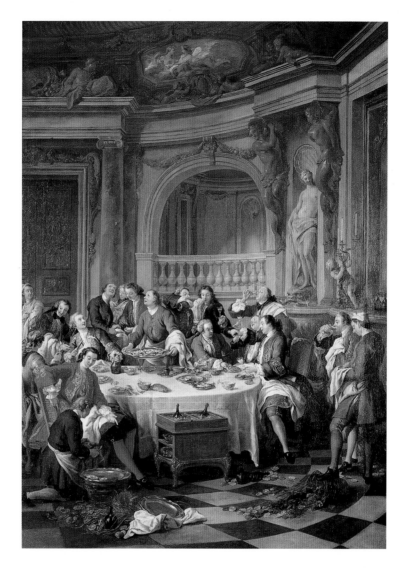

95 Jean François de Troy, *Oyster Luncheon* (1735), oil on canvas. Musée Condé, Chantilly.

sion to separate from her husband, also added to the bleakness of the artist's situation (although he still had his young mistress, Lydia Delektorskaya).[16] Matisse undoubtedly conceived of this oyster painting as his last will and testament, and if it does not proclaim sex, it was probably meant to express what sex is all about, and what most of Matisse's art is about – pleasure and the affirmation of life.

The modern concept of the courses of a meal – from soup to fish to meat to salad to dessert to fruit and cheese to coffee and brandy – was not widely established until the nineteenth century. Only in Russia had each course consisted of one or two dishes, and the meal made up of a progression of individual foods, usually served to each diner by a servant. In the nineteenth century this manner of dining was referred to as service *à la russe*. The more usual meals of the upper classes for centuries consisted of an array of varied foods set out on the table all at once, referred to as service *à la française*. Each 'course' of a meal served *à la française* included many dishes, and the foods were passed around from host to guests. The master of the house, rather than servants, carved the meat and passed it round.[17] Before the nineteenth century, menus in the West exhibited an astonishing diversity of items at each course of a meal. A good example of a pre-nineteenth-century feast, so different in so many ways from a modern meal, is the menu shown opposite for a banquet given by Pope Pius V in 1570.

Each stage of this sumptuous Renaissance meal seems grotesquely diverse. Custard pies and fried onions and boiled calves' feet appear in the same course. Salted pork tongues are served with marzipan balls. The papal menu reveals the fashionable new taste for relatively spiceless foods, compared to great meals of earlier times in Europe. There is much less pepper, cumin, coriander, nutmeg, cinnamon, and much more meat prepared in its own juices than in previous centuries. Catherine and Marie de' Medici's possible role in this development has already been mentioned. For all their novelty, however, the courses in the papal banquet follow tradition in that they are organized by cooking method and whether they are hot or cold. Boiled and roasted foods are separated, for example. This ordering depends on the medical theories mentioned in the Introduction – the degrees of heat, cold, moistness and dryness of various foods and their different cooking methods combine to achieve a balanced, healthy diet. Naturally, such a banquet as this hardly constitutes ordinary fare in whatever order, but it tells us of the ideal progression of courses in a grand meal at the highest levels of society in the sixteenth century.

Fruit appears in several courses of the pope's banquet and is a vital part of food painting. The fact that fruit outnumbers every other kind of item in food paintings has already been mentioned. It takes a powerful role in some of Aertsen's innovative sixteenth-century works. Caravaggio's basket of fruit of around 1600

First Course

Cold delicacies from the sideboard
Pieces of Marzipan and marzipan balls
Neapolitan spice cakes
Malaga wine and Pisan biscuits
Plain pastries made with milk and eggs
Fresh grapes
Spanish olives
Prosciutto cooked in wine, sliced and served
with capers
Grape pulp and sugar
Salted pork tongues cooked in wine, sliced
Spit-roasted songbirds, cold, with their tongues
sliced over them
Sweet mustard

Second Course

Hot food from the kitchen: roasts
Fired veal sweetbreads and liver, with a sauce of
eggplant
Salt, sugar and pepper
Spit-roasted skylarks with lemon sauce
Spit-roasted quails with sliced aubergines
Stuffed spit-roasted pigeons with sugar and capers
sprinkled over them
Spit-roasted rabbits, with sauce and crushed
pine nuts
Partridges, larded and spit-roasted, served with
lemon slices
Pastries filled with minced veal sweetbreads and
served with slices of Proscuitto
Strongly seasoned poultry with lemon slices
and sugar
Slices of veal, spit-roasted, with a sauce made
from the juices
Leg of goat, spit-roasted, with a sauce made
from the juices

Soup of almond cream, with the flesh of three
pigeons for every two guests
Squares of meat aspic

Third Course

*Hot food from the kitchen: boiled meats
and stews*
Stuffed fat geese, boiled Lombard style and
covered with sliced almonds, served with cheese,
sugar and cinnamon
Stuffed breast of veal, boiled, garnished with flowers
Milk calf, boiled, garnished with parsley
Almonds in garlic sauce
Turkish style rice with milk, sprinkled with sugar
and cinnamon
Stewed pigeons with mortadella sausage and
whole onions
Cabbage soup with sausages
Poultry pie, two chickens to each pie
Fricasseed breast of goat dressed with fried onions
Pies filled with custard cream
Boiled calves' feet with cheese and egg

Fourth Course

Delicacies from the Sideboard
Bean tarts
Quince pastries, one quince per pastry
Pear tarts, the pears wrapped in marzipan
Parmesan cheese and Riviera cheese
Fresh almonds on vine leaves
Chestnuts roasted over coals and served with salt,
sugar and pepper
Milk curds with sugar sprinkled over ring
shaped cakes
Wafers[18]

(illus. 5) has often been considered the first Italian still-life and was certainly a very influential one. There exist, too, innumerable Dutch still-lifes of the seventeenth century with fruit as a primary subject. The fruit painting lived on in Western painting into the twentieth century. This was partly due to its visual attractiveness, but fruit meant more than this. Dietary concerns also made fruit important. Medical wisdom of the Middle Ages and Renaissance regarded fruit as a 'cold' food, and a particularly dangerous one, likely to disturb the balance of the human constitution. But medical treatises also recommended fruit as an appetite stimulator. During the progress of a grand meal, it would renew the appeal of eating. It encouraged healthful consumption. According to one eighteenth-century writer on the history of medieval French feasts, Le Grand d'Aussy, fruit was originally a pre-meal appetizer, something like a modern *hors d'œuvre* to get the stomach juices flowing, and only in the four-teenth century did it join the actual courses of the banquet.[19] This appetizing role continued. The fruit that colourfully graces so many paintings of food, especially feast images such as Pieter Claesz.'s *Still-life with Turkey Pie* of 1627 (illus. 125), acts therapeutically on the imagined diners, and perhaps on the viewers too, to make eating attractive, to whet the senses, to stimulate the taste for food.

RESTAURANT

The social rank of a restaurant diner is indicated by the restau-rant's exclusivity and expensiveness, the type of food served, the expertise and servility of its waiters, and the richness of the table accessories and room decor. The entire restaurant ritual involves far more than a means to satisfy hunger. In some ways a modern restaurant meal corresponds to Horenbout's princely meal of the early sixteenth century, a matter of social definition.

Humble eating establishments, as well as Michelin five-star culinary palaces, can offer an arena for social statement. The American luncheonette and some fast-food restaurants provide counter service, without the degree of individual attention of a separate table; they provide inexpensive cutlery and napkins that the eater may have to collect, but no tablecloth is laid. To eat in such establishments marks the diner as unpretentious, ordinary, economical, a man of the people, important associa-tions in democratic nations, even for the powerful.

The history of the modern restaurant has recently been rewrit-ten with an emphasis on social meanings and politics, and the story gives added meaning to a variety of food paintings of the

nineteenth and twentieth centuries. In *The Invention of the Restaurant* Rebecca L. Spang seeks to differentiate the modern restaurant from the traditional inn, cook shop or tavern.[20] The restaurant, invented in Paris in the 1760s, began as a place for those who needed to restore their health. Spang identifies the inventor as Mathurin Roze de Chantoiseau, and refutes the long tradition that links the rise of the restaurant to the consequences of the French Revolution. As she persuasively points out, the restaurant developed more than twenty years before the fall of the Bastille – and had nothing to do with aristocrats' chefs looking for new employment. A 'restaurant' was at first not a place at all, but a food, a restorative, a broth or bouillon made from boiled meat and meant to give strength to the sick. What came to be called a restaurant was a place devoted to serving these restorative broths to those who were weak and ill.

According to Spang, these new establishments distinguished themselves from other eating houses not only by their hospital-like function – diet after all had always been a part of health concern – but by the fact that the diner could order exactly what he wanted at a fixed price for each individual dish, and have it served personally at any time of day at an individual table. Inns at the time in Paris charged per head for meals, provided a large common table where everybody ate from the same dishes, and served the meal at certain times. One could not order something special to eat, or eat at a specific time of one's own choosing. One of the innovations of the restaurant – related to these novelties of service – was the menu card that listed the array of goods for sale and the price of each item. As late as the 1820s, guides to Paris had to explain to visitors the use and purpose of a menu.[21]

The new restaurants provided small tables, niches or private rooms, and Spang emphasizes the new privacy and delicacy afforded by these public spaces. One advertisement for a restaurant in 1767 noted:

> Those who suffer from weak and delicate chests, and whose diets therefore do not usually include an evening meal, will be delighted to find a public place where they can go have a consommé without offending their sense of delicacy, as one might have a *bavaroise* [tea in a carafe, sweetened with herbal syrup] in a café while enjoying the pleasures of society.[22]

Delicacy of health led to delicacy of the fare offered, and restaurants very quickly expanded from serving just consommé to serving

large meals of exceptionally high quality and sophistication. In the well-appointed spaces of these fast-growing public establishments, a new luxuriousness of food and environment was notable.

The restaurant, according to Spang, also acquired political associations. The sickly diners of the Old Regime could, by their very sensitivity, associate the restaurant with aristocratic allegiance. During the Terror, when fraternal street banquets were among the public expressions of revolutionary zeal, the restaurant, aglow with privacy and intimacy as well as sensitivity, was often seen as a menace to decent society. Napoleon's administration, however, depoliticized the restaurant, and presented it solely as a beacon of gustatory supremacy – with Paris as its capital. The Napoleonic attitude proved successful. In the 1820s Brillat-Savarin, although a royalist, denied the restaurant's aristocratic exclusivity. He claimed it as a democratic institution, which permitted all those with sufficient funds to sample the finest cookery, food that in previous centuries would have been served only to the elite of society.[23]

Spang's concern with the restaurant as a particular intersection of public and private spheres provides some fascinating and psychologically rich ideas. The eaters in a restaurant isolate themselves, communing in small groups. Yet they display themselves and their privacy publicly. They eat with others, while remaining separate. If they wanted truly to be private, they could take the food for sale and eat it elsewhere, but they stay in the restaurant and exhibit themselves. It is a negotiation of sociability in a mass society. Spang is no doubt right to see the intimacy and conversational character of the restaurant experience as fundamentally different from the open discussion groups and the wholly public environment of the coffee house – as it existed in the seventeenth and eighteenth centuries – those places where political, scientific and intellectual symposia unfolded in England and France.[24]

It is less certain that the distinctions between traditional eating places and the modern restaurant were as great as Spang believed. The restaurant advertisement of 1767 quoted above suggests that individual service and payment already existed in cafés. The restaurant, it seems, merely applied to the consumption of food the café's system of ordering and paying for drinks. Paintings further indicate that earlier inns and taverns included small tables and individual service, and embraced private conversation, for example, Caravaggio's by-no-means-unusual *Supper at Emmaus* of 1601 (illus. 96).

The inn depicted by Caravaggio shows the 'public privacy' that Spang consideres essential to the modern restaurant. Christ

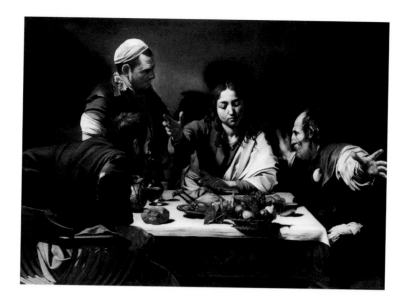

96 Michelangelo da Caravaggio, *Supper at Emmaus* (1601), oil and egg tempera on canvas. National Gallery, London.

and the two disciples sit on individual chairs at a small table, not at some long board with benches, and the waiter stands ready to serve their individual needs. Of course the painting primarily presents a religious message about the verity of Christ's resurrection. The miracle becomes apparent to his followers at this supper, and the message might skew the representation of the inn. The subject concerns intimate communication, and contrasts between those who recognize Christ's divinity (the disciples) and one who does not (the waiter). A small, private table gathering conveys perfectly the idea of a personal communication to a select few. Nevertheless, Caravaggio would not have conceived his small restaurant-like group in a vacuum. He evidently described a setting that was understood by his seventeenth-century audience.

The ability of the diner to choose a specific meal at any time of day may be one factor that distinguishes Spang's concept of the restaurant from earlier establishments. But although the late eighteenth-century places she describes offered a greater array of choices and with more flexibility, these characteristics probably represent only a slight change from previous tavern procedures, and even today restaurants limit what and when a patron can order. A guide to Paris eateries in 1828 lists the times when restaurants open and close, and no round-the-clock restaurants are cited. Even the 'bouillons', those places that continued to serve healthful consommés to the sickly, had specified times when their fare would be available.[25] If the eighteenth-century restaurants had offered their wares at all times, that practice clearly did not

continue. But Spang's emphasis on this point does serve to underline the personal service and private choice of the new restaurants. Certainly the idea of eating out was nothing new. Inns and cook shops, food stalls and street vendors had provided food for a large section of the urban populations for centuries. Not everyone had cooking facilities. Take-out and eat-in foods were commonplace in the Middle Ages and later. The clientele of inns, like those of restaurants, comprised locals as well as travellers. The Paris restaurants of the later eighteenth century were just one more outlet for distribution – although somewhat more aristocratic in tone and somewhat more healthful in claim.

What truly separated the restaurants of the 1760s from earlier eating houses was the delicacy of the fare. The novelty lay in the idea that one could find on public premises carefully prepared victuals that were tasty as well as healthy, as Brillat-Savarin noted in his gastronomic memoirs. What a remarkable thing, he recalled, that fine food suddenly became widely available in restaurants in the 1760s – how different from the crude offerings of previous times.[26] In an inn scene by Jan Steen of *circa* 1665 (illus. 97) the clientele celebrate Prince's Day, paying respect to the Dutch royal house. But even on such an occasion, there is a flat cake, bread, some ham, oranges (perhaps a reference to the House of Orange), and not much else besides a lot of drink. Most other tavern interiors of the fifteenth, sixteenth and seventeenth centuries show a similar lack of variety or sophistication in food. Oysters and mussels (which may largely play a symbolic role as signs of

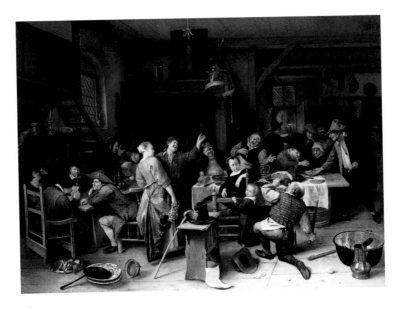

97 Jan Steen, *Celebration of Prince's Day* (c. 1665), oil on panel. Rijksmuseum, Amsterdam.

Eros) are about the most exquisite fare offered in such paintings, nothing like the delicate and eventually sumptuous meals provided by Parisian restaurants in the late eighteenth century. This change in the late eighteenth century represents one aspect of the civilizing trend that was gradually transforming the West, as Elias and Mennell describe.[27]

In the later eighteenth century traditional eating establishments became temples of skill, art, luxury and sophistication – a sought-after experience for all levels of society. Restaurants presented that which had been obtainable previously only in the grandest of households. Although Spang no doubt recognizes the aristocratic overtones of the Parisian restaurant rightly, in the wider picture its basic political meaning was democratization – even when, as was often the case, restaurants stood for elitism and exclusivity. The expensive restaurant fundamentally offered noble, refined dining in sumptuous circumstances to anyone who could pay for it. And still today, few restaurants are so expensive that a relatively poor man cannot experience fine dining at least once or twice. The restaurant disseminates exquisite taste.

Of course, not all restaurants provide the same calibre of social meaning or quality of food. The superior restaurant has a host of poor relatives to feed various categories of people. How did painters present restaurants? Although no late eighteenth-century paintings of Paris restaurants may exist, there is an interesting range of French restaurant canvases by van Gogh, painted about a century after the 'invention' of the modern restaurant, that can introduce the subject.

In a painting of the 1880s, van Gogh depicted the interior of a modern restaurant in Paris or its suburbs (illus. 98). He emphasized the sense of togetherness that a restaurant provides – tables all in line in a common space, each one beautifully covered in clean white linen, glassware and plates, and decorated with flowers. The tables, however, are very much alike – a good illustration of Spang's analysis of the intersection of public and private in the restaurant. Each table is an island of privacy, but it is in the same space as all the other islands. Van Gogh also presented here the restaurant as an art gallery, a place to enjoy paintings as well as food – a broad arena for all sorts of pleasurable consumption. He himself organized an exhibition of Japanese prints in a Paris café, so he was aware of the possible role of visual art in a food context. As in so many of the Impressionist works that influenced him, the restaurant appears here as a modern place of untroubled physical well-being. The tables stand prepared, waiting for the guests. It is a wonderful picture of anticipation. Yet, as is frequently the case

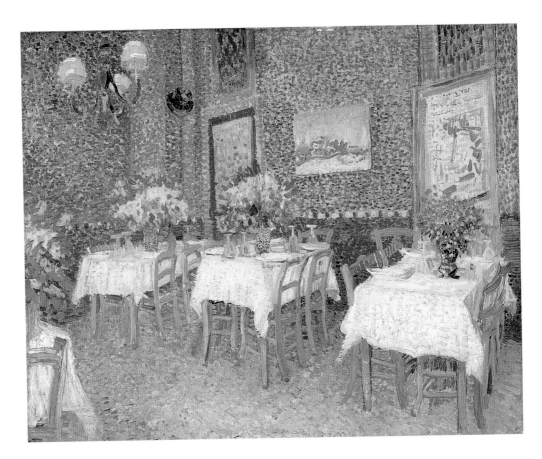

in van Gogh's art, a note of darkness arises. The very emptiness of the dining room strikes a discordant tone. Like his images of empty boats, empty bedrooms, empty shoes and empty chairs, the empty restaurant carries a touch of despair and loneliness. Here the tables remain unfilled; there is no table for the viewer and, most crucial of all, there is nothing to eat.

People do appear in van Gogh's painting of a restaurant in Arles of 1888 (illus. 99), but they look distant and unapproachable. Van Gogh's sense of isolation comes through in this image too – a depiction of a communal eating place that signals the artist's feelings of separateness from everybody around him. He blocks access to everybody else in the painting. This contrasts with the warm intimacy and friendship of Renoir's *The End of the Lunch* of 1879 (illus. 82). The Arles restaurant is also very different from the Paris eateries that van Gogh had depicted the previous year. This is a working-class place with long tables – a communal manner of eating – and the carafes and utensils appear cruder than those in the Paris restaurant. No tablecloths grace the

98 Vincent van Gogh, *Interior of a Paris Restaurant* (1887), oil on canvas. Kröller-Müller Museum, Otterlo.

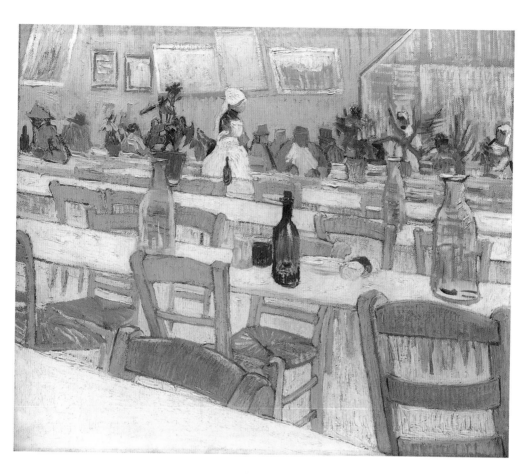

99 Vincent van Gogh, *Restaurant in Arles* (1888), oil on canvas. Private collection.

bare furniture here. Van Gogh repeatedly expressed sympathy for working-class people – and on many occasions tried to make himself one of them.[28] In the Arles painting, no doubt, he sought to celebrate the world of working men's eateries. Whether the tone of personal isolation obviates the sense of solidarity is debatable, but at the very least van Gogh illustrated the fact that nineteenth-century restaurants served the working man as well as the well-heeled. All classes commonly ate out.

Harold Gilman's painting of a London eating house from 1913–14 (illus. 100) presents an English version of van Gogh's restaurant for the common man. Although the customers of this establishment are glimpsed only partially, sufficient details of clothing are shown to indicate the class of the clientele. The bold advertisement on the wall and wooden (rather than upholstered) booths for the diners further characterize the social status of the place. Gilman rather subtly expresses the experience of eating in this common man's café by planting the viewer in one of the

100 Harold Gilman,
An Eating House
(1913–14), oil on canvas.
The Graves Art
Gallery, Sheffield.

booths, peeping over the tall wooden seat-back to see the other
eaters, yet remaining ensconced in a separate personal space. We
are differentiated from the rest of the restaurant, even happily
walled off from the other people, yet also part of the unpreten-
tious interior. Spang's concept of restaurants as spaces where pub-
lic display and private life conjoin seems particularly apt in regard
to this close-up and distanced depiction of a London eating house.
There is a particularly urban psychology at work here too, which
Kirk Varnedoe has analysed in the context of Degas' Paris street
scenes.[29] In the big modern city, individuals come close to others
physically, but keep their psychological distance by avoiding
eye contact and many other means. The way that passengers in
a crowded subway carriage focus on neutral spaces and evade
communication with those nearby exemplifies the mental situa-
tion. This is also what is found in Gilman's restaurant picture.
Restaurants, of course, arose in the French metropolis, not in
the country.

The specific class of people catered for, and the kind of food
available, need to be considered when looking at paintings of eating
houses and shops for refreshment. The distinction between bar
and restaurant in some places in Europe could be important.
Medieval guilds created distinct groups of food vendors, separating
in many cities those who sold cooked food from those who sold
raw, those who sold drink from those who sold solid food, those
who sold in the street from those who sold indoors, those who sold

cured pork products from those who sold other meats, and so on. Such professional distinctions, which kept one vendor from dealing in another's wares, were not always observed, and many purveyors belonged to several guilds. Still, this balkanization of the food trades had consequences, even in the nineteenth century, when many antiquated restrictions became redundant. In some cities in Germany, still today, beer halls and wine bars are strictly separate. Although both sell alcoholic beverages, wine bars do not sell beer, and vice versa.

These medieval discriminations determined some of the specifics of modern restaurants. Nevertheless, all manner of blurring also occurred, and what once may have been an eating establishment with severely restricted fare often expanded to encompass many other sorts of food offerings. The distinctions among bars, taverns, inns, cafés, coffee houses, tearooms, brasseries, bistros and food stalls are indistinct. The differentiating names continue, but the name does not always signify a particular fare or service. Sometimes the vestigial name identifies the social class of the clientele, or whether entertainments are also available, or the size of the public space, or the furniture arrangement of the establishment, or whether one can sit at a bar as well as a table. Inns originally offered rooms for sleeping as well as meals, but by the later nineteenth century numerous places called inns lacked sleeping facilities. Brasseries in nineteenth-century France were originally large beer parlours for a less-than-opulent class of patrons. Today they serve far more than beer, and their difference from bistros appears to lie in the size of the eating hall. Within any such category or name all kinds of finer or broader classifications and associations might exist, and paintings of such places cannot be fully understood merely by the title of the establishment depicted.

Three nineteenth-century paintings exemplify the problem of defining restaurants narrowly. From 1837 is Ditlev-Konrad Blunck's portrait of Danish artists in the Osteria La Gensola in Rome (illus. 101). An osteria can be an inn or a tavern without sleeping facilities, but is usually operated as a modest hotel with meals included. The artists at the right side of the painting dine together at a long table. One artist receives a plate of food from a waiter (or perhaps he is asking questions about the food). At another table sit mothers and children, and children and pets also play on the bare floor. This inn is a homely place, unpretentious, family-oriented, probably an extension of the artists' living quarters – a *pensione circumstance*, and the restaurant, so it seems, provides a substitute family for the guests. As in Manet's later *Luncheon in the Studio* (illus. 83), the artists' lives appear informal.

101 Ditlev-Konrad Blunck, *Danish Artists in the Osteria La Gensola, Rome* (1837), oil on canvas. Thorvaldsen Museum, Copenhagen.

Everything in the osteria dining room, where food preparation and storage also take place, rejects strict formalities and ritual. The artists lean this way and that; frock coats have been removed; legs sprawl; and one artist sketches the other diners.

Around 1850 Ludwig Passini painted a similar group in another Roman haunt, the Caffe Greco, a famous meeting place for artists (illus. 102). The foreign artists at the right take coffee, rather than a full-course meal. But biscuits and sweets are on the bar, and more substantial solid edibles are available. The Caffe Greco, decorated with liquor bottles, evidently sold as much alcohol as it did caffeine. Bars and cafés also often became indistinguishable from one another. What began as a place to drink coffee turned into a place to drink wine or spirits or beer, and this is the case with the Caffe Greco. It is very unlike the Osteria La Gensola, a men's club more than a family home, and a more urbane world too, where patrons dress more formally, although lounging postures obviously still proliferated.

Eating and drinking establishments are too varied in class, sophistication, food offerings, professional or social associations and décor to permit much generalization. The Osteria La Gensola and the Caffe Greco existed at the same time in the same city, and both places served foreign artists. But they are worlds apart in emphasis, atmosphere and furnishings. What remains similar is the restaurant as a friendly and relaxed meeting point. Blunck's and Passini's paintings both show food's role of social gatherer,

102 Ludwig Johann Passini, *Artists in the Caffe Greco, Rome* (*c.* 1850), watercolour on paper. Hamburger Kunsthalle.

consumption as a means to encourage communal relationships, both large and small. Indeed, many eating pictures are about inter-relationships of people more than they are about food per se.

Food and its setting, as many novelists have shown, can reveal the background, attitude, ideals and emotions of a character or event. Just as a *pronk* still-life by Dutch seventeenth-century artists, filled with expensive goods, alludes to the social, economic and cultural character of the patron, so too the kinds of restaurants represented by artists help to describe the figures shown. Both sorts of painting, in a sense, come together in Picasso's *Tavern* of 1913–14 (illus. 103), where a restaurant still-life appears. The artist depicted the solid simple fare, menu card, tableware and other fragmentary details of a cheap Paris eatery and bar. The fragrant details call forth a particular urban, bohemian milieu.

The aristocratic eating scenes in private residences, already discussed, presented a progression toward wider social inclusiveness; the portrayal of the power of individuals gradually became the portrait of a group. Restaurant pictures particularly concern this social function. Restaurants may be open to all, but they usually attract specific kinds of people. Restaurants as well as private parties at home cater to individuals of common interest, economic level, profession and social standing. Still, restaurants usually facilitate human interaction, and work against solitude. In painting, there are few more potent ways of expressing loneliness and

existential angst than isolating a diner or drinker in a restaurant milieu, as Edvard Munch's self-portrait of 1906 in that very situation clearly shows (illus. 71). The alcoholic Norwegian painter sits pathetically in a restaurant with nothing in front of him but a bottle, a glass of wine and an empty plate. No one else appears, save waiters, very small and distant from Munch. The artist comes to a place of sociability, but finds himself alone. Van Gogh's implied separation from other people in his Arles restaurant painting (illus. 99) sets forth a similar story more subtly.

Part of the despair and loneliness of van Gogh's and Munch's scenes of restaurant isolation stems from the restaurant's function as a meeting point for lovers. The restaurant frequently serves as a preliminary to love-making. Spang's analysis shows that restaurants in the eighteenth century quickly acquired an association with sexual liaisons and encounters, with private rooms for seduction, adulterous assignations and places for prostitutes to ply their trade. The socializing facet of the restaurant could take on a sexual glare. Edouard Manet's *Chez Père Lathuille* (illus. 104) shows a couple engaged in ardent conversation – a perfect coupling of love

103 Pablo Picasso, *Tavern* (1913–14), oil on cardboard. State Hermitage Museum, St Petersburg.

104 Edouard Manet,
Chez Père Lathuille
(1879), oil on canvas.
Musée des Beaux-Arts,
Tournai.

and food, public and private. On the whole, the erotic aspects
of the restaurant tend, like the sexuality of the market scene, to
enhance the air of pleasure, to reinforce the lusty nourishment of
food in general. But in the case of *Chez Père Lathuille*, Manet's
unsentimental attitude arises. The coffee is about to be served by
the waiter in the background, and thus the end of the meal is
signalled. But the love life portrayed in the foreground has not
been brought to completion. The young man does not seem to
have yet conquered his lady, and the end of the meal metaphori-
cally announces the end of the liaison.[30] Manet's painting also
illustrates the public privacy of the restaurant. The intimacies of
lovers play out in broad daylight in front of everyone in Paris.

One more nineteenth-century restaurant picture, Jean Béraud's
representation of the Patisserie Gloppe in Paris of 1889 (illus. 105),
further indicates the variety of establishments that might be called
restaurants and the varied etiquettes that operated in such places.
The Patisserie Gloppe was a speciality store, offering pastries of

105 Jean Béraud,
*La Patisserie Gloppe
on the Champs-Elysées*
(1889), oil on wood.
Musée Carnavalet,
Paris.

course, but also alcohol, as Béraud's picture clearly shows. It is
really a kind of bar. But unlike the Caffe Greco, the clientele are
mostly women and children. The specific speciality food offered
has its own manners. The patrons eat with their fingers. No
utensils are apparent, and the informality carries over into other
aspects of this restaurant. The tables have no cloths, and patrons
can eat standing up – not just at the counter, but in the middle of
the restaurant, near neither bar nor table – with a plate in their
hands, buffet-style. The clothes of the clientele reveal that the
figures are well-to-do. The patisserie was evidently the family
sweetshop of wealthy Parisians, and the manners displayed show
not vulgar actions, but the refined approach to such food.

In the twentieth century, Edward Hopper produced some of the
most compelling restaurant paintings, many of which exhibit his
habitual taste for scenes of alienation. One of his most famous
works, *Nighthawks* of 1941 (illus. 106), lights up a modern all-
night diner in the midst of a dark city, only to deflate this island of
communality with non-communicating figures and great blank
spaces. Hopper's wife Jo described the diner as 'cheap' and the fig-
ure at the left as 'sinister', and several commentators have linked
what they see as a picture of impending doom to van Gogh's *Night
Café* (1888; Yale University Art Collection, New Haven), which
the Dutch artist described as a painting of hell.[31] The coffee served

in Hopper's painting adds yet another touch of irony. This beverage tends to signify togetherness, communality, relaxed give-and-take and conversational warmth – all that one fails to find in his images.

Hopper's harrowing *Automat* (illus. 72) is a more extreme version of the same vision, placed in the newest of eating houses, the Automat in New York. The patron purchased the food by means of what would now be called vending machines, little metal compartments on the wall, which opened when coins were inserted. The whole affair seemed people-less – perfectly suited to Hopper's view. The receding lights and broad space reflected in the dark restaurant window make the woman even more lost in the middle of nowhere, with just a pathetic radiator to talk to. The fine fruit in the bowl behind her, ironically, are not to be eaten. They are a window display, and probably made of plaster or plastic or *papier mâché*.

In 1971 Richard Estes produced a photorealist painting of an American diner that well illustrates the bitter tone of Postmodernism (illus. 150). The gleaming aluminium eatery displays the period's chic appreciation of Art Deco style – an ironic taste for 'old-fashioned modern' – a style once sleek and progressive that had become quaint and campy. Estes's diner shows no people, no food, no friendliness. It takes a step further into emptiness than Hopper. Telephone booths in the foreground,

106 Edward Hopper, *Nighthawks* (1941), oil on canvas. Art Institute of Chicago.

107 Richard Estes,
Diner (1971), oil on
canvas. Hirshhorn
Museum and Sculpture
Garden (Smithsonian
Institution),
Washington, DC.

furthermore, obscure much of our view of this restaurant, and,
in tune with the rest of this cityscape, these devices of communi-
cation are empty, unused. There is no gathering together for
social delight in Estes's luncheonette. The glittering surfaces of
the scene all appear false and tawdry. This development started
in the 1960s with Pop Art. But whereas Warhol, Lichtenstein
and Thiebaud mocked traditional food imagery with jabs of fun,
Estes and other artists after 1970 offered no amusing embrace of
new foodstuffs or modern life. They presented only numbness.[32]

Estes's diner, Munch's lonely drinker, van Gogh's restaurant in
Arles and the two Hopper images all fly in the face of the over-
whelming majority of food paintings in their unhappiness, in their
lack of satisfaction. But in these 'ironic' food pictures little food is
shown. If Hopper and the other artists had piled up succulent edi-
bles for the customers, the effect would be different. The lesson is:
if the aim is to express despair in a food context, leave out the food.

The restaurant remains one of the few places today where a per-
son of modest or even strained means can experience the luxury of
servants. The restaurant waiter or waitress, like the aristocrats who
attend the duc de Berry (illus. 67), offers deference. Those serving
in the restaurant paintings discussed above play their parts with
varying degrees of dedication. The waiter in Manet's *Chez Père*

Lathuille (illus. 104) stands respectfully at attention. La Gensola's waiter in the middle of Blunck's painting (illus. 101) stands so informally that he might even be one of the artist guests. The Caffe Greco's barman too appears friendly rather than deferential, chatting with clientele. Munch's waiters will never serve him. And Hopper's counterman looks at his nighthawks with a wary glance – like a convenience-store clerk with some tough customers. The restaurant sells respect and rank and obedience, but these paintings tell us that we don't always get what we pay for.

As far as servant pictures are concerned, restaurant waiters differ from scullery maids and other kitchen help in that they interact directly with the diner – and publicly offer respectful subservience – as in Caravaggio's innkeeper at Emmaus (illus. 96).[33] Nicolaes Maes's seventeenth-century kitchen pot-cleaner (illus. 59), fast asleep, exhibits an amusing slothfulness, and presents her mistress with the occasion to express the it's-so-hard-to-get-good-servants-these-days attitude of superiority. Maes painted his lady of the house in the act of addressing the viewer – she complains with a wry smile directly; she is not alone with the servant. In order to make her elevated position known, she must have an audience. A restaurant, that public–private realm, presents that necessary audience and an arena for what should be a soothing, flattering relationship of master and servant.

PICNICS

The English word 'picnic' (like the French *pique-nique*) does not distinguish between table-laid dining out of doors and dining out of doors on the ground – on either cloth or grass. But there is a fundamental difference. Paintings of dining at a table in the open air, at least before the eighteenth century, represent the normal conception of a meal – untied to any permanent site. Before dining rooms became common in the eighteenth century among the wealthier classes, eating took place at a moveable and collapsible table, and anywhere it was set up became the dining area. Eating out of doors merely represented the pleasures or necessities of the warm season – it was not a special kind of meal.

Sandro Botticelli's series of four paintings of 1483 that depict Boccaccio's tale of Nastagio degli Onesti includes a scene of outdoor dining (illus. 108). The painting primarily concerns a dramatic story of love, parapsychology and eternal torment. The young man called Nastagio, whose offer of marriage has been rejected by the woman he loves, wanders disconsolately through a forest when

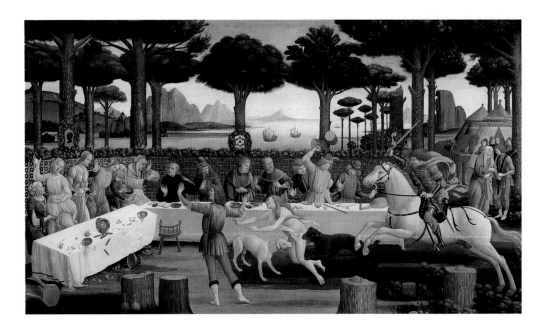

he sees a vision of a woman chased and killed by a hunter and his
dogs. Nastagio recognizes the vision as the recurrent punishment
that awaits any woman who rejects her faithful lover. He arranges
an outdoor banquet in the forest and invites his beloved. The same
vision appears to all those present, and, at the urging of Nastagio,
the woman accepts his offer of marriage.

Botticelli, of course, focused on the violent vision that interrupts
the banquet, and the amazement of the guests. But in illustrating
the tale he nevertheless provided a glimpse of elegant outdoor
dining in the early Renaissance. An L-shaped arrangement of cloth-
covered tables hugs the perimeter of the forest clearing. Heraldic
decorations adorn the trees, and a beautiful woven screen surrounds

108 Sandro Botticelli,
*The Story of Nastagio
degli Onesti*, (1483)
panel three, tempera on
panel. Museo del
Prado, Madrid.

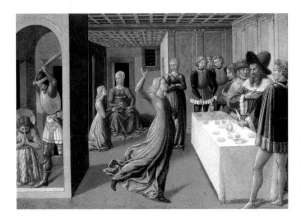

109 Benozzo
Gozzoli, *Feast of
Herod* (1461–2),
tempera on
panel. National
Gallery of Art,
Washington, DC.

the diners. They sit in what may be called an outdoor room – a partially enclosed man-made space, still part of nature. A stool and low-backed chair are also visible. Tents in the right distance evidently provide an area for the meal preparation. Despite the upset of the drama, we can discern a lute for the aural delectation of the diners, and some unidentifiable food served in small bowls, placed sparsely on the tables.

There is very little difference between this outdoor banquet and the indoor meal depicted by Benozzo Gozzoli in his representation of the *Feast of Herod* (illus. 109) – just the setting changes. In these two fifteenth-century dining scenes, long tables parallel the walls of the eating space; white cloth covers the boards on trestles; benches or low-backed chairs provide seating; and the food appears in small, widely separated individual bowls and trenchers. Small loaves of bread rest directly on the tablecloth. Herod occupies a central place at the table, and the eldest and most regally dressed male in Botticelli's picture does likewise. The latter also sits beneath a heraldic device, which further distinguishes his position, serving a similar purpose to a cloth of honour. A lower-class variant of the same idea can be seen in Bruegel's *Peasant Wedding* (illus. 110), where a cloth hangs behind the centrally placed bride. The Limbourg brothers cleverly portrayed the duc de Berry in front of a great fireplace screen, which functioned to isolate and honour the noble host of the banquet (illus. 67).

No throne-like seat distinguishes the chief male figure in either of these two fifteenth-century meal pictures. Not even Christ sits on such a chair in most Last Supper scenes. One eater of roughly the

110 Pieter Bruegel the Elder, *Peasant Wedding* (*c.* 1568), oil on panel. Kunsthistorisches Museum, Vienna.

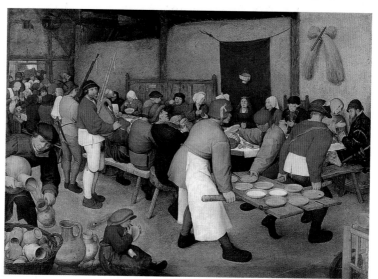

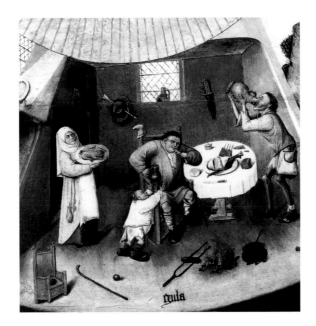

111 Hieronymus Bosch,
Gluttony, from the
*Seven Deadly Sins and
the Four Last Things*
(*c*. 1485), oil on panel.
Museo del Prado,
Madrid.

same period who does occupy a grandiose throne is the gross figure
who represents Gluttony in Hieronymus Bosch's depiction of the
Seven Deadly Sins (illus. 111). The fat glutton gobbles his food in
a carved high-backed chair – pointedly similar to the potty chair in
the foreground, thus emphasizing the crudity of his desires and
actions. The thrones here are ironic, signs of rank that outdo any
king or Christ himself while dining; it is a falsely aggrandizing
touch. Bosch's sinner is also one of the few eaters in Western paint-
ing to put food directly into his mouth – a suitably repulsive display
to condemn the man. The glutton's cooking fire rests on the floor
near his dining table. In the paintings by Gozzoli and Botticelli, no
such fires appear, and whatever cooking was done was evidently
not near the banquet areas. Kitchens of the time tended to produce
smoke and noise and unpleasantness, and respectable diners kept
far away. The fire in Bosch's painting might illustrate the glutton's
necessity to eat quickly, but more probably it indicates the humble
cottage life.

Outdoor eating at tables in later centuries continued the same
reiteration of indoor meals – for all classes. Willem Buytewech's
Merry Company in the Open Air (illus. 112) of 1616–17 replicates
the atmosphere and dissolute figures of this artist's well-known
indoor scenes of lolling dissipation.[34] The dandies and gaudily
dressed prostitutes, discarded musical instruments and exotic pets of
his rich interiors merely move outdoors. The food of this sophisti-
cated company includes a large peacock with upraised wings (as an

ostentatious centrepiece), trenchers, several salts and, of course, drinking vessels – which together describe a scene of wealthy debauchery. Food and sex and indolent enjoyment flow together in this image. The setting acts as little more than a change of wall-paper. These diners hardly move into nature. The cloth-covered table and the merry-makers stay within the confines of the portico of some grandiose house. The landscape beyond, with antiquated architecture and arched trees, resembles an artificial stage set. It is just a backdrop.

Lancret's painting of a luncheon in a park (illus. 78) presents an eighteenth-century version of Buytewech's subject. The table and figures similarly remain within a man-made environment – walls, gazebo and a huge urn serve to make the park as little like raw nature as possible. His figures are more uproarious than Buytewech's – in fact, they are roaring drunk, clambering onto the table, splashing the wine, etc. The nonchalance of the Baroque has descended into comic Rococo dishevelment. The broken dishes and empty flasks in the foreground immediately give us a message of wild inebriation.

But Lancret, unlike Buytewech, adds a note of criticism. The fig-ures in the left background seem to look askance at these wealthy indulgents at the table. Indeed, the ham in the centre of the table might refer not only to the proper sort of cold food for a drinking party (salty and easy to handle), but also to the pig-like character of the participants. Critical or not, Lancret's painting hardly damp-

112 Willem Buytewech, *Merry Company in the Open Air* (1616–17), oil on canvas. Staatliche Museen, Berlin.

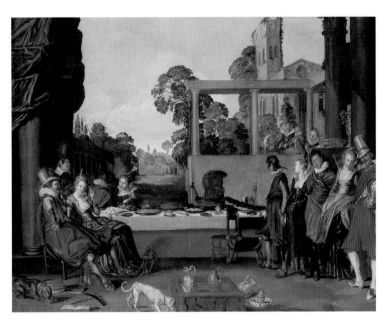

ens the anarchic delight of this vision of food and drink – it belongs to a tradition of illustrating the joys and stupidities of drunkenness that goes back at least to the ancient Greeks. Drinking is such a large subject that it deserves a separate study, but beverages cannot be entirely ignored in this book; they are the critical accompaniment – and often the main feature – of a great deal of food imagery. In Lancret's painting, there is little interest in the meal – it is just an excuse to drink, or a metaphor for the drinkers.

In paintings of lower-class eating out of doors at tables, a *kermesse* or dance usually provides the occasion – and it is usually a large group endeavour. Paintings by Pieter Bruegel the Elder (*c.* 1568; Kunsthistorisches Museum, Vienna) and Peter Paul Rubens (*c.* 1636; Louvre, Paris) established the type – showing a landscape or square with rollicking figures drinking, dancing, feeding and making love. Eating outdoors in such works stems from the impossibility of finding any indoor space large enough to accommodate the throng. The tables in these paintings provide some sense of stability amid the debauchery. Artists such as David Wilkie and Adam Wolfgang Toepffer carried the tradition into the early nineteenth century.[35] But the common people's open-air fairs and celebrations became more sedate and sober in their hands, and in the works of artists who came later. By the time of Albert Auguste Fourie's painting of a working-class outdoor wedding feast of the 1880s (illus. 91), the formerly wild and indecent people look positively refined and wholesome. Common folk have become figures of reserve and pleasant decency. The table provides some sense of decorum in eating in the open air, but the people do not seem to need any help. The table out of doors in any case declares that nature is no more than a room defined by mankind – and the appurtenances of normal dining can be placed anywhere.

Eating on the ground seems different. It can be a sign of poverty or a majestic vision of social grace and privilege, but it inevitably situates the diners in the landscape more powerfully than any table-centred meal. The diners consume their food in unaccustomed postures, free of the restrictions of rooms and furniture, and must address themselves directly to grass and trees and rocks and soil. Pieter Bruegel the Elder in the mid-sixteenth century showed peasant harvesters eating their midday meal on the ground (Metropolitan Museum of Art, New York). But the meal on the ground does not have to be a thing of peasant life. The ground-bound meal, the true picnic, has its origins, so it seems, in the hunt. During a day of sport, the hunters must take refreshment. It was common to take a break from the action informally, eating fine delicacies on grass or cloth. Carle van Loo's *Halt in the Hunt*

113 Carle van Loo,
Halt in the Hunt
(1737), oil on canvas.
Musée du Louvre,
Paris.

of 1737 exemplifies the genre (illus. 113). The elegant sporting
folk sample ham, rabbit, meat pie and wine. They balance porce-
lain plates on their laps, as servants unload the hampers. For all
the refinement of the costumes and manners, the eaters get close
to the natural world, on a level with their dogs, and use fork and
knife while seated on the ground. The equivalent class association
and sensibility in the twentieth century would be the après-ski
party: wealthy skiers lounging in alpine cabins (or imitation alpine
cabins on the grand hotel's property), refreshing themselves and
socializing after a day of vigorous and expensive sport.

Claude Monet's *Déjeuner sur l'herbe* of 1865 (illus. 89) typifies
the nineteenth-century, middle-class picnic – urbane and sophisti-
cated, but divorced from the hunt. The fashionably dressed figures
are not like the menial labourers in Courbet's *Stone Breakers*
(1849; destroyed), who toil in the countryside with a lunch bucket
nearby. Monet's people do not live in the country, or labour at all.
For these Parisians, a picnic represents a cooling escape from the
city, a plunge into nature's delights – no matter how short-lived
or buttoned-up. They drink wine from crystal glasses, feast on
gourmet meat pies and roast fowl, and wear fine garments, but
still manage to unwind and lead the simple life, lounging on the
ground, removing jackets, gathering informally. The title *Déjeuner
sur l'herbe* deliberately reiterated that of Manet's controversial

painting of 1863 (Musée d'Orsay, Paris). But Manet's meal in the woods included a seated nude among the modern picnickers. The nude was a burlesque of the Arcadian themes of traditional art, and mocked the idea of the nude itself as an aesthetic subject. Monet's picnic leaves out the tendentious nude. But his picnic also presents an updated realist rendering of what can be considered an Arcadian or pastoral cliché of literature and art. In strictly modern terms, Monet recalled those eternal visions and stories of man in harmony with nature, bathing in the woods, delighting in simple physical pleasures in nature, casting aside the artificialities of town life. He made Arcadia mundane, modern, fashionably clothed and believable. He avoided Manet's satire and retained a touch of the freedom, naturalness and appreciation of earthy beauty associated with Virgil, Titian, Claude and Pope in their various celebrations of the pastoral ideal.

Monet's picnickers, however, are closer to the privileged huntsmen of van Loo (illus. 111) than they are to the piping shepherds of the ancient world. They use fine china, and evidently acquired their food from Parisian caterers rather than from country ovens.

James Tissot's *Holiday* of about 1876 (illus. 128) reveals an artist very much aware of the works of Manet and Monet. This Frenchman in Britain reworked the Impressionist picnic with a tighter style and an English accent. The setting is more civilized than Monet's – a park rather than woods – with a colonnaded pond and neat walkways. It is a garden rather than raw nature. But the elegant recreants lounge on the ground or lean indolently this way and that. Food lies on a simple cloth, and the beauties of autumn plants and air and light create a stunning portrayal of polite delight. Torpedo bottles of aerated mineral water (often called Hamiltons in England) and the fashionable Japanese-style tea articles (all the rage in the 1870s) speak of non-alcoholic pleasures. The men's casual wear (including the banded, brimless caps) and the women's patterned gowns represent the height of high style. It is afternoon tea, with appropriate cakes and sweets. Cream is poured into a proffered cup of tea, and a chaperone quietly keeps watch over these indolent young people of money and sophistication. They take their refreshment, as the title states, during a holiday – a break from the workaday world. This notion of a breather, a halt in normal activities to recover one's well-being, was central to the hunt picnic, and to the Arcadian picnic, and to all picnics, where lunching out of doors in nature represents a change from city life. Tissot brilliantly captured the qualities of relaxation: the bent wrist of the right-most young woman, and

the tilt of her upper body; the sprawl of her neighbour with head upheld by delicate hand; the tea-pouring girl who kneels; and the men in the background who epitomize standing at ease. Picnics on the ground, like seventeenth-century Dutch still-life, present a lolling atmosphere, a note of disarray.

The food responds to the general nonchalance. The torpedo bottles flare out. The cake has been cut, but not eaten. The tea tray sits at an informal angle. The teapot has been removed from the tray. There is no rigid order here, as the chestnut leaves dip and creep through the upper zone of the painting as in a Japanese screen. Tissot's painting appears less rigid and 'composed' than Monet's.[36]

All these pictures serve as more than mere justifications for an outing. The meals make the trip into nature a social event. They are not lonely repasts to accompany individual meditations; they are group activities. The food acts as a congenial gathering point.

John Sloan's *South Beach Bathers* of 1907–8 (illus. 44) transfers the woodland meal of the nineteenth century to the American seaside – a testament to the increasing attraction of saltwater swimming and beach culture in general as a holiday activity. Before the mid-nineteenth century, when artists such as William Powell Frith and Claude Monet painted beach vacations, few holidaymakers ventured to the sea. In earlier decades the well-to-do either visited cities or resorted to inland spas such as Bath, and the lower classes had neither the time nor the money to go anywhere. Places such as Brighton, Blackpool, Deauville, Trouville and Nice grew into hotel-cluttered resorts only in the later nineteenth century. Sloan's beach scene on Staten Island in New York City is a working-class outing, and, more than the clothes or manners, the food identifies the social level. These city folk eat hotdogs, the inexpensive common fare of common people's pleasure grounds. The food forms the centre of the group. Food functions as an instrument of human interaction.

Like Fourie's wedding celebration (illus. 91), Sloan's painting gives the working class a dignity and gracious nonchalance foreign to most pre-nineteenth-century depictions of lower-class persons. Bruegel's peasants and Murillo's beggar children (illus. 110, 33), among others, appear coarse, amusing or stupid – at best pretty and mostly worse. (Horemans's eighteenth-century painting of a cook, illus. 56, is an exception.) For Sloan, a member of the Ashcan School, the lower-class subject, no matter what the artist's political leanings may have been, represents realism, as noted already with regard to the still-lifes of Monet and Harnett. Sloan's sympathetic portrayal of working-class fun did not lead

him to ignore the unseemly aspects of etiquette. By the time of Sloan's picture, eating solely with one's hands, as these figures do, was a sign of impolite society, and eating without any plates or napkins at all only heightens the unaffected character of the image.

In these paintings, most picnickers seem to be city dwellers who indulge in country meals as a relief from their man-made environments. The picnic subject affords the artist a field where man and nature interact playfully. Nature provides a refreshing ambience, but never impinges on the unnatural requirement of man. Food fits well into this artificial / natural scheme. Man only pretends to re-enter nature, and protects himself with cloth, metal, ceramics and caterers' creations. Food stems from the natural world of living things, but man transforms it into dead matter, and imports it back into nature during a picnic. The meal during the hunt, the source of the picnic concept, adds another layer of man / nature complexity. In the hunt, man seeks out game in nature, an ancient task of food gathering that became sport. But man halts during this harvesting of nature to eat food he has brought from his artificial home. The issues of fetishism rise up mercilessly in the very idea of a picnic.

The picnic stands as the ultimate vision of the artificiality of the natural – and the view of Tissot's holidaymakers (illus. 82) picnicking not in the bosom of nature, but in a garden, which is a natural landscape created by man, redoubles the doubtfulness of the whole endeavour. The picnic subject itself deals with these basic issues of the real and the artificial. At its core, it exposes the problem of realism in art. Exactly what does it mean to represent reality in paint, and how artificial or natural are humans anyway?

COFFEE, TEA AND CHOCOLATE

The kinds of meals that most encourage a relaxed tone, in addition to picnics, are light refreshments outside the main repasts of the day. The most common of these occasions is the taking of coffee, tea or chocolate. Coffee as a meal-closer has already been mentioned. Its function as a separate episode of consumption similarly asserts quiet satisfaction. Silvestro Lega's *The Pergola* of 1868 (illus. 114), for example, happily illustrates the informalities of tea time or coffee time in the table-less open air. The subject here has a domestic setting and an exclusively female cast. Lega suggested the refreshing effects of the beverage by placing the ladies of the house in the shaded arbour, opposed to the bright heat beyond, and in contrast to the sunlit servant with teapot. He perfectly described

114 Silvestro Lega, *The Pergola* (1868), oil on canvas. Pinacoteca di Brera, Milan.

summer détente in addition to the prerogatives of a well-staffed household.

Coffee, tea and chocolate first spread through Europe in the seventeenth century. Pope Clement VIII drank his first cup of chocolate in 1594, but Madame de Sévigné in 1671 still referred to chocolate drinking as a new fad. The earliest coffee house in Italy opened in 1645, in England in 1652 and in Paris in 1672. The first sale of tea in London occurred in 1657, and Catherine of Braganza introduced this Chinese drink to the English court in 1662. All three drinks counted as powerful drugs in their early years in Europe, and at times could be afforded only by the wealthy. Taxation rather than rarity or difficulty of transport usually caused the high cost. The extravagant British tax on tea led to the Boston Tea Party of 1773, and ladies of the period kept their tea locked up in tea caddies.[37] The ebony chest with key in Antonio de Pereda's painting of chocolate of 1652 (illus. 4) probably served a similar purpose.[38] This early European depiction of the New World drink was naturally produced in Spain, where cocoa had been shipped from Mexico in large quantities since 1586 (Cortez had brought some back to Spain from the Aztecs in 1527). In Pereda's cozy still-life, the chocolate accompanies not only some colonial Mexican pottery, but also a jar of water – a regular follow-up to the often bitter brew. More than a hundred years later, Jean Etienne Liotard's lovely *Chocolate Girl* (illus. 115) serves the same drink with an identical water chaser.

Like Pereda's painting of chocolate in a beautiful safe, Johann Zoffany's portrait of John, Lord Willoughby de Broke, and his family at tea (illus. 135) proudly expresses expensiveness. Zoffany painted it *circa* 1766, when high tariffs on tea were enacted, or about to be enacted, and he made the favourite English refreshment a rather grand affair. The finest porcelain and a magnificent silver tea water urn create a sumptuous tribute to lordly wealth and taste. And just to indicate that riches and privilege are no excuse for indulgence, Lord Willoughby de Broke reprimands his son for grabbing a piece of buttered bread. Morality and education as well as pride come into play in this work.

The high-class associations of coffee, tea and chocolate did not continue into the nineteenth century. Even van Gogh's peasant potato eaters could afford coffee in the 1880s (illus. 39). What may have continued to play a part, however, is a certain moral tone, because, among other things, coffee, tea and chocolate were all alternatives to alcohol. The early literature on all three brews continually draws a contrast with alcoholic beverages. Montesquieu, in condemning coffee houses as breeding grounds of political sedition, claimed that even the drunkenness of taverns would be preferable.[39] The comparison was inevitable. And although accusations of political plotting in coffee houses recurred (with some justification) over the centuries in various countries, coffee represented a beverage of thought and reason, rather than drunken revelry. There are no paintings of wild dissipation among tea drinkers, or chocolate fanciers, or coffee-house addicts. Lancret's jolly luncheon mates drink wine, not tea or coffee (illus. 78) – and the results are amusingly plain. Lega's pretty ladies of the house (illus. 114), in turn, do not get drunk in the afternoon, but take a more gently conversational drink.

The typical mood and also the origins of coffee appear in Constantin Hansen's cozy scene of Danish artists in Rome in the 1830s (illus. 116). The men relax in a painter's studio, savouring coffee and long Near Eastern pipes – a sign of coffee's source in that region. And the headgear and position on the floor of several of these artists further alludes to the Near East. There may indeed have been a fashion for such smoking instruments and clothes at the time, and even perhaps sitting on the floor instead of chairs – but this would probably have been a bohemian fad rather than a mainstream taste. In any event, the accoutrements of coffee and the coffee itself speak here of delicious indolence and other physical delights associated with Islamic culture. The West repeatedly linked the Near East to un-Christian notions of complete material indulgence.[40] Coffee was one signifier of that

115 Jean Etienne
Liotard, *The Chocolate
Girl* (1743–5), water-
colour on parchment.
Gemäldegalerie,
Dresden.

116 Constantin
Hansen, *Danish Artists
in Rome* (1837), oil on
canvas. Statens
Museum for Kunst,
Copenhagen.

mythic vision. The connection of coffee to the Near East enhanced
the drink's associations with listless, easy, friendly and meditative
sociability. Hansen's artists may be half play-acting, dressing up
and pretending to be Arabs, but they also effectively display the
perception of coffee drinking at the time.

Henry James in the opening of *The Portrait of a Lady* (1881)
perfectly expressed in words the similar meaning of tea – as a
moment of quiet satisfaction that evokes particular environs,
time of day and dawdling contemplation:

> Under certain circumstances there are few hours in life more agree-
> able than the hour dedicated to the ceremony known as afternoon
> tea. There are circumstances in which, whether you partake of the
> tea or not – some people of course never do – the situation is in
> itself delightful. Those that I have in mind in beginning to unfold
> this simple history offered an admirable setting to an innocent
> pastime. The implements of the little feast had been disposed upon
> the lawn of an old English country-house, in what I should call the
> perfect middle of a splendid summer afternoon. Part of the after-
> noon had waned, but much of it was left, and what was left was of
> the finest and rarest quality. Real dusk would not arrive for many
> hours; but the flood of summer light had begun to ebb, the air had
> grown mellow, the shadows were long upon the smooth, dense

turf. They lengthened slowly, however, and the scene expressed that sense of leisure still to come which is perhaps the chief source of one's enjoyment of such a scene at such an hour. From five o'clock to eight is on certain occasions a little eternity; but on such an occasion as this the interval could be only an eternity of pleasure. The persons concerned in it were taking their pleasure quietly, and they were not of the sex which is supposed to furnish the regular votaries of the ceremony I have mentioned. The shadows on the perfect lawn were straight and angular; they were the shadows of an old man sitting in a deep wicker-chair near the low table on which the tea had been served, and of two younger men strolling to and fro, in desultory talk, in front of him. The old man had his cup in his hand; it was an unusually large cup, of a different pattern from the rest of the set and painted in brilliant colours. He disposed of its contents with much circumspection, holding it for a long time close to his chin, with his face turned to the house. His companions had either finished their tea or were indifferent to their privilege; they smoked cigarettes as they continued to stroll. One of them, from time to time, as he passed, looked with a certain attention at the elder man, who, unconscious of observation, rested his eyes upon the rich red front of his dwelling. The house that rose beyond the lawn was a structure to repay such consideration and was the most characteristic object in the peculiarly English picture I have attempted to sketch.

Quiet meditation and friendly relaxation cling to tea, coffee and chocolate. These associations are as important as their earlier high-class associations. Van Gogh portrayed peasants drinking coffee not just because it would have been a common sight at the time. Van Gogh, the socialist-like supporter of the poor, wanted to defy the artistic traditions of representing peasants as wild, drunken louts. He wanted to work against the indecent picturings of Jacob Jordaens and Jan Steen (illus. 81, 97), and he showed these lower-class folk as grave, sober and thoughtful – by showing them with coffee. Coffee also served the purpose of making the peasants seem bound together by friendship, a vision of amicable solidarity.[41]

Even Picasso in the fragmentarily allusive and disarranged art of Cubism dwelled on the restful and amiable mood of coffee. In a collage of 1913, *The Cup of Coffee* (illus. 117), he evoked 'café' as both drink and place. He half spelt out the word with a 'c' and an 'E' functioning perhaps also as door and doorknob to enter such an establishment. The tile-like collage pattern at the right side of the picture seems to suggest not only the floor of a café but

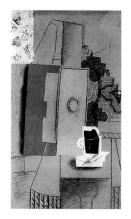

117 Pablo Picasso, *Cup of Coffee* (1913), collage. National Gallery of Art, Washington, DC.

also the aromatic steam rising from the cup of coffee. The drawn curves on this fragrant cloud of patterning further indicate vapour moving upward. The wallpaper collage at the upper left describes the wall decoration of the café, while the rope moulding at the bottom of the picture defines the decoration of the table on which sits the stable and charming cup of very dark coffee. The scene might appear lonely. Only the viewer can savour the coffee. But the handle of the coffee cup is on the left, which implies that, unless one is left-handed (and Picasso was not), the coffee cup stands before someone on the other side of the table, facing the viewer. Picasso thus suggests the gregariousness of coffee drinking, its function as a softly pleasant social glue.

The thoughtful and inactive air of tea, coffee and chocolate can also be seen in a late eighteenth-century portrait of a tea set by Jean Etienne Liotard (illus. 118). Here, an afternoon snack has ended, and Liotard presented his warm beverage unusually – from the servant's vantage. It is an oblique view. We learn of the petite meal from its remnants. In a somewhat similar vein, Liotard showed a servant carrying chocolate (illus. 115) without illustrating the receiver of this delicacy. The artist seems as subtle as his contemporary, Chardin. In the still-life painting, Liotard depicted the remains of tea on a tray as it would be seen by the maid in charge of cleaning up. The beautiful and expensive porcelain tea service, imported from the Far East, is lively but desolate. The silver spoons and several teacups lie deranged and upset. The tea takers were evidently not famished, because some bread remains –

118 Jean Etienne Liotard, *Still-life: Tea Set* (1781–3), oil on canvas mounted on board. J. Paul Getty Museum, Los Angeles.

and a nearly full bowl of sugar lies beneath a pair of elegant tongs. The typical sense of abundance and repletion associated with food paintings thus appears here too – but by inference only. We are invited to appreciate the image forensically, reading the tell-tale details of what transpired. Apparently only three people had a snack; three others either failed to arrive or the host merely prepared for the possibility that other guests might arrive. The three upside-down cups, lying neatly in their saucers, each accompanied by a spoon, were evidently unused. That is how they were originally served, bottom up, to keep dust or other foreign substances from the drinking vessel. The used cups lie this way and that, upturned and with spoons resting in their hollows. Some of them are partially filled with tea. No people are present, but we know of their presence and can perceive an artistic substitution. The Chinese figures painted on the chinaware, standing and seated in scenes of pleasure, act like stand-ins for the European tea drinkers. They act like flashbacks. The toleware tray, metal spoons and bread tell us that we are in the West, not China. And Liotard, who had lived in exotic lands – Turkey and Greece – loved to mingle East and West, painting European ladies and himself in oriental garb, or giving Western items and scenes an Eastern flavour.

In this painting, one of several pictures of tea and coffee sets that Liotard produced late in life in Geneva, food, or rather drink, appears largely by implication. We come to realize how distinctly identifiable are the containers and serving utensils of particular foods and beverages. Only tea could have been served with the objects represented. In many cases it takes only a half-seen item in a painting to portray a specific food or time of day or set of circumstances.

This is apparent in a Cubist work of 1915 by Juan Gris, *Breakfast* (*Le petit déjeuner*) (illus. 119). Apart from its use at the finale of a meal, and as a separate refreshment during the day, coffee also functions as the identifying drink of breakfast – that modern meal, which only became significant in the eighteenth century and gained distinctive attributes in the nineteenth. Tea reigns today as the morning beverage in Britain and in some of its former colonies, but for most of Europe and America coffee is the eye-opener of choice. 'Wake up and smell the coffee' is a current American imperative phrase that means 'open your eyes and look what's going on'. The combination of coffee and wake-up time reveals how closely coffee and the first meal of the day are connected in the modern American mind. Whether breakfast is 'Continental', consisting of coffee and a roll with butter and jam, or a full American affair, evolved from nineteenth-century English

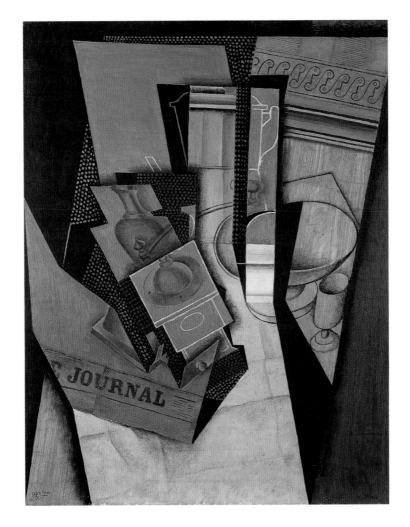

119 Juan Gris,
Breakfast (1915),
oil and charcoal on
canvas. Musée National
d'Art Moderne, Paris.

practice, with eggs, bacon, sausage, toast, cereal, juice, potatoes and other heavy items, coffee remains the liquid accompaniment.

It is unclear whether the artist, a dealer or a museum curator devised the title of Gris's painting. But the Cubist image was surely called *Breakfast* because of the coffee items represented. A coffee mill, with crank and open drawer, is clearly visible, as is the profile of a home coffee-maker. The empty compotier and wine glass do not immediately signify breakfast, but the coffee does. No matter what Gris may have intended (and he could very well have conceived his image as an afternoon picture or merely a formal arrangement of some of his familiar Cubist café objects), the coffee elements determined the title that the work bears today in the Musée National d'Art Moderne in Paris. Coffee means the

start of the day, especially when one grinds the beans oneself, puts a homely coffee-maker on the table and reads a newspaper – as presented in Gris's picture. Cubist images, playing representation against abstraction in a sometimes difficult-to-read manner, often rely on small visual or verbal clues to signal the subject of the work. A fragment of a glass, a playing card, or a curtain cord, is enough to hint at what is depicted. The Cubists gave careful consideration to their naturalistic allusions, and Gris's coffee items automatically suggest the mind and mood and situation and meanings of breakfast.

The dallying folk in Buytewech's scenes (illus. 112) drink alcohol – and so too do other sexually excited people linked to food and drink in art. One rare amorous caffeine painting is a turn-of-the-century image by the Belgian artist Leon de Smet – *Interior* (illus. 120). There, a couple kiss rapturously as tea items sit on the table. Even in this image, however, the lovers embrace on a couch quite distant from the beverage. The relation between the hot drink and the hot activity remains uncertain. The couple may not have even begun to take their time over warm infusions. To make matters even more ambiguous, the man and the woman are placed next to a small copy of a famous statue – George Minne's *Youth* (1898). Minne's sculpture epitomizes isolated self-absorption; it presents a narcissistic boy of emaciated sadness and non-communication, and really makes us doubt the togetherness of the adjacent couple.

120 Leon de Smet, *Interior* (1903), oil on canvas. Museum voor Schone Kunsten, Ghent.

Caffeine drinks seem to dampen licentious behaviour. This may be why Hopper's insomniac nighthawks (illus. 106) appear so glum. They are drinking coffee without alcohol and recognize their barren state, and they are too unstimulated to make love.

The quiet character of tea, coffee and chocolate usually finds its most familiar sphere in the middle-class home. Paul Signac described the rituals of middle-class life with tea or coffee in *The Dining Room* of 1887 (illus. 121). The beverage accords with the heavy drapes, plate rack, potted plant, stout, well-dressed gentleman and delicate tableware. The napkin in a napkin ring at the left tells us, if nothing else does, of careful bourgeois life. The table linen was changed once a week, and each member of the family was expected to return a napkin, carefully rolled, in an identifying ring for seven days. Signac was a radical leftist in the 1880s, and his politics seem to come through here. The stiltedness of middle-class existence is revealed by the daily habits of the table, including afternoon tea or coffee.[42]

Signac's painting seems to mock the sobriety of coffee, and so too does Jean Brusselmans, in a painting of 1935 (illus. 122). A lonely woman grinds coffee in her working-class kitchen, which, with its soberly decorative display of utilitarian objects, is a hymn to kitchen equipment – especially coffee machinery. She holds on her lap – between her legs – the typical home coffee grinder, a mill very like the one illustrated in Juan Gris' Cubist work (illus. 119). She cranks away at her groin, and the solitary, masturbating gesture underlines the unrapturous character of coffee.

121 Paul Signac, *The Dining Room* (1887), oil on canvas. Musée d'Orsay, Paris.

122 Jean Brusselmans, *Woman in a Kitchen* (1935), oil on canvas. Museum voor Schone Kunsten, Ghent.

Tea and chocolate are not far behind coffee in the thoughtful but unloved category, and Marcel Duchamp wittily played upon this conception. In his debased sex machine of 1915–23, *The Large Glass* (Philadelphia Museum of Art), he planted a chocolate grinder at the foundation of his sadly mechanized vision of failed love. He presented an identical chocolate grinder in a separate painting of 1913 (illus. 123), presumably with similar meanings. With reference to the artist's notes and entire *œuvre*, scholars frequently link Duchamp's chocolate-grinder imagery to a French folk saying of onanistic implication: 'bachelors grind their own chocolate'.[43] The grinder seems to epitomize unhappy solitary sex. In the painting of 1913 and *The Large Glass*, the modern machine for milling the cocoa beans has the sturdy, undecorated engineering of a factory object. It lacks the quaint old qualities of earlier crushing devices such as the mortar and pestle (beautifully pictured by Chardin in several canvases). Duchamp's portrait of a kitchen utensil laughably takes on the sober character of a blueprint. He mocked not just love and chocolate – the un-love drink – but also those artists, such as the Futurists, who wanted to heroicize modern technology.

123 Marcel Duchamp,
*Chocolate Grinder
(No. 1)* (1913), oil on
canvas. Philadelphia
Museum of Art,
Pennsylvania.

The chocolate grinder in *The Large Glass*, according to
Duchamp's notes and comments, produces a sexual spasm – it is
a kind of electric shock generator to effect the transmutation of
men's love gas into love liquid – just as chocolate, bitter or sweet,
is ground into soluble powder to become a warm beverage. His
kitchen equipment expresses something of the same idea of sexual
depression conveyed by Jean Brusselmans's painting (illus. 122) –
but in a much more comic and mockingly grandiose fashion.
Despite the satire, Duchamp's chocolate grinder should be placed
among those paintings that pay homage to the simple power of
kitchen instruments, similar in this light to the beautifully silhouet-
ted coffee-maker that appears in several works by Matisse (e.g.,
illus. 124). As such, the subject really belongs to chapter Two. The
shimmering copper cauldron in Manet's *Still-life with Carp* (illus.
66) is a triumph of kitchen equipment majesty. There are many
other behind-the-scene objects of great visual strength in food paint-
ings. The weaponry of Aertsen's cook (illus. 49) comes to mind.

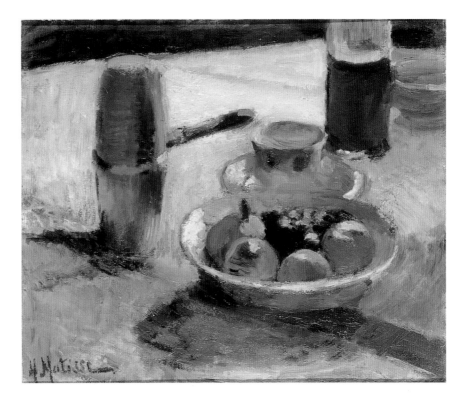

124 Henri Matisse, *Fruit and Coffee Pot* (*c.* 1898), oil on canvas. State Hermitage Museum, St Petersburg.

These objects work against the richness and prettiness that so often mark the vessels and décor of the meal table. A simple kitchen instrument has the power to imply immediately the naked truths that lie behind the finery of a banquet. Duchamp, like Matisse and Manet, chose his subjects carefully – and if his *Large Glass*, among other things, depicts the unpoetic mechanism of love, then a chocolate grinder was the perfect object to evoke a world of strength and unadorned action. The thoughtful but unimpassioned associations of caffeine drinks also recommended the chocolate machine for Duchamp's purposes.

CELEBRATIONS

Meals are usually ordinary acts, marking the divisions of the day. But they also serve as grand occasions to celebrate rites of passage, major holidays and important gatherings. Among the most familiar celebration meals in art are wedding feasts. Gerard David's *Marriage at Cana* of around 1500 (illus. 16), Pieter Bruegel the Elder's *Peasant Wedding* of around 1568 (illus. 110) and Albert Fourie's painting of an outdoor wedding banquet of 1886 (illus. 91)

125 Pieter Claesz., *Still-life with Turkey Pie* (1627), oil on panel. Rijksmuseum, Amsterdam.

represent this important food subject here, as do Pieter Claesz.'s *Still-life with Turkey Pie* of 1627 (illus. 125) and Chardin's *The Brioche* of 1763 (illus. 69). The orange blossoms in both of these last still-lifes indicate a marital theme. An orange blossom appears in the beak of Claesz.'s decorative turkey, and a sprig of orange blossoms sits atop Chardin's brioche. For centuries, oranges – and especially orange blossoms – have been the insignia of marriage festivities. In Gerard David's painting, for example, an orange rests on the table near the centre of the picture. Albert Fourie's bride wears a crown of orange blossoms, and the young female lead in Alfred Hitchcock's movie of 1938, *The Lady Vanishes*, mentions the items of her imminent marriage in London: veil, white wedding dress and 'orange blossoms'.[44]

There are many paintings of the *Marriage at Cana*, and these illustrations of the famous biblical episode, in which Christ changed water to wine, give us a good glimpse of eating ceremonies associated with marriage. In the painting by Gerard David, fowl is carved. Salt is available for flavouring, and a pie, probably a meat pie, is being brought to the table. The bride sits majestically in the middle of the table, before a tapestry, a cloth of honour. Christ, of course, remains important in the scene, but even he is displaced to the side at a wedding, where the bride, above all others, takes centre stage. Despite the sudden lack of wine, David's marriage is a great affair.

Bruegel's peasant bride cannot afford to offer fowl to her guests (illus. 110). They eat multi-coloured porridge, and drink ale or cider from large clay pots. The bride here too sits before a cloth of honour, but it is not as fine as the one in David's painting,

and there is also a paper crown above her, a touch probably meant to mock the whole occasion. The peasants, like the bride herself, appear rude, typical of Bruegel's jaundiced view of the common man, and several of the guests are shown grotesquely with spoons in their mouths. The elegantly dressed men to the right of the bride represent the lawyer, who drew up the marriage contract, and the landowner on whose property the bride lives. The artist put the peasants in their place – and without much kindness. The sardonic humourist Bruegel might, in more modern terms, be showing us a ludicrous trailer trash marriage celebration, where the partygoers eat Doritos and watch wrestling on TV. If he intended his painting as a sour commentary on man's stupidity and materiality, he failed to make these characteristics seem unlikable. Satisfaction still reigns when bellies are full.

The Claesz. still-life (illus. 35), like that by Gerard David, displays wealth to salute a marriage. An oriental carpet on the table, fine metalware, a costly nautilus cup, Far Eastern porcelain and the great turkey pie crowned with the stuffed animal itself make this a sumptuous marriage banquet. Even devoid of figures, the grandeur of the event is clear. Banquets themselves often stand as memorable events – meals so great that the participants will forever recall the magnificence or significance of the occasion. I once took an overnight train from Nice to Paris sharing a compartment with two elderly southern French ladies, who recounted in infinite detail the wedding breakfast of every girl in their village 50 years ago – how fresh the rolls had been, how well the napkins had been folded, what sort of delicacies had been served, etc. It did not seem to matter that one of the women thanked God that her miserable son-of-a-bitch husband had finally died (after beating her every day of their marriage) – the wedding breakfast remained the high point of her life. Paintings such as the Claesz., or one by Fourie examined below, no doubt functioned as marriage photos do today, documents of accomplishment, to certify significant stages of life.

Chardin's marriage still-life (illus. 69) is subtler than that of Claesz. He reduced the flamboyance of a Baroque sideboard image and the fanfare of a wedding banquet to a few sensitive items – a fine porcelain sugar bowl, two love apples, three cookies, a like number of cherries and some oil or alcohol in a tall glass bottle. The delicately displayed goods indicate richness without ostentation. The small number of objects in this plain interior creates an atmosphere of intimacy – as if it is a wedding breakfast for the bride and groom alone. Shapes of maleness and femininity in the bottle and bowl, respectively, at either side of the painting describe the sexual underpinnings of marriage, with the explosive

form of the brioche at the climactic centre. The very sideboard setting – before the meal is consummated – suggests a foretaste of the conjugal bliss to come. The painting shows an imminent future of sweet fecundity. An even quieter salute to marriage possibly appears in a still-life painting of 1633 by Francisco de Zurbarán (illus. 31). Here again, oranges, associated with marriage, crop up – but with lemons too. Lemons had been used since ancient Roman times to purify water. The fruit supposedly kept water fresh and potable by filtering out pollutants. In Zurbarán's picture, the lemons lie next to a rose and a cup of water, and probably declare the chastity of the bride – like the purest of waters. The rose would signify her loveliness.[45]

Albert Fourie (illus. 91) presented a friendlier look at a lower-class celebration than did Bruegel. His era welcomed happy visions of proletarian culture. Socialism in the 1880s affected the arts deeply – even the work of minor provincial painters such as Fourie. In this wedding painting, we sit at the table as participants. A cloth of honour still exists here – as blankets; these also screen the party from the rest of the world in what is probably a public park. The celebrants seem touchingly sincere, the children are engaging – and the food tempts. A lovely homemade pie sits before us, and a great roast fowl rests in the centre of the banquet table. Rarely have the charms of common people, drinking from crystal glasses and dressed in the best they can muster, been portrayed with such sweetness. And the beautiful natural surroundings elevate the figures to Arcadian characters.

A wedding feast, of course, is a once-in-a-lifetime event for most brides, and in that regard is similar to other banquets meant to celebrate just one occasion. The men who celebrate the Peace of Münster of 1648 in the painting by Bartholomeus van der Helst (illus. 75) participate in a similar sort of singular meal. Although these marriage and special event feasts cannot be accepted as objective transcriptions of reality, the repetitiousness of seating arrangements, sorts of food, table settings and decorations such as orange blossoms, in the hands of different artists, do give some indication about these kinds of meals.

Single event banquets essentially function to gather people together. Food in these circumstances works as a magnet to draw families, friends, communities or important people to one spot for a length of time. Without food, the sense of togetherness would deflate. What all these wedding scenes and such subjects as van der Helst's *Peace of Münster* describe is communal reinforcement. The feast cements the participants. The meal uses the fundamental satisfactions of eating to celebrate a common cause.

126 Pieter Bruegel the Elder, *Fight between Carnival and Lent* (1559), oil on canvas. Kunsthistorisches Museum, Vienna.

These single event feasts differ from seasonal rituals which are repeated at regular intervals. The single celebration does not really tell time, or place the participants into a grand cycle of commemoration.

Pieter Bruegel the Elder's *Fight between Carnival and Lent* of 1559 (illus. 126), in contrast, is time-sensitive and ritualistic. It is also all about food. This celebration picture concerns two important annual food-sensitive holidays – Carnival (or Mardi Gras, or Shrovetide), dedicated to meat, and Lent, the abstemious period that follows Carnival, dedicated to fish. Bruegel's painting is an allegory that, despite the symbolism and elisions of time and slanted purpose, provides many details of pre-modern food selling and consumption in the public realm. The scene presents a whole range of folk customs and religious practices that generally took place in Flanders between Epiphany (the feast of the Twelfth Night of Christmas) and Easter. Given the rest of Bruegel's *œuvre*, the artist probably intended to portray the world as filled with fools and nonsense, greed and stupidity. The city square acts as a satiric stage for the painter.[46]

The title of Bruegel's painting describes the foreground event – a symbolic battle between Prince Carnival and Dame Lent – between the forces of Mardi Gras joy and Lenten penance. The fat master of Carnival rides a barrel on a boat and holds out a spit with a fowl, pig head and sausages. The emaciated leader of Lent sits on a wooden chair atop a wheeled platform – the sort used in Easter plays – and holds out two miserable dried fish on

a wooden spatula. A host of followers with accessories attend each figure. Such mock fights, like the folkloric plays and masquerades that take place elsewhere in Bruegel's marketplace, were actually enacted in the Middle Ages and Renaissance – so the allegory of denial and indulgence in terms of food is not entirely the painter's invention. But it is the incidentals of the picture that provide clues to the realities of sixteenth-century food. It is not only fish that are the food of Lent, but also pretzels – they appear as decoration and snacks everywhere among the penitants. When a pretzel appears in a painting from a Catholic region, its reference to Lent, or to a particular season, or to a tone of spirituality, should be recognized.

Pancakes and waffles, on the other hand, according to Bruegel's painting, obviously belong to the side of Carnival. Among other things, the picture shows how they were cooked and sold in the open square. The pancake baker or waffle maker, in the centre of the panel, keeps her batter in a pan and bakes the cakes in a large two-armed metal press or gridiron over an open flame. The fire is made from twigs placed on the ground. Here is a good picture of what public cook stalls looked like – even if this is a special seasonal celebration. The fishmonger's outdoor shop – on the side of Lent, of course – shows how unreal Aertsen's and Beuckelaer's market scenes probably were. A few fish on the counter and a few more in a basket are all that are for sale here. There is no ocean-sized catch to be hauled into the market. With yearly rituals such as Carnival and Lent, food takes on more symbolic overtones. Repetition encourages strongly associative scenarios, objects and actions.

The combat between man's pleasure and pain, between satisfaction and remorse, acted out through the consumption of special foods, lies in the foreground of Bruegel's work. Meat here represents all the temptations of the flesh, all the tastes of indulgence. Meat is the stuff of the world. Fish represents the opposite. Pieter Claesz.'s lonely herring in a seventeenth-century still-life, dry and dead and cut (illus. 42), calls to mind the same ideas and mood as does Bruegel's Dame Lent. An artist can alter or deepen a painting's meaning by inserting special foods into an otherwise familiar subject.

While a necessary insignia of the holiday, the meaty tenor of Bruegel's Prince Carnival is probably misleading. There are many paintings of peasant pancake and waffle makers and eaters, all of whom signify pre-Lenten revels, but very few Canivalesque peasants appear with much meat. The *carne* of Carnival, as it appears in the foreground of Bruegel's *Fight Between Carnival and Lent*,

was largely symbolic. So too, probably, are the sausages and pigs' feet and eggs that adorn one figure in Frans Hals's *Shrovetide Revellers* (illus. 127).

The jolly fellow with the meat in the Hals painting is no doubt meant to be Hans Wurst (Johnny Sausage), the equivalent of Bruegel's Prince Carnival, an imaginary character of Mardi Gras celebration, or an actor playing that part. In Dutch folk plays of the period, there is also a figure called Mr Pickled Herring, the equivalent of Dame Lent. The theatrical element of Hals's painting brings into question the veracity or at least the commonness of the foods on the table at the base of the picture. Here there is a bowl filled with sausages (and note how the casing is kept closed with 'toothpicks') and pigs' feet. There is also a plate at

the right with one sausage and a dollop of mustard. At the left is a mustard pot, a hot brazier, a bagpipe (the instrument of raucous folk music) and rush matches to light pipes (such as the one stuck in the hat of Hans Wurst). In the centre of the table, before the laughing drunk blonde, is a beer stein – a sign of the general inebriation of the crew shown. In all likelihood, the image symbolizes Carnival rather than describes the actuality of that supposed meat festival. The celebrants and their accessories are too artificially representative to depict the usual goings-on of Mardi Gras in the seventeenth-century Netherlands.

Noteworthy in the *Shrovetide Revellers* is the spoon stuck into the hat of the drunken man at the left. Just as people carried their own knives to the table, they may have brought spoons. But it is significant that in several of Hieronymus Bosch's paintings of the early sixteenth century the artist depicted what are clearly fools with spoons stuck in their hats. It is therefore possible that the spoon in Hals's carnival figure is also a symbolic touch – a sign of drunken folly. Hals's picture is possibly condemnatory – an image of silliness and indecency connected with traditional Catholic holidays.

The Twelfth Night Christmas feasts of the seventeenth century, as portrayed by the Flemish artist Jacob Jordaens in several canvases (illus. 81), rarely include meat. There is a little ham in one of his paintings of the subject.[47] Like Hals's *Shrovetide Revellers*, Jordaens's pictures include dressed-up figures – especially the 'Bean King', selected to 'lead' the company for the evening, and again these images may be more symbolic than naturalistic. In some versions of the festival, cakes were served, and whoever discovered a bean in his portion of cake became the 'Bean King'. In any event the 'ruler' shown in Jordaens's paintings, with paper crown and drunken jollity, is a burlesque monarch, ruling a nation of happy fools – and such pictures, as suggested with regard to the Hals's painting, have been interpreted as specifically anti-Catholic condemnations of traditional libertine holidays.[48]

Whether these are pointed chastisements or not, Jordaens emphasized the distinctly vulgar, showing arse wiping, vomiting, drunken singing and all manner of dishevelment and loose behaviour. It is all rather silly and obscene – and there is little to consume apart from alcohol and some waffles and pancakes, but, still, the figures' enjoyment is infectious. And just as the deathly mementos of seventeenth-century Dutch still-lifes fail to dispel the satisfactions of food, so too Jordaens's feasts seem to celebrate pleasure more heartily than they condemn errors.

The Twelfth Night images depict an annual Christmastide event, and like all such repeated banquets, serve to remind the viewer not only of seasonal changes, but also of permanence. They ultimately present an endless cycle of time, a soothing vision of order and stability and a known future, even as they represent a specific moment in the year. The Twelfth Night paintings are like the calendar pages in the *Très riches heures du duc de Berry* (illus. 67), markers of particular time and definers of the constancy of time in general. Food plays a major role in such time machines. The pancakes of carnival, the pretzels and fish of Lent, the bean-in-the-cake of a Twelfth Night function as do Marcel Proust's *petites madeleines*, recollections of special experiences and the passage of time, of physical change and the permanence of memory. Food is a Pavlovian reminder. In the United States, the association of turkey with Thanksgiving is absolute. Even if turkey is served at some other time of the year, it is somehow a reordering of the calendar, a revival of this autumn festival. If a different dish is served as the centrepiece of a Thanksgiving meal, then the replacement is thought of as a turkey substitute rather than a thing unto itself. Norman Rockwell's Thanksgiving painting of 1943 (illus. 45) rightly focuses on the great roast bird. The idea of family togetherness is there as well, but it is the food that marks the occasion, makes the repeated celebration memorable on the tongue. The turkey vivifies the historical account of English Pilgrims in early seventeenth-century America surviving in the wilderness with native friendship and native food, and the country as blessed by God.

Rockwell no doubt had paintings of the *Last Supper* in mind when he designed his image. Tintoretto's version of the *Last Supper* (San Giorgio Maggiore, Venice) with a perspectival table comes to mind. But Rockwell Americanized the holy subject, and, most importantly, replaced the chalice and bread with turkey. As Proust recognized, taste, as much as any sense, makes the past come alive. Food animates memory, and even paintings of foods can fulfil that function. Rockwell used all these associations for patriotic purpose. His Thanksgiving picture was meant to illustrate 'freedom from want' – one of the four freedoms mentioned by Franklin Roosevelt in a famous speech of 1941. The speech defined the aims of American democracy and prepared the country for war in defence of democratic life. By the time Rockwell painted his image in 1943, the USA was a participant in the Second World War – and the painting took on an even greater political meaning. The Thanksgiving meal became a declaration that America would persevere. The mountainous roast

bird at the head of the table stood for victory over adversity, a world without ration cards, a vision of abundance that says all will be well. The painting has a therapeutic effect similar to the market scenes of Aertsen and his followers.

Most of these American references would be lost on viewers outside North America – just as the oranges in Jan Steen's tavern scene of Prince's Day (illus. 97), in celebration of the House of Orange, would be lost on modern non-Dutch viewers. No doubt many of the foods in the paintings discussed here had specific celebratory meanings. The eggs might salute births, and the pies might be Christmas puddings. Our knowledge of food customs is limited. But in any event food acts as Proustian memory aids in innumerable holidays and can replay that role in paintings. It seems unlikely that the owners of food paintings would hang seasonal or memorial works at only certain times of the year (although altarpieces were opened and closed in accord with the Church calendar and specific saints' days), but it is possible that they relived events and seasons imaginatively through the pictures of food in their houses, just as portraits of women at the time of their marriage decorate the drawing rooms of eighteenth- and nineteenth-century British houses, signalling the rites and rights of the wifely domain. In certain societies at certain times a painting of a basket of oranges might say the same thing as a portrait of a young bride.

TIME

Food celebrations, as has been mentioned, involve time. Various holiday feasts mark the year and reinforce a cyclical understanding of our lives. The force of food as a memory aid has also been noted. The smell and taste of specific foods cause a collapse or reliving of time – through the power of memory. And paintings of those foods can similarly play with time. These works are not alone among eating pictures in their attachment to the description of time. Monet's picnic, *Le Déjeuner sur l'herbe* (illus. 89), for example, implies a period of the week – a weekend, when urban people get a break from their daily jobs, just as Tissot's picnic (illus. 82), entitled *Holiday*, describes a time of rest from normal labour. Those linkages charge the mood of picnics, automatically, with notions of relaxation – and heighten the satisfactions of the subject.

But food paintings serve additional time-defining purposes: times of day, and periods of hunger and fulfilment are represented.

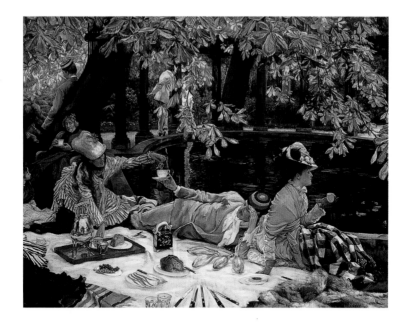

A painting such as Bonnard's *Before Dinner* in the Metropolitan
sets a dinner table before us. But the title and the postures of the
two waiting women at the left show that eating has yet to begin.
The painting delineates a particular moment of appetite stimula-
tion and self-control. It portrays the feeling and ritual of anticipat-
ing pleasure and yet not embracing it immediately. Convention
and timing pervade the meal – even though Bonnard's image
describes modern French life and not the feasts of Native North
Americans or New Guinea natives, where an anthropologist
would expect ritualistic actions. Even in the secular West, it is
not customary to gobble as soon as one is hungry at a communal
repast – and a quiet dinner among friends can be considered a
communal feast. The times of meals differ widely in countries and
eras, but there are always standard periods for feeding – the meals
act as a kind of clock, ticking off the sections of the day. Paintings
can also create moods and suggest states of mind and meaning
through the representation of time and food. Many of the meals
looked at above, especially those with coffee, represent the termi-
nation of eating – and a resplendent sense of satisfactory fullness
thereby clings to them. The hints of anxiety or the need to con-
form implied in Bonnard's picture do not arise in Renoir's or
Manet's luncheon paintings (illus. 82, 83), which depict the
quiet end of a meal.

There are few sad ends of meals in painting. Grun's gregarious,
delighted vision of the end of a dinner party (illus. 80) is more

typical. Perhaps the element of time underlies some of the unpleas-antness found in food preparation pictures. All those servants toiling in dark kitchens before the end of the eighteenth century define not only the coming of feeding times, but also the arduous delay of eating that preparation entails. The anxious desire to start a meal also underpins paintings of 'saying grace', discussed below. The prayer of thanks for food occurs before the eating begins – not after, and that time-sensitive situation seems to colour such images – they involve a slight measure of fortitude, or self-control, of delaying pleasure for the greater glory of God. Time and the emotions of time creep into food paintings persist-ently, because eating in all its forms usually accords with clock and calendar and the temporal rhythms of digestion.

POVERTY, CHARITY, PRAYER AND CHILDREN

Class-consciousness pervades food imagery, and various paintings that carefully define particular social levels through setting, table-ware, kinds of food and manners of eating have already been examined. They include van Gogh's lower-class eatery in Arles (illus. 99), with clothless communal tables, and Liotard's tea remnants that speak of higher social life – expensive china and the implied presence of servants (illus. 118). There are images of kitchen help toiling in dolorous circumstances (illus. 52) and of noble diners, assisted by deferent waiters (illus. 17). Candy has been noted as a sign of wealth in the seventeenth century, and turnips as a sign of poverty in the nineteenth (illus. 70). A closer examination of some representative paintings of the poor and their food, however, is required.

Food as basic physical sustenance is nowhere more apparent than in images of the poor, who stand closest to starvation. Before the nineteenth century transformed the life of the poor through industrialization, the poor in art consisted of agricultural workers – the peasantry. The truth, however, was that although peasants planted, tended and harvested food, they were not always able to eat it. In some of the images, as in Aertsen's and Beuckelaer's pictures (illus. 18 and 24), the peasants tend to be well-fed, contented figures, surrounded by abundant produce. Like the food they harvest and sell and eat, they represent the fecundity of the earth. Poverty remains invisible in such works – it is inappropriate in images of market themes and peasant feasts. But if poverty seems inimical to the subject of food in art, it remains visible in scenes of charity.

Charity sometimes appears in art symbolically – as a suckling mother, or other personification of this virtue. It also appears in the illustrations of the lives of saints, for example in a wonderful polyptych in the Metropolitan Museum of Art in New York by an unknown fifteenth-century artist, which shows the charitable food activities of St Godelieve, the patron saint of Belgium and the helper-saint for those with in-law problems.[49] In this altarpiece, St Godelive gives to the poor the spicy red chicken that her un-Christian in-laws intended for the visiting Duke of Burgundy. The spicy chicken miraculously returns to the dining table when the duke arrives. In another panel, one of the servants of Godelive's mother-in-law sees the saint give food to the poor from the family larder. But the donated food miraculously turns into worthless wood chips when the servant–spy's accusations are investigated. The St Godelive altarpiece delights our attention, because it deals with charity at its most basic, physical level – in terms of food.

One hardly notices the starving poor in the St Godelive altarpiece. The saint is the focus. This is not always the case with charity food pictures, but when the poor are shown prominently, they are usually either taunted or prettified. David Vinckboons, for example, mocked the needy in a painting of *circa* 1610, which shows the giving of bread to the poor at the gates of a monastery (illus. 129). There are some crippled figures noticeable in the crowd of hungry people that stand before the gates, but most of the poor seem grotesque, rambunctious, thieving and cheating folk. One doubts the truthfulness of their deplorable appearance, because one healthy little girl in the foreground is being taught how to walk with crutches – and thus to be able to beg more fruit-

fully. The monk who distributes bread, moreover, does so through a metal grille – to keep the raucous crowd at a safe distance. For those who could afford to commission or buy such an image, the need to spend money on charitable works is denied, and the propriety of saving one's riches for something other than the undeserving poor is declared. In a way very different from other soothing food pictures, Vinckboons's painting calms guilt.

Murillo's *Pie Eaters* of 1662–72 (illus. 33), in contrast to images of the starving poor, makes light of lower-class poverty, but does so while presenting the peasants as charming characters. The ragged boys apparently enjoy their poverty, and the sense of well-being of the poor here comes by means of food. These children have lots to eat; their sales basket is filled. They gorge themselves and only their handsome dog needs to beg. Bare feet and torn clothes do not seem to indicate deprivation or unhappiness. The poor are shown as nice and charming. The notes of condemnation in Vinckboon's picture cannot be found here.

Although most art historians consider Murillo's beggar children as merely tender genre scenes, it is conceivable that such images of the poor were meant to invite charitable acts – just as today the United Way campaign in the US or Oxfam in Britain attract donations for the poor and suffering by attaching to their advertisements pictures of needy but good-looking people, especially sweet children.[50] But ultimately the painting may lead the viewer to the same conclusion as Vinckboons's image – the poor do not require any assistance from us. They are in rags, but they seem to enjoy themselves. The plentiful food creates a vision of satisfaction. It is possible that the patrons of Murillo's many paintings of contented beggar children may have blessed the poor for their good spirit, and kept their money for other things. Of course, it is not only food that makes Murillo's beggar boys palatable. Their physiques are well proportioned, even elegant, and beautifully disposed, as in the delicate gesture of the left-hand child about to swallow a piece of pie. Vinckboons's peasants, in contrast, are ugly, misshapen monstrosities.

It is unlikely that van Gogh thought of his *Potato Eaters* (illus. 39) as a charity picture. His peasants earn their livelihoods. But like Murillo's paintings, it makes the humble of the earth seem pleasing and content. An almost sacred light and peace envelops these poor folks sharing their meal, as if it were a religious subject. Although van Gogh had socialist leanings, and his peasants are not attractive, this image leads to the same conclusion generated by the Murillo – the poor do not need our assistance.

The poor frequently also figure in scenes of prayer at table –

saying grace, thanking God for whatever they have to eat. Such works, in tune with van Gogh's quasi-religious potato eaters, show Christian humility and an ennobling vision of people who gladly accept their lot in life.

Paintings of saying grace at table primarily appear in Protestant countries. Although Roman Catholics also give thanks to God before eating, their serious prayers and rituals take place in church, before an altar presided over by a priest. Even the monks dining in a monastery refectory in a fresco by Sodoma (illus. 130) are not shown in attitudes of prayer or thanks. The monks, including St Benedict at the head of the table, handle food and drink silently, and eat nothing but fish – a little self-denial no doubt – but they do not formally thank the Lord for this bounty.

More important than poverty in defining representations of saying grace is the presence of children. Most paintings of the subject from the sixteenth century to the twentieth include young people.[51] Saying grace, or, as the subject is also sometimes called, 'grace before meat', often seems to concern the education of children, as well as the need to thank God for one's victuals. Jan Steen produced several paintings of grace before meat, some with poor folk, and others with better-off families (illus. 131), but all include

130 Sodoma, *Monks at Table with St Benedict* (1505–8), fresco. Cloister of Monte Oliveto Maggiore, Buonconvento, Tuscany.

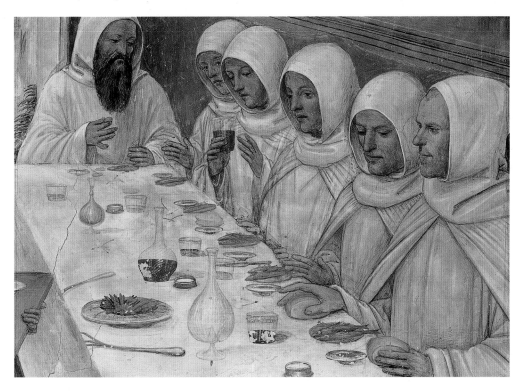

131 Jan Steen, *Grace Before Meat* (?1660), oil on panel. Belvoir Castle, Leicestershire.

children – and sometimes they receive direct instruction on how to give thanks, how to hold their hands in prayer.

In the eighteenth century Chardin continued this theme of spiritual education, and in one of his best-known figure paintings showed a small child learning how to pray at table (illus. 132). In the nineteenth century in the Netherlands, Belgium and Britain, pictures of saying grace – all with children present – proliferated. Arthur Hughes's sweetly sentimental painting of a poor fisherman's family, *The Skipper and his Crew* (also called *Saying Grace*), dated 1881, presents children and their parents seated in a quaint cottage, humbly in prayer before a large steaming pie (illus. 133). The cutest of the children seems torn between lust for food and the necessity of giving thanks. He does not seem able to raise his prayerful hands completely when faced with tempting pie.

Norman Rockwell brought the subject into the mid-twentieth century in *Saying Grace* (illus. 134), but presents it in a semi-public realm – a restaurant. An elderly woman and her small grandson pray before their truck-stop meal, giving an unusual moment of grave religiosity to an off-hand clientele. Although no one else gives thanks for the lunchroom fare, everyone observes the lesson with respect and even reverence. Teaching the young about the presence and magnanimity of God is what such paintings are all about.

The reason, no doubt, that an educational theme haunts scenes of table prayer is because food is so directly understandable, so materially apparent, as a gift. Although one may be able to comprehend God's mercy and helping hand intellectually, it is

132 Jean-Baptiste-Siméon Chardin, *Prayer Before a Meal* (1744), oil on canvas. State Hermitage Museum, St Petersburg.

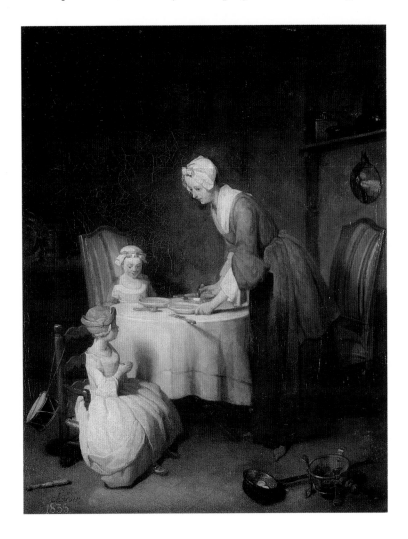

133 Arthur Hughes, *The Skipper and his Crew (Saying Grace)* (1881), oil on canvas. Maidstone Museum & Art Gallery, Kent.

134 Norman Rockwell, *Saying Grace* (1951), oil on canvas. Private collection.

easiest, especially for the young, to digest such concepts in physical terms: here is the nourishment one craves, and it is given by God. The whole educational role of saying grace in art is connected to the physicality of food noted in the Introduction. The varied interpretations of Aertsen's market scenes almost all assume that the food in the foreground represented gross material goods, the earthy stuff of the here and now. Saying grace as a theme in art brings together, in a somewhat uneasy alliance, spirituality and materialism. Pictures of saying grace show instruction in spiritual concepts through the actions of the stomach and the senses of sight, smell and taste.

For Protestant painters in particular, and their patrons, saying grace pictures also presented a way to tackle a potent religious subject similar to the Last Supper – table-focused and about the presence of God – but without the mysticism of the Catholic Mass. Instead of the miraculous consuming of God in bread and wine, the Protestant learns to understand God's assistance and mercy and goodness in his daily meal.

Saying grace paintings also belong to the general category of children's meal pictures. Like charitable food scenes, almost all such works concern not only the parental duty to sustain their offspring, but also the good deed of instructing the young. The seventeenth-century Dutch scene by Gerard Terborch (illus. 55), which presents a child and mother peeling apples, also concerns education – meal preparation that metaphorically tells the young about human mortality – or at least tells them about the necessity of worldly toil. And it is food in all these works that provides the instructional tool. The physicality of food, meaningful to children as well as adults, makes teaching effective.

In the realm of upper-class eating in the eighteenth century, Zoffany's painting of Lord Willoughby de Broke teaching his son manners and self-control at the tea table (illus. 135) has been noted already. Also in the eighteenth century, Jean-Baptiste Greuze showed a spoilt boy chided for feeding his food to his dog (illus. 136). Greuze's child, through gentle scolding, learns to understand the bounty given him and not spend it profligately. The eighteenth century's concern with education, re-thinking past conventions of learning and instituting more humane and rational systems attuned to a child's frame of mind – Pestalozzi and Rousseau were important here – operates in these food-and-teaching paintings of the Enlightenment.

Not all children's meals in art concern education. Gustave van de Woestyne, for example, produced a charming painting of five middle-class children at their own dining table – and no preaching

135 Johann Zoffany, *John, 14th Lord Willoughby de Broke, and his Family in the Breakfast Room at Compton Verney* (*c.* 1766), oil on canvas. J. Paul Getty Museum, Los Angeles.

or teaching enters this nursery world. The artist, rather, exhibits some patronizing appreciation of British kiddy food – white bread and butter, potatoes, milk – all shown from the adult's perspective, looking down on these small, neat youngsters (this Belgian artist lived in England from 1914 to 1919). The significance of the painting lies in its date: 1919 – the year after the First World War ended. The scene says all is well; things will continue as before; the world is ordered. The social and physical collapse of Europe disappears here. Well-behaved children with abundant food, good manners and clean clothes describe the next generation with assuring pleasure. Food and the meal serve to quell anxiety and deny the fearful state of both Britain and Belgium after the conflict, with populations depleted, landscapes ravaged, governments overturned and general uncertainty everywhere. Comforting food set out nicely in the nursery makes all seem well.[52]

The diverse themes of this chapter on meal paintings cohere at a distance. The celebratory banquets, friendly picnics, restaurant experiences, children's meals and coffee *tête-à-têtes* bring people together for pleasure and communication. These meals affirm social rank and the continuity of time and community. They affirm the significance of rites of passage and the rituals of religion. They

opposite:
136 Jean-Baptiste Greuze, *The Spoilt Child* (1765), oil on canvas. State Hermitage Museum, St Petersburg.

thus affirm stability, and whether meditative or inebriating, these gatherings act as social glue. Meals in art today still signify togetherness. When the feminist artist Judy Chicago wanted to celebrate women, she orchestrated a collaborative installation piece composed of decorated dining tables: *The Dinner Party* (1979; Brooklyn Museum of Art, New York). The intimacies and freedoms of private dining, encouraged by Dutch still-life, seem different from the group images. But these works also salute the life-affirming joys of physical indulgence. And when hints of sin and death enter meal scenes, they appear as manipulable objects, or are overwhelmed by expressions of satisfaction. When artists work against food conventions, portraying lonely restaurants, for example, they are really only toying with the mainstream celebration of pleasure and control. As a whole, meal paintings affirm our mastery over the world and over our destinies.

FOUR

Decorative and Symbolic Food

The symbolic and the decorative have a difficult time in the sphere of food imagery, because food, as has been seen, speaks immediately of physicality. Food is the subject that is chosen to represent material lusts. It is the tangible, physically understandable model used to instruct children in spiritual matters. It is such a common part of experience that it registers automatically as neither grand spectacle nor deep statement. Profound revelations, however, are not impossible in food art. The inconsequentiality of food imagery permits the painter to ignore pompous ideological declarations and ambitious concoctions of dignified form. Instead, the artist of food paintings can freely explore things more real, more honest, more delicate, more private, more sensitive and more truly felt. A kitchen still-life by Chardin (illus. 48) probably tells us more about perceptions of the world, ideals and emotions in the eighteenth century than a grandiose history painting of the period. A still-life by Chardin expresses a belief in natural order, a desire to explore rarified private feelings and an enjoyment of domestic happiness as a great human goal.

Combining the purely decorative and the purely symbolic together in one chapter may seem perverse. One mode strains away from intellectual meaning to describe beauty and visual power. The other strives to give intellectual depth by making an object or scene represent a concept on a higher plane of understanding. Both formalism and symbolism, however, share an avoidance of that familiar physicality of food, the bodily smell and taste and satisfying consumption that cling to carrots and peas and beer and lamb chops. Symbolism and decoration both fight against the prosaic nature of food.

Some symbolic food and some decorative food have already been touched on in previous chapters. Various victuals suggested, if not symbolized, sexuality, Christ's sacrifice or nationalism. And Cézanne's works, for instance, have been described as unnaturalistic

arrangements, perceived by many as purely decorative images of
food and food accessories. The removal of food from the domestic
and commercial realm of consumption – from market, kitchen,
dining area – deserves some further attention. Some food paintings
depart so far from the circumstances of normal food selling,
preparing and eating that they should be treated separately.

The real reason why symbolic food images have been placed
together with purely decorative ones in this chapter is that it is
often hard to tell the two kinds of painting apart. Works such
as Delacroix's *Still-life with Lobsters* (illus. 1), for instance, has
been interpreted as a symbol-like representation of a healthy diet
and also as a purely decorative arrangement of colours.

A modest food painting of 1924 by the Swiss artist Félix
Vallotton, *Marigolds and Tangerines* (illus. 137), illustrates how
symbolism and formalism can be so tightly interwoven that the two
understandings of the single image cannot be separated. The viewer
realizes immediately the primarily decorative, formal concerns
of the artist, because the still-life objects seem so isolated, as if
carefully arranged in a vacuum. Vallotton's work here departs only
marginally from Fantin-Latour's earlier exquisitely delicate orches-
trations of fruit and flowers (illus. 63). But Fantin-Latour, working
among mid-nineteenth-century realist artists, at least implied a

137 Félix Vallotton,
*Marigolds and
Tangerines* (1924), oil
on canvas. National
Gallery of Art,
Washington, DC.

coherent domestic situation when he painted a book, a cup and fruit together. In the Washington painting, the items suggest a snack while reading. They rest on a table as if in use. In contrast, Vallotton's beautiful simplicity of composition and colour harmony dominate any possible domestic circumstance of his pot of flowers and three tangerines on a wicker surface.

One recognizes the likeness of colour of the marigolds and the fruit in Vallotton's painting, and notes the boldly balanced composition of two horizontal bands with one vertical form in the very centre of the canvas. The composition reflects the sunflower paintings of van Gogh. But van Gogh always kept his food subjects, as opposed to his flower paintings, in relatively naturalistic habitats – breakfast tables, a butcher's shop seen across the street, a restaurant. Vallotton placed his van Gogh-like pot on what seems a wicker chest, an unlikely support – and the strands of reed match in shape and width the marigold petals. The warm tones of the wicker also become a more golden variation of the colour of the fruit and flowers. The tangerines and marigolds are virtually the same hue, and the shapes of the citrus fruit also echo the rounded forms of the blossoms. Like flowers in a pot, the fruit exists for visual pleasure. Who would place tangerines next to a pot of marigolds on a wicker surface? Only someone interested in harmony of form and colour. It is the obviousness of the parallels between fruit and flowers that declares this to be an arrangement of beauty for beauty's sake.

This painting seems to have nothing to do with tangerines as food. Yet Vallotton's simple confection, in which the symmetry of the flowerpot's placement plays against the asymmetries of the tangerines and marigolds, still possesses some symbolic meanings – or at least oblique allusions. There is a face-off between East and West in this still-life. The tangerines (or 'mandarins' in French and German) and the wicker (grown and cured in Asia) form an exotic contrast to the distinctly European flowers and humble Western pottery. And for all their rarified delicacy, the objects hardly constitute a hothouse collection of recherché elegance. The flowers, like the pot, are commonplace, and by 1924 tangerines could be found in any market in Europe (they appear on the bar of Manet's *Folies-Bergère* of the 1880s, illus. 46). The piece of rattan furniture, imported widely since the eighteenth century, could be bought cheaply almost anywhere. Vallotton's painting demonstrates the harmonious beauties that can be created from the humblest of everyday articles.

There might even be a political aspect to this exquisiteness of lower-class materials, because Vallotton, at the turn of the century,

had produced some wonderful left-wing prints of social ills and political commentary.[1] The plebian tinge here, even in the 1920s, might hint at the power and beauty of the working class. All these non-decorative 'meanings' of the Vallotton could be called 'symbolic', which makes it difficult to assess what is purely decorative in the work. The same kind of problem plagues Cézanne's still-lifes. For some, those studio-prop apples and pears and onions are no more than shapes and colours. For others, the food brims with sexual reference and personal anxieties, as well as Classical allusion. In both artists' still-life pictures, however, the food, for all its possible significance, remains outside ordinary conditions of ingestion. Whether Vallotton's tangerines are representative of the East or the commonplace or anything else, they are not noticeably for eating. They have little or nothing to do with nourishment or the pleasures of consumption or the difficulties of preparing meals or the presentation of physical necessities in the marketplace. Nobody would look upon Vallotton's fruit as a dessert waiting to be served.

The Vallotton painting explains why the 'purely decorative' and the 'purely symbolic' are treated together here. Some food paintings, however, possess symbolic properties less problematically – this is often true in traditional religious images.

In the thirteenth century Adam of St Victor had asked: 'What is a nut if not the image of Jesus Christ?' He then explained: 'The green and fleshy sheath is his flesh, his humanity. The wood of the shell is the wood of the cross on which that flesh suffered. But the kernel of the nut from which men gain nourishment is his hidden divinity.'[2] This sort of religious symbolism continued to cling to some food images for centuries. Certainly in images of the Virgin and Child, where Christ holds an apple or grapes, the fruit represents more than a snack. The apple in the hand of baby Jesus clearly symbolizes his redemption of the sin of the Garden of Eden. The apple identifies Christ as the new Adam. In Masaccio's *Virgin and Child* from the Pisa polyptych (*c.* 1426; National Gallery, London), the infant Jesus eats a bunch of grapes obviously with reference to the Eucharistic wine, made from grapes, and, by extension, alludes to Christ's sacrifice. Food in such cases easily attains the role of symbol merely from the context of the painting as a whole.

Even in religious paintings in Roman Catholic societies, however, the symbolism of food is not always sure and clear. Carlo Crivelli included fruit and vegetables in most of his altarpieces – apples, pears and cucumbers occur most often. Some of these edibles form garlands or swags in the margins or backgrounds of the pictures and can perhaps be considered meaningless ornament.

138 Carlo Crivelli, *Annunciation with St Emidius* (1486), panel transferred to canvas. National Gallery, London.

But in a painting of 1486 of the *Annunciation with St Emidius* (illus. 138) a large cucumber and apple lie in the foreground just outside the house of the Virgin, and they do not act as mere decoration. They do not appear to have anything to do with the life or miracles of St Emidius, the patron saint of the town of Ascoli, where Crivelli's painting originally hung. The volumetric vegetables cast strong shadows. They are prominent objects in the sacred scene and probe into the viewer's space. There is no clear documentation about the meaning or purpose of such recurrent food items in Crivelli's art. Are they here symbols of the incarnation of Christ

– who was conceived in the womb of Mary at the moment of the Annunciation? The apple might easily refer to Christ as the new Adam – but a cucumber? Are these allusions to sexuality – breast and phallus, symbols of the sinful sexuality outside the chaste home of the Virgin? Are they references to abundance, to fecundity? Or are these vegetables proud references to the economic products of Italian agriculture? Whatever the exact meaning in fifteenth-century Italy, Crivelli's apple and cucumber could not have been merely incidental objects in the picture. They make no sense lying in the street. Their unnatural position tells us that they must have some symbolic purpose, or reference beyond mere description.

Religious symbolism could become yet more uncertain in the seventeenth-century Protestant Netherlands, when a more down-to-earth symbolism of a moralizing character appeared in emblem books, the best known of which was by Jacob Cats, published in 1628.[3] Armed with such literature, art historians have noted Cats's identification of cream as spirit, and whey as fleshly pleasure, and the churning of butter as an emblem of hard work that brings success.[4] They have looked at Dutch paintings of cheese and seen moral rottenness, looked at eels and seen the slipperiness of life. It has been noted above that both context and documentation are needed to make any such interpretation persuasive. Religious or moral symbolism requires some substantial backing in anything other than an image of the Virgin or a painting hung in a church. Not even Pieter Claesz.'s still-lifes (illus. 42, 85, 125), with their obvious symbols of *vanitas* – pipes, mirrors, watches, skulls – are necessarily assemblages of symbolic objects to be read as some diagram of salvation. Although some of the objects depicted may have symbolic value, a picture as a whole does not necessarily stand as a symbolic vision or narrative. A woman can wear a wedding ring as a symbol of her married state, but that symbol does not mean that her identity resides wholly and essentially in her role as a wife.

Giuseppe Arcimboldo's series of 'plant-portraits' of the seasons (illus. 139), painted in 1573 for the Holy Roman Emperor Rudolf II, represents a strange but more straightforward example of symbolic food painting. The artist composed clusters of fruit and vegetables to create human heads. Each of the bust-length profiles symbolizes a season of the year – and comprises appropriately seasonal food. The figure of *Summer* shows which vegetables in sixteenth-century Europe ripened during that season. There are peaches, garlic, artichoke, cherries, cucumber, peas, maize, aubergine (eggplant), strawberries and wheat. In the head of *Autumn*, there are grapes, mushrooms, pumpkin, pear, apple,

turnip and carrot. These symbolic portraits display a charming
ingenuity – a clever and witty way to personify the cycle of nature
and the fruits of man's labour through the year. They proved
immensely popular in the courts of Europe, and numerous replicas
of Arcimboldo's fascinating food portraits were produced.[5]

'Mannerist' artists in the sixteenth century delighted their
sophisticated clientele with precious artificiality, chic reversals of
expectations, crossword-puzzle-like games of allusion, and delib-
erately entangled images of open-ended meaning.[6] Arcimboldo's
paintings fit the Mannerist mould, although unlike many such
works they are not inexplicable. Like celebration pictures, these
seasonal personages represent time, making us aware of both the
infinitely repetitive replenishment of nature and the inevitable
withering of our earthly bodies. But it would be wrong to become
too doleful or grave. Arcimboldo's paintings, created amidst fash-

ionable court life, brim with entertainment (perhaps to alleviate the fits of depression of the patron, Rudolf II). The heads are arch caricatures, with a host of visual puns – peas for teeth, pumpkin for noggin, etc. The amusement links these Mannerist images to the rest of food painting – food is almost always joyful. But unlike most of the other works examined here, they have no naturalistic context or explanation. They do not represent a meal, or a kitchen, or a market. The symbolic message – representations of the season – cannot be understood as occurring in normal circumstances. One could claim the January scene of the duc de Berry's feast (illus. 67) as an equivalent picture of a season. But the narrative and the banquet setting make the Limbourg brothers' calendar page a fundamentally different kind of portrait from Arcimboldo's. The sixteenth-century paintings symbolize not only time, but also abundance – the fruits of the earth create these figures of fertility. Market scenes by Aertsen, Beuckelaer, Campi and so many others in subsequent centuries declared that same vision of fecundity and eternal food supply – but in more mundane terms. Meaning, however, is not the same as symbol.

Pieter Bruegel the Elder's *Land of Cockaigne* (illus. 140), however, is a genuinely symbolic painting, with food as its prime subject. It depicts a legendary place of gluttonous delight. Cockaigne represents a utopia for those who want to eat endlessly and without care. A thirteenth-century French poem describes Cockaigne as paved with pastries and its houses made of edibles – rather like the witch's cottage in the tale of Hansel and Gretel.[7] Three big-bellied men sprawl on the ground in the centre of Bruegel's image. Each represents a different social class (knight,

140 Pieter Bruegel the Elder, *Land of Cockaigne* (1567), oil on panel. Alte Pinakothek, Munich.

peasant and burger), and each has eaten to his heart's content.
They are so full that they are unable to get up. Their forms splay
outward from the table built round a tree that holds the remains
of their repast. At the left stands a sheltering cottage with pies on
its roof for yet more gorging. At the right a goose and a pig appear
ready for slaughter, and in the distance a peasant eats his way
through a mountain of porridge.

Art historians have tended to interpret the painting, like many
others by Bruegel, as a moral condemnation, a satirical picturing
of swinish mankind's stupid pleasures.[8] It is true that the painting
of Cockaigne illustrates man's weak nature, and the pathetic
creature's material hankerings. Bruegel had similarly designed
engravings of various sins, including gluttony, and had also
produced engravings of the Seven Virtues (1559–60). Most of
the pictures of Virtue, it might be noted, delicately and wryly
defy their titles – in small details and marginal symbols. They
hint that Justice is not always just; Faith can be impious; and
Hope does not have much hope. It seems possible that some
similarly sophisticated, double-edged attitudes pervade Bruegel's
Land of Cockaigne as well. For all its foolish dreams of animal
contentment, the painting shows men satisfied with their lot.
They doze dreamily, look up at the sky with blissful expression,
and certainly do not face any horrible consequence. There is
nothing to fear. More pies and porridge await them. They do
not seem grotesque enough or disgusting enough to generate our
disdain or our pity. In fact, this land of eternal food looks rather
attractive. It belongs to the same world of Aertsen's market
pictures of the same date (illus. 15, 24). One can see both criticism
and delight in the same imagery – and again, perhaps, what is
most significant is the linkage of food and physical pleasure,
whether condemned or praised.

This double message was not peculiar to the sixteenth century.
Wayne Thiebaud's painting of pies of 1963 (illus. 29), with the
gooey goods arrayed in a pattern that suggests infinite extension,
can be read as a satire on crass American taste and mass produc-
tion. But like Bruegel's work, some attractive elements mitigate
or even deny the critical stance. The paint pigment is luscious,
richly buttered onto the canvas, and the colours of the pies are
not nauseatingly garish, but wonderfully subtle – creams and tans
mingle with delicate reds and bluish tints. Thiebaud's cafeteria
desserts look tasty. Bruegel and Thiebaud both seem to deride
man and society through foodstuffs, but this does not matter.
What both paintings play with, and depend on, is the connection
of food and pleasure. Despite the intentions or first impressions,

what succeeds and lasts longest in such works is the attractiveness of edibles.

Bruegel's *Land of Cockaigne* represents an earthly paradise. In most of Western art, images of grand joy depict religious visions, after-lives of holy contentment. Food suggests the earthly, the material, the world we live in. And what Bruegel's painting, and indeed many other food paintings, offer the viewer is an alternative heaven, a physical heaven of satisfaction here and now. It is hardly surprising that food and bodily delight should go together. But in conceiving of ideal conditions and places, Western artists usually neglect physical feelings – Raphael in the Vatican presented mighty cloud banks, and Byzantine artists in Ravenna depicted other-worldly realms of shining gold. Many food paintings present a humbler picture of deep pleasure, drawn from everyone's physical experience, a joy linked to the real world. Despite all the genuflecting to morality and religion, artists reserved some of their sincerest expressions of satisfaction for the painting of food.

Bruegel's *Cockaigne* and Arcimboldo's *Summer* belong to the world of secular food symbolism, and so too do several works of the sixteenth-century Mannerists. But many Mannerists, unlike Bruegel and Arcimboldo, favoured seemingly symbolic messages and narratives that are not fully understood. François Clouet's *Lady at her Bath* (illus. 141) exemplifies the Mannerist allegory.

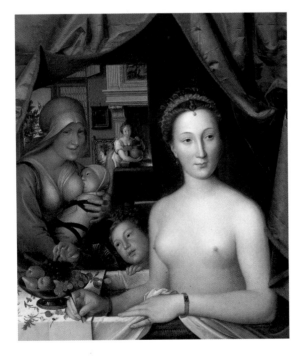

141 François Clouet, *Lady at her Bath* (*c.* 1550–70), oil on panel. National Gallery of Art, Washington, DC.

The sexy nude in her draped bathtub probably represents a royal mistress, but which mistress of which French king remains in question. Amid the curious figures and props, which include a wet nurse, a maid with water and a painting of a unicorn, a young boy attempts to grab some fruit from a bowl. The painting never quite crystallizes into a legible story, and the fruit remains an ambiguous symbol.

Late nineteenth-century Symbolism bears some similarity to Mannerism. Symbolist artists also deliberately dwelled on ambiguity and emblematic strangeness in their works, including food paintings. But they created mysteries to fight materialist understandings of the world. Paul Gauguin's *Still-life with Puppies* (illus. 142) admirably represents a Symbolist picture of food. It shows a casserole of milk with fruit and goblets, and defies a simple interpretation. Something ritualistic seems to be happening in this painting, where our sense of normal space and size evaporate. The three blue goblets, each with a small Cézannesque apple, and the puppies, also three in number, suggest something more than just an odd feeding place for pets. A mystery of grand significance plays out here, and food occupies a significant place. Gauguin, like Clouet, refused to state anything clearly, but things symbolic are certainly implied. Nineteenth-century Symbolists, like sixteenth-century Mannerists, delighted in the unnatural and the enigmatic, and food sometimes animated the paintings of both groups of artists, adding a discordant touch of earthy substance.

Clouet's *Lady at her Bath* possesses sexiness as well as mystery. Sex and food imagery was discussed briefly in chapter One, in connection with the sexuality of foodstuffs in market paintings, in which the shape, name and legends of various edibles stimulated erotic meanings. Paintings of oysters also raised the topic. Sexual possibilities may be perceived too in many other works discussed – from Sánchez Cotán's melon (illus. 62) to Oudry's dead animals (illus. 34). The healthful vigour of food as well as its profligate forms persistently invite erotic associations.

In twentieth-century food paintings, one would expect a strong sexual thrust from Surrealist painters, mostly followers of Freud, in their explorations of the unconscious through free association, automatism and the description of dreams. But although there are some erogenous foods in Surrealist art, there are fewer than one might expect. The joyous spirit of most food subjects destroys the psychological gravity needed for serious sexual investigation. A painting by René Magritte of 1935 entitled *The Portrait* (illus. 143), in which a ham steak on a plate stares back at us with a single eye, appears devoid of sexual intimations. The image, however,

142 Paul Gauguin,
Still-life with Puppies
(1888), oil on wood.
Museum of Modern
Art, New York.

in which meat refuses to be dead matter, probably reflects a
Surrealist film of 1929, *Un chien andalou* (An Andalusian dog),
by Salvador Dalí and Luis Buñuel. In the film, a close-up of an
animal's eye (presented as if it were a woman's eye) is slashed with
a razor, and sadistic sexuality runs rampant.[9] Furthermore, eyeballs
for Freudians, of course, were merely substitutes for testicles –
remorseful Oedipus plucked out his eyes. Still, the sexuality is
oblique. Surrealists, like Mannerists and Symbolists before them,
sought ambiguity and strangeness – because the unconscious mind

143 René Magritte, *The Portrait* (1935), oil on canvas. Museum of Modern Art, New York.

was irrational. But beyond the bizarre in the Magritte, there is also a meal subject ever so slightly off course. The overturned fork rests on the wrong side of the plate, and a water tumbler stands next to the wine. The improper table setting helps to unbalance the scene and assists the Surrealist tone – but does not eroticize the image.

Perhaps the most impressive Surrealist suggestion of sexuality in food is by the Surrealist-influenced American painter Peter Blume. His *Vegetable Dinner* of 1927 (illus. 144) offers erotic symbolism without doting on the fantastic, or the obvious, or the mythical. In

144 Peter Blume,
Vegetable Dinner
(1927), oil on canvas.
National Museum of
American Art
(Smithsonian
Institution),
Washington, DC.

Blume's painting, a woman at the left, cigarette in hand, sits at a counter, where another figure, perhaps male – but uncertainly so – pares fleshy, anatomical vegetables with a sharp, dangerously held knife. While the figure at the right slices a potato, tumescent carrots and protuberant squash await dissection. The left-hand woman's dress pulls across her body intimately, her staring, profile head – hieratic, Egyptian? – seems like that of a sleepwalker. Through the window we see boats at full sail, a stormy sky and rough waters on the New England coast. The violent action of the outdoor scene gives the indoor events, by contrast, an unearthly quiet, as if the food preparation was in slow motion. The aggressive landscape might represent, given the psychological concerns of Surrealism, interior worlds, the feelings of these superficially calm people.

No one in Blume's painting wears squash as breasts or puts a carrot between legs, but the sexuality and yearnings of the image capture the sexual power of food. The painting is too vague, too open-ended, to be called a symbolic depiction of food – but it certainly cannot be placed in the same category as those sixteenth- and seventeenth-century kitchen and market images of chapter Two. It is not the eroticism that makes Blume's picture different – many of Aertsen's and Beuckelaer's peasants possess

sexual associations – but the mood, making it a nebulous dream vision instead of a down-to-earth description.

James Rosenquist's *I Love You with my Ford* of 1961 (illus. 145) is a more recent sexually allusive food painting, but it is much less mysteriously symbolic than Blume's or Magritte's work. Like many other paintings by this Pop artist, *I Love You with my Ford* displays popular culture to express emotional experience. Rosenquist in many interviews and comments repeatedly refers to his billboard-like paintings as souvenirs of personal experience and revelations of his psychological states.[10] *I Love You with my Ford* uses a car ad and a movie fragment evidently to recall or portray backseat sex vividly. And the Chef Boyardee spaghetti at the bottom of the painting, cribbed from a can label or magazine advertisement, symbolically refers to the guts, the emotional power of the act of love. The spaghetti might refer to ejaculation, but it is more likely that Rosenquist merely intended this food to represent metaphorically the feelings of the moment depicted. Although he made a number of works that criticized the American government and political situations, most of his paintings of the 1960s appear to avoid the critical spirit of Pop Art and remain sincere sentimental expressions. In *Ford*, Rosenquist did not depend on traditional food imagery, but responded to

145 James Rosenquist, *I Love You with my Ford* (1961), oil on canvas. Moderna Museet, Stockholm.

146 Oskar Kokoschka,
The Red Egg (1940),
oil on canvas.
Nàrodní Gallery,
Prague.

the gooey, explosive and powerful visions of food created by
Madison Avenue. Whether naïve or satirical, Rosenquist, like other
food painters in the 1960s, broke away from the conventions of
the food subjects established by the Dutch in the seventeenth
century.

Another twentieth-century symbolic food painting, this time
without sexual suggestion, is Oskar Kokoschka's *The Red Egg*
(illus. 146). In this complex image Kokoschka attempted to com-
ment on world politics and to represent the sad state of his Czech
homeland. Czechoslovakia appears as a broken red egg on a plate
with four forks. This small piece of food is to be cut up and
devoured by the powers of Europe that surround the dining table.
The British lion, a French cat, Italy's Mussolini and Germany's
Hitler all appear. Next to the dining table in the centre of the
painting is the name of the agreement of 1938 that permitted the
destruction of Czechoslovakia – the Munich Pact. This permitted
Germany to take over the Sudetenland region of Czechoslovakia –
and the rest of the country was soon conquered. The painting
makes a bitter and ironic statement. Kokoschka completed it in
1940, when the world war that the Munich Pact intended to avert
was in full swing. The painting seems uneasy. Symbolic details
and realistic portraits exist side by side, as do illusionistic space
and illogical scale relationships. The red colour of the egg is not
necessarily a political designation, but merely a means to indicate
the symbolic, unnatural character of the food item.

Kokoschka's cumbersome and confused painting hardly speaks well of the power of food imagery to treat political themes. Bartholomeus van der Helst's painting of a banquet to celebrate the Peace of Münster (illus. 73) more successfully uses food to express political meanings. The Peace of Münster in 1648 had brought the Thirty Years War to a close and also ended the 80 years of war over the division of the Netherlands. The feasting scene shows warriors, civic guards, happily at peace. There is no piling up of detailed references.

Decorative food seems more simple. In many fifteenth-century manuscript illuminations, the margins and backgrounds of the religious subjects and narratives frequently include colourful decorative food. The victuals act rather like wallpaper. They appear as an embellishing pattern, and most of the time have nothing to do with the main subject.[11] Significantly, in almost every such case, the decorative food is fruit. This appreciation of the beauty of fruit also lies behind the endless still-lifes of grapes and peaches, oranges, plums and cherries that spill down the history of art from Caravaggio's fruit basket of *circa* 1600 (illus. 5). In time, depictions of fruit were about visual delight rather than savoury nourishment, but even here there may be symbolic overtones.

Cézanne's fruit is important here. Cézanne's followers considered his fruit paintings purely formal arrangements, but also celebrated these supposedly meaningless images of good design as 'symbols' of art independent of gross reality. The seeds of such formalist notions already seem to appear in the innumerable baskets of fruit by a thousand painters after 1600. Beauty is fruit; fruit is beauty – and representative of art itself. In other words, paintings of fruit are often not so much pictures of dessert as they are triumphs of art. The still-life, particularly the fruit still-life, became an aesthetic concoction, virtually devoid of meaning as things to eat – it became a purely decorative subject. Picasso's innumerable paintings of bowls of fruit, whether Cubist or Surrealist, often fit this description. Still life lends itself to purely artistic manipulation – it is a subject arranged by the artist. And the beauty of fruit no doubt encouraged that aestheticism, that devotion to the purely artistic over the demands of everyday subject matter.

An artist such as Chardin could make all sorts of food beautiful – a brioche, or even a glass of water (illus. 48, 69). But in the history of food painting, if an artist wants to dabble in the purely decorative, he usually turns to colourful fruit. It is difficult, however, to remain meaningless. Decorative beauty often acquires symbolic power, and this is especially true in numerous portraits

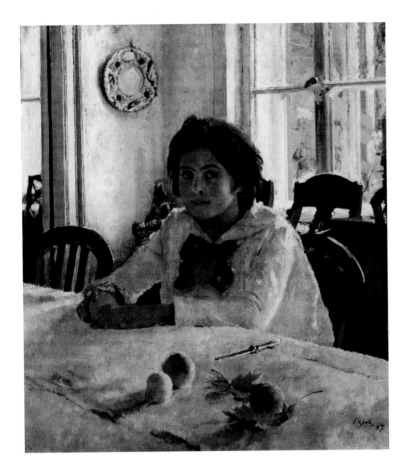

147 Valentin Serov,
*Vera Mamontova (Girl
with Peaches)* (1887),
oil on canvas. State
Tretyakov Gallery,
Moscow.

of women with fruit. Such images are echoes of the Judgement of
Paris, that mythical beauty contest, as has already been mentioned.
Even Valentin Serov's portrait of Vera Mamontova of 1887, also
titled *Girl with Peaches* (illus. 147), belongs to this tradition. The
ancient myth remains only a hint here. The sitter is not a *femme
fatale*. But sexual attractiveness, as well as decorative beauty, is
embedded in the myth. Beauty for the sake of beauty, and beauty
as a symbol of erotic power, are both suggested. The decorative
and the symbolic merge.

Serov's sweet young woman gazes expectantly out of this
Impressionist-like painting. She holds a peach in her hands, and
another three peaches lie on the cloth-covered dining table, with
a knife and several autumn leaves. There is no place setting to
suggest a formal meal – the leaves imply an informal occasion; the
table is a mere repository for beautiful seasonal decoration from
a walk in the woods. Serov's painting portrays an easy-going and
well-to-do existence in the country. Vera Mamontova might eat

the fruit. There is a knife to cut the peaches. But there is no firm evidence of this. She merely holds a peach without any preparatory gestures of consumption. The fruit really functions, it seems, as a symbol of the young woman's beauty, her fresh, healthy vitality, her glowing colour. This role for the peaches ends up as a kind of surreptitious symbolism – not very bold and definite, but a background murmur of emblematic meaning. The fruit here are like the flowers in numerous other portraits of women – delicate allusions to physical beauty. To understand the subtle power of fruit in female portraiture, all one has to do is to substitute imaginatively a beef jerky or herring or a bowl of beans or a roast chicken for the fruit. The woman becomes then a laughing stock instead of a figure of decorative beauty. Only fruit, it seems, can give such a painting august symbolic depth.

* * *

In the later twentieth century, colour photographs transformed the world of cookbooks and culinary magazines and the history of food imagery. The endless glowing photos of slices of seared beef with a pink centre topped with basil and truffles, or desserts with puffs of whipped cream and chocolate, have made most foods as visually appealing as traditional paintings of fruit. Even the likes of bean soup and farina are made to look exciting through colour enhancement, glorious surroundings, spectacular lighting and the close-up. But through most of the history of food painting, this sort of retinal delight resided primarily in fruit.

The food imagery of such publications as *Gourmet Magazine* also makes us aware that beauty can stimulate the appetite. Everything looks tasty and our stomach juices start to flow. That ancient recommendation for health – a healthy appetite – continues, and if most food paintings of the past fail to equal the dazzle of modern advertising, this does not mean that they did not aim to produce a similar stimulating effect. Like *Gourmet Magazine*, the history of food paintings, with only a few exceptions, presents a vision of happiness. Like those articles in modern food publications that warn of high cholesterol amid images of glorious meals, the introduction of signs of death in various sixteenth- and seventeenth-century paintings fails to counter the overwhelming satisfaction of the food imagery as a whole. It seems that the deepest source of this satisfaction resides not in health, or the calming of hunger, but in the fetishistic sense of human control offered by the representation of food.

In the fifteenth century food in art remained incidental to larger narratives. Salome dances before Herod – with food on the table. The bread and wine of paintings of the *Last Supper* are significant, but the focus is on Christ's actions and words and not on the eating. Most of the images serve Christian aims first and the qualities of edibles second. Even the duc de Berry's New Year celebration takes place within the pages of a devotional book of hours. Not all fifteenth-century food pictures bear religious instruction. Botticelli's tale of Nastagio degli Onesti takes place in a distinctly secular world – but the outdoor banquet does not play a primary role in the story. Food first became important in sixteenth-century art. Sixteenth-century food paintings led to the explosion of vital food imagery in the seventeenth century, and that art in turn influenced the representation of food for 300 years. Claesz. and Rembrandt and Snyders and other food painters of the seventeenth century would never have developed their imagery had not masters of the sixteenth century shown the way.

Chardin and Manet and Matisse elaborated the dictates of these seventeenth-century food painters, and Warhol, near the finale of our history, mocked the same dictates. But, again, we should remember that food first became important in sixteenth-century art. Those astounding paintings by Aertsen and Beuckelaer, where everyday food rises up large and biblical story sinks into obscurity, are not the only works of the sixteenth century to set the new course. Bruegel's *Cockaigne*, *Fight Between Carnival and Lent* and *Peasant Wedding* made food a chief ingredient of art. So too did Carracci's low-class genre paintings of the 1580s, the *Bean Eater* and the *Butcher's Shop*. The developments of the sixteenth century eventually produced Caravaggio's isolated basket of fruit of *circa* 1600, in which food became an independent subject of art, treated with care by one of the great masters of painting. This book has emphasized the fetishism of food paintings, and the power of man to govern his representation of survival, to reconstruct nature, to determine his existence. That very notion fits well with sixteenth-century ideals, optimistic Renaissance celebrations of the power and dignity of humans. Food painting embodied not just the growing secularism of the Renaissance, but, more important, the confident human-centredness of that period. And food painting carried the Renaissance spirit far into the history of art.

References

INTRODUCTION

1 J. A. Brillat–Savarin, *The Physiology of Taste; Or, A Meditation on Transcendental Gastronomy*, trans. M.F.K. Fisher (New York, 1949), p. 2.

2 On the imagery of death and the condemnation of worldly pleasures in Dutch art of the sixteenth and seventeenth centuries, see J. G. van Gelder, 'Van Blompot en Blomglas', *Elsevier's Geïllustreerd Maandschrift*, XLVI (1936), pp. 73–82; Ingvar Bergstrom, *Dutch Still-life Painting in the Seventeenth Century* (London, 1956), pp. 154–90; Eddy De Jongh, 'Realisme en schijnrealisme in de Hollandse schilderkunst van de zeventiende eeuw', in *Rembrandt en zijn tijd*, exh. cat., Paleis voor Schone Kunsten, Brussels (1971), pp. 143–94; E. De Jongh *et al.*, *Still-life in the Age of Rembrandt*, exh. cat., Auckland City Art Gallery (1982). Alan Chong, 'Contained under the Name of Still Life: The Associations of Still-life Painting', in A. Chong and W. Kloek, *Still-life Paintings from the Netherlands, 1550–1720*, exh. cat., Rijksmuseum, Amsterdam, and Cleveland Museum of Art (1999), pp. 11–36.

3 On the ancient system of temperaments and the balancing of foods, see Terence Scully, *The Art of Cookery in the Middle Ages* (Woodbridge, Suffolk, 1995), pp. 41 ff, and Gunnar Ottoson, *Scholastic Medicine and Philosophy* (Naples, 1984), pp. 127–94. The human body, according to Galen, Hippocrates and others, contained four basic fluids, or humours: black bile, yellow bile, blood and phlegm, each related to the four elements (and each also tied in many cases to astrological forces).

4 See the fourteenth-century recipes of the French royal chef, Taillevent, in Terence Scully, *The Viandier of Taillevent* (Ottawa, 1988). See also Emilio Faccioli, ed., *Arte della cucina: libri di recette testi sopra lo scalco, il trinciante e i vini del XIV al XIX secolo*, 2 vols (Milan, 1966).

5 The four mid-sixteenth-century paintings by Beuckelaer were in 2001 acquired by the National Gallery, London.

6 See Alan Davidson, ed., *The Oxford Companion to Food* (New York, 1999), under 'Humours'.

7 The connection of apples with the sin of Eden probably in part depends on a Latin pun: *malum* can mean both 'apple' and 'evil'. In early Jewish writings the fruit of the tree of knowledge was described variously as the grape, fig, wheat, palm or lime. In Christian literature, apples were associated with the Tree of Knowledge by the fourth century. See Meyer Schapiro, 'The Apples of Cézanne: An Essay on the Meaning of Still-life', in *Modern Art: 19th & 20th Centuries. Selected Papers* (New York, 1978), p. 35, n. 36. In painting throughout the Middle Ages and into the early Renaissance, apples most frequently appear in Eden, but other fruits sometimes crop up. In the van Eycks' altarpiece of the *Adoration of the Lamb* of 1432 (Cathedral of St Bavo, Ghent), for example, Eve holds some kind of citrus fruit. A work from the sixteenth century or later that shows anything but an apple in Eden is unknown to me.

8 On Cassatt's murals for the World's Columbian Exposition of 1893 in Chicago, and the quotation cited above, see Griselda Pollock, *Mary Cassatt: Painter of Modern Woman* (London, 1998), pp. 40–41.

9 See Howard Hibbard, *Caravaggio* (New York, 1983), pp. 80–85.

10 *Ibid.*, pp. 17–18, 40–43.

11 In the case of the Judgement of Paris, there is no uncertainty about the kind of fruit – an apple is the prize in all extant references to the myth.

12 The hierarchy of subject matter has its origins in ancient writings on poetry. On the low status of still-life painting, see M. Kirby Talley, '"Small, usuall, and vulgar things": Still-life Painting in England, 1635–1670', *Walpole Society*, XLIX (1983), pp. 133–223; Guido M. C. Jansen, '"On the Lowest Level": The Status of Still Life in Netherlandish Art Literature of the Seventeenth Century', in *Still-life Paintings from the Netherlands*, pp. 51–7.

13 On the dating of Caravaggio's *Basket of Fruit*, its northern European precedents and the status of the image as the first Italian still-life painting, see Sybille Ebert-Schifferer, 'Caravaggios *Früchtkorb*: das früheste Stilleben?', *Zeitschrift für Kunstgeschichte*, LXV/1 (2002), pp. 1–23.

14 Charles Pierce, *Le dîner à la Russe* (London, 1857), as quoted in Valerie Mars, 'A la Russe: The New Way of Dining', in *Luncheon, Nuncheon and Other Meals*, ed. C. Anne Wilson (London, 1994), p. 124.

15 On *Cloaca*, see *Cloaca / Wim Delvoye*, exh. cat., New Museum of Contemporary Art, New York (2001), and Dan Cameron *et al.*, *Wim Delvoye: Cloaca. New and*

Improved (Milan, 2002).

16 See Karl Marx, *Das Kapital*, in *The Pelican Marx Library* (Harmondsworth, 1975). The theory of commodity fetishism is elaborated and analysed in G. Lukacs, *The History of Class Consciousness* (London, 1971), and J. Derrida, *Spectres of Marx* (Chicago, 1994). See also Hal Foster, 'The Art of Fetishism: Notes on Dutch Still Life', in *Fetishism as Cultural Discourse*, ed. E. Apter and W. Pietz (Ithaca, NY, and London, 1993), pp. 251–65.

17 See Sigmund Freud, 'Fetishism', in *Standard Edition of the Complete Work of Sigmund Freud*, ed. J. Strachey, vol. XXI (London, 1961), pp. 149–58, and 'Splitting the Ego in the Process of Defence', *ibid.*, vol. XX (1964), p. 276.

18 Schapiro, 'Apples of Cézanne', pp. 1–38.

19 On Warhol and the reception of his works, see K. McShine, *Andy Warhol: A Retrospective*, exh. cat., Museum of Modern Art, New York (1989); *Andy Warhol: Heaven and Hell Are Just One Breath Away! Late Paintings and Related Works, 1984–1986*, exh. cat., Gagosian Gallery, New York (1992); Georg Frei and Neil Printz, eds, *The Andy Warhol Catalogue Raisonné*, vol. I (London, 2002).

20 Keith Moxey, *Pieter Aertsen, Joachim Beuckelaer and the Rise of Secular Painting in the Context of the Reformation* (New York, 1977), pp. 117–19, n. 1.

21 See John Loughman and John Michael Montias, *Public and Private Spaces: Works of Art in Seventeenth-Century Dutch Houses* (Zwolle, 2000), pp. 40–41.

22 *Ibid.*, pp. 40–42 and *passim*. See also John Michael Montias, *Artists and Artisans in Delft* (Princeton, NJ, 1982), chapter 8.

23 The tailor's shop painting, from 1653, is by Quirijn van Brekelenkam, in the Worcester Art Museum, Worcester, MA. The painting of the marble-floor room is by Pieter Janssens Elinga, in the Hermitage, St Petersburg.

24 John Loughman, 'The Market for Netherlandish Still Lifes, 1600–1720', in *Still-life Paintings from the Netherlands*, p. 88.

ONE

1 For example, Dirk Bouts painted the fall of manna in one panel of an altarpiece devoted to the *Seven Sacraments* (1464–7; St Pierre, Louvain). Bouts positioned the image near a larger panel of the *Last Supper*, where Christ holds a Eucharistic wafer in his hand. The typological connection is obvious. And in a fresco of 1564 by Alessandro Allori (Palazzo Vecchio, Florence), the wafer and chalice of the Eucharist appear above a scene of the fall of manna.

2 See Stephen Mennell, 'On the Civilizing of Appetite', in *Food and Culture: A Reader*, ed. C. Counihan and P. van Esterik (New York and London, 1997), pp. 315–37; Norbert Elias, *The Civilising Process*, 2 vols (Oxford, 1978–82).

3 Cited in Mennell, 'On the Civilizing of Appetite', pp. 327–8.

4 Thomas Archer, *The Pauper, the Thief and the Convict* (London, 1865).

5 Maguelonne Toussaint-Samat, *History of Food*, trans. A. Bell (New York, 1988), pp. 307–8, 313, 357. See also Marjorie Brown, 'The Feast Hall in Anglo-Saxon Society', and A. S. Weber, 'Queu du Roi, roi des Queux: Taillevent and the Profession of Medieval Cooking', both in *Food and Eating in Medieval Europe*, ed. Martha Carlin and Joel T. Rosenthal (London and Rio Grande, 1998), pp. 12 and 155.

6 There are two versions of Aertsen's *Butcher's Stall*, one in Uppsala, Sweden (illus. 14), and one in the North Carolina Museum of Art, Raleigh, the latter discovered in 1993. Both bear the date 1551, and both are certainly by Aertsen. Some scholars believe that the North Carolina painting is the earlier version. See *Still-life Paintings from the Netherlands*, no. 1.

7 On the innovations of Aertsen, see Moxey, *Pieter Aertsen*, pp. 1–5.

8 On Classical references to still-life paintings and their importance for later Western artists, see Eberhard König, Christiane Schön *et al.*, *Stilleben: Geschichte der klassische Bildgattungen in Quellen-texten und Kommentaren* (Berlin, 1996), and Alan Chong, 'Contained under the Name of Still Life: The Associations of Still-life Painting', in *Still-Life Paintings from the Netherlands*, p. 20. On Classical literary sources specifically relevant to Aertsen's markets, see Margaret A. Sullivan, 'Aertsen's Kitchen and Market Scenes: Audience and Innovation in Northern Art', *Art Bulletin*, LXXXI (2 June 1999), pp. 236–66.

9 See Charles Sterling, *La nature morte de l'antiquité à nos jours* (Paris, 1952).

10 See George Marlier, 'Het Stilleven in de Vlaamsche Schilderkunst der XVIe Eeuw', *Jaarboek van de Koninklijk Museum voor Schoone Kunsten, Antwerpen* (1941), pp. 89–100; J. A. Emmens, '"Eins aber ist notig": Zu Inhalt und Bedeutung von Markt- und Kuchenstucken des 16. Jahrhunderts', *Album Amicorum J. G. van Gelder* (The Hague, 1973), pp. 93–101.

11 See Walter Friedlander, *Die Altniederlandische Malerei*, 14 vols (Berlin and Leiden, 1924–37), vol. XII, p. 113; Moxey, *Pieter Aertsen*. There are some other interpretations as well. Elizabeth Alice Honig, in *Painting and the Market in Early Modern Antwerp* (New Haven, CT, 1998), sees some of Aertsen's markets as pictures about deception and perception, and idolatry and seduction. Reindert Falkenburg, on the other hand, relates Aertsen's innovations to the rhetorical strategy called ironic eulogy, as employed, for example, by Erasmus; see R. Falkenburg, 'Matters of Taste; Pieter Aertsen's Market Scenes, Eating Habits and Pictorial Rhetoric in the Sixteenth Century', in *The Object as Subject*, ed. Anne W. Lowenthal (Princeton, NJ, 1996), pp. 13–28.

12 Howard Davis made this interpretation in discussions at Columbia University in the early 1970s.

13 For the less-than-convincing view that Soutine and other Jewish artists, in painting such carcasses, had ritual sacrifice in mind, see Avigdor Poseq, 'The Hanging Carcass Motif and Jewish Artists', *Jewish Art*, XVI/XVII (1990–91), pp. 139–56.

14 See Barry Wind, 'Annibale Carracci's "Scherzo": The Christ Church *Butcher Shop*', *Art Bulletin*, LVIII (1976), pp. 93–6. In his footnotes Wind admirably summarizes

earlier interpretations of the Carracci butcher painting, including those of D. Posner, who sees the work as an example of pure realism, and J. R. Martin, who sees the work as an allusion to the studio (*bottega*) of the Carracci. Wind also notes interpretations of meat stalls as *vanitas* images.

15 On hunting privileges and hunt imagery, see Susan Koslow, *Frans Snyders: The Noble Estate; Seventeenth-century Still-life and Animal Painting in the Southern Netherlands* (Antwerp, 1995), pp. 219–57.

16 On Delacroix's *Still Life with Lobsters*, see Barthélémy Jobert, *Delacroix* (Princeton, NJ, 1998), pp. 99–100, and Lee Johnson, *The Paintings of Eugène Delacroix: A Critical Catalogue*, 6 vols (Oxford, 1981–9), vol. I, p. 171.

17 Nancy Ann Finlay, 'Animal Themes in the Painting of Eugène Delacroix', PhD thesis, University of Michigan, 1982; see Jobert, *Delacroix*, pp. 99–100.

18 Denis Diderot, *Oeuvres complètes* (Paris, 1876), vol. X, pp. 97–8.

19 Zoffany worked happily for George III of England, and apparently never had any interest in the revolutionary political and social movements of his era – he lived from 1733 to 1810. His beggars are ideologically closer to those portrayed by Murillo in the seventeenth century than to the ones that figure in the popular prints of the French Revolution.

20 Moxey, *Pieter Aertsen*, pp. 117–19, n. 1. See also the comments on the hanging of Dutch still-life paintings in the seventeenth century in John Loughman, 'The Market for Netherlandish Still Lifes, 1600–1720', in *Still-life Paintings from the Netherlands*, p. 95.

21 For the role of women in seventeenth-century Dutch markets, and some discussion of sexual imagery, see Elizabeth Anne Honig, 'Desire and Domestic Economy', *Art Bulletin*, LXXXIII/2 (June 2001), pp. 294–315. Honig sees female vendors in Dutch paintings as almost always un-eroticized. For a critical consideration of the status of women and the likening of apples to breasts in later market imagery, see Linda Nochlin, 'Eroticism and Female Imagery in Nineteenth Century Art', in *Women, Art and Power, and Other Essays* (New York, 1988). Most of the twentieth-century literature on Dutch still-life notes the sexual implications of various foods.

22 Honig, 'Desire and Domestic Economy', p. 294.

23 Translated and commented on by Corinne Mandel, 'Food for Thought: On Cucumbers and their Kind in European Art', in *Foodculture*, ed. B. Fischer (Toronto, 1999), p. 53. The painting by Giovanni da Udine is in the Loggia of Psyche, Villa Farnesina, Rome.

24 On the history of modern food processing, see Jack Goody, 'Industrial Food', in *Food and Culture*, chapter 24.

25 On the rapid growth of advertising and the corporate organizations it served from 1850 to 1930, see Clemens Wischermann and Elliott Shore, eds, *Advertising and the European City: Historical Perspectives* (Aldershot, Hampshire, 2000), pp. xvii, 1–31.

26 See the background, for example, of the right-hand panel of Robert Campin's *Annunciation* (or *Mérode*) *Triptych*, c. 1425, Metropolitan Museum of Art, New York.

27 See Toussaint-Samat, *History of Food*, chapter 15.

28 *Ibid.*, chapters 16 and 17.

29 *Ibid.* pp. 553–4.

30 Sidney W. Mintz, 'Time, Sugar and Sweetness', in *Food and Culture*, pp. 357–9.

31 The morally dubious aspects of Dutch trade remain largely hidden or downplayed in Dutch paintings of the seventeenth and eighteenth centuries, although Julie Hochstrasser, in a paper given at the Midwest Art History Society conference in Milwaukee in 2002, made a fascinating attempt to point out such features in a variety of Dutch paintings of the period. She has published some of her points in *The Low Countries and the New World(s): Travel, Discovery, Early Relations* (Lanham, MD, 2001), pp. 91–112.

32 From Roger Vaultier, 'La gastronomie régionale en France pendant la Révolution', *Grandgousier*, 7e année (1940), no. 4, pp. 80–81; cited in Stephen Mennell, *All Manners of Food*, 2nd edn (Urbana and Chicago, 1996), p. 62.

33 See Julie Hochstrasser, 'Feasting the Eye: Painting and Reality in the Seventeenth-century "Banketje"', in *Still-life Paintings from the Netherlands*, p. 73.

34 I must thank Natanya Blanck for identifying the vegetables in this painting by Kahlo.

35 One of the few paintings of macaroni is by an artist named J. Mieg, who in the 1820s, in a painting in the Musée des Beaux-Arts in Mulhouse, showed some lower-class people at an open-air pasta stall in Italy eating macaroni or spaghetti while standing. They eat with their hands.

36 See Robert Herbert, *Impressionism* (New Haven, CT, 1988), pp. 79–81. On Manet's picture, see also Bradford Collins, *Twelve Views of Manet's Bar* (Princeton, NJ, 1996).

TWO

1 Lévi-Strauss's chief writings on food are: 'The Culinary Triangle', *Partisan Review*, XXXIII (1964), pp. 586–95; *The Raw and the Cooked* (London, 1969); *The Origin of Table Manners* (London, 1978). The consideration of his Structuralist concepts of food – ultimately based on the structure of language – is presented here merely as an enriching approach to rethink the contents of food preparation paintings, and in no way represents an attempt to follow this writer's ideas strictly. For a critique of Lévi-Strauss's view of food, which points out his static, overly generalized, ahistorical understanding of society and his futile search for fundamental structures in eating habits, see Mennell, *All Manners of Food*, pp. 6–15.

2 Anne W. Lowenthal, 'Wtewael', in *The Dictionary of Art*, ed. Jane Turner (New York, 1996), vol. XXXIII, p. 419. See also A. W. Lowenthal, *A. W. Joachim Wtewael and Dutch Mannerism* (Doornspijk, 1986).

3 For the suggestion that the scene with Christ may be a painting on the wall or a mirror, see K. M. Birkmeyer, 'Realism and Realities in the Paintings of Velázquez', *Gazette des Beaux-Arts*, LII (July–August 1958), pp. 63–77; and N. Bryson, *Looking at the Overlooked* (Cambridge, MA, 1990), p. 152. Bryson considers the

work in terms of class distinction.

4 Cats who attack food are common in kitchen still-life painting. Like the hunting dogs who sniff hungrily at dead game, the cats may help to stimulate the appetite of the onlooker. But both the dog and cat in their respective circumstances might also be thought of as *vanitas* figures, turning bad, destroying the goods of the earth, depleting food supplies.

5 Diderot, *Oeuvres complete*, vol. X, pp. 194–5.

6 J. Lopez-Rey, 'Goya's Still-lifes', *Art Quarterly*, XI (1948), pp. 210–60. Goya's still lifes of a similar character include a scene of three lonely, bleeding salmon steaks (Oskar Reinhart Foundation Museum, Winterthur), and a butchered sheep that looks like a car wreck (Louvre, Paris); both can be dated *c.* 1808–12.

7 See Robert Rosenblum, *Transformations in Late Eighteenth-century Art* (New York, 1960).

8 For religious and austerely monastic interpretations of Sánchez Cotán's still-lifes, see Sterling, *La nature morte*, pp. 70–71, and Bryson, *Looking at the Overlooked*, p. 66.

9 See William B. Jordan and Peter Cherry, *Spanish Still Life from Velázquez to Goya*, exh. cat., National Gallery of Art, London (1995), p. 29.

10 See chap. One, n. 2 above.

11 Simon Schama, *An Embarrassment of Riches: An Interpretation of Dutch Culture in the Golden Age* (New York, 1987).

12 See Toussaint-Samat, *History of Food*, pp. 297–308.

13 See Mariet Westermann, *The Amusements of Jan Steen: Comic Painting of the Seventeenth Century* (Zwolle, 1997), p. 49; Schama, *Embarrassment of Riches*, pp. 153–8; and H. Perry Champman *et al.*, *Jan Steen, Painter and Storyteller*, exh. cat., National Gallery of Art, Washington, DC (1996), pp. 103–8.

14 See above, Introduction, n. 18.

THREE

1 See Mark Girouard, *Life in the English Country House* (New Haven and London, 1994). On the gradual change in eating rooms, see C. Anne Wilson, 'From Mediaeval Great Hall to Country House Dining-room: The Furniture and Setting of the Social Meal', in *The Appetite and the Eye*, ed. C. Anne Wilson (Edinburgh, 1987), pp. 28–55.

2 On the history of forks in Western dining, see Bridget Ann Henisch, *Fast and Feast: Food in Medieval Society* (University Park, PA, 1976), pp. 188–9. The eleventh-century manuscript drawing, illustrated by Henisch, appears in Rabanus Maurus, *De universo*, in the Abbey Library of Montecassino, codex 132, bk xxii, chap. 1, *de mensis et escis*. The Montecassino manuscript is a copy of a ninth-century copy of Isidore of Seville's seventh-century universal encyclopedia.

3 See Reay Tannahill, *Food in History* (New York, 1973), p. 283. See also Stephen Mennell's doubts about this proposed history in Mennell, *All Manners of Food*, pp. 63–9. La Varenne's cookbook, *Le cuisinier françois*, of 1651 is often cited as the clearest literary evidence of a break with medieval cuisine. See Anne Willan, *Great Cooks and their Recipes* (London, 1977), p. 31.

4 The Templars built the original complex. French revolutionaries particularly disliked the prison tower of the Temple, and the complex was finally pulled down by Napoleon in 1811.

5 See, for example, Jean de Wavrin's illumination of the *Banquet at the Court of King Joao of Portugal* in a Netherlandish manuscript of *c.* 1500, *Chroniques d'Angleterre* (British Library, London).

6 The Montmartre restaurant and its social environment depicted by Renoir here is identified in Herbert, *Impressionism*, p. 72.

7 Leo Tolstoy, *Anna Karenina*, trans. Constance Garnett (Cambridge, MA, 1917), chapter X, Part 1.

8 The reason that cheese disappeared from later Dutch still-life paintings remains uncertain. The Dutch dairy industry, particularly cheese production, kept its fine reputation after 1625, and butter continued to appear in Dutch still-lifes. See Wouter Kloek, 'The Magic of Still Life', in *Still-life Paintings from the Netherlands*, p. 43.

9 See, for example, the German artist Georg Flegel's *Still Life with Stag Beetle* of 1653 (Wallraf–Richartz Museum, Cologne), and the Swiss painter Joseph Plepp's *Still Life with Cherries* of 1632 (State Hermitage Museum, St. Petersburg).

10 Peter Brears, 'Decoration of the Tudor and Stuart Table', and C. Anne Wilson, 'Ideal Meals and Their Menus', in *The Appetite and the Eye*, pp. 56–97 and 98–122.

11 Lowenthal, *The Object as Subject*, p. 29.

12 On Steen's disorderly home pictures, see Westerman, *Amusements of Jan Steen*, pp. 158–63.

13 On the supposed aphrodisial qualities of shellfish and oysters in particular, see E. De Jongh *et al.*, *Tot lering en vermaak: Bete Kenissen van Hollandse genre voorstellingen uit de zeventiende eeuw*, exh. cat., Rijksmuseum, Amsterdam (1976), no. 62; and H. R. Hoetink *et al.*, *Dutch Painting in the Golden Age*, exh. cat., National Gallery of Art, Washington, DC (1982), no. 32.

14 Westermann, *Amusements of Jan Steen*, p. 197, proposes that the woman in this tiny Steen sprinkles salt to 'catch the bird', with the 'bird' as penis, and a reference to the folk myth that you can catch a bird by sprinkling salt on its tail.

15 The connection of this painting with Manet's fiancée is noted on the website of the National Gallery of Art, Washington, DC.

16 A useful chronology of Matisse's life and art can be found in John Elderfield, *Henry Matisse: A Retrospective*, exh. cat., Museum of Modern Art, New York (1992).

17 See Peter Brears, '*A la française*: The Waning of a Long Dining Tradition', and Valerie Mars, '*A la Russe*', both in *Luncheon, Nuncheon and Other Meals*, pp. 91–145.

18 Tannahill, *Food in History*, pp. 279–80.

19 On the medical warnings regarding fruit and also the role of fruit as an appetite stimulator, see William Edward Mead, *The English Medieval Feast* (New York, 1967), p. 162. Le Grand d'Aussy's comments on fruit in medieval feasts, first published in 1783, are quoted in *ibid.*, p. 162.

20 R. L. Spang, *The Invention of the Restaurant* (Cambridge, MA, 2000).

21 See, for example, Jean Marie Vincent Audin, *Le veritable conducteur parisien* (Paris, 1828; reprint Paris,

1970), p. 52.

22 Spang, *The Invention of the Restaurant*, p. 34. The Bavaroise was named after the princes of Bavaria who accompanied the Princess of Bavaria at her wedding to Philippe d'Orléans; it was a speciality of Procope's coffee house in Paris; see Toussaint-Samat, *History of Food*,, p. 600

23 Brillat-Savarin, *Physiology of Taste*, pp. 325–35.

24 For a discussion of the role of the coffee house in the development of capitalist society, see Juergen Habermas, *The Structural Transformation of the Public Sphere* (Cambridge, MA, 1989), chapter 2.

25 Audin, *Le veritable conducteur parisien*, pp. 52–3.

26 Brillat-Savarin, *Physiology of Taste*, pp. 326–8.

27 See Elias, *The Civilising Process*, and Mennel, 'On the Civilizing of Appetite'.

28 See *The Complete Letters of Vincent van Gogh*, trans. J. van Gogh-Bonger and C. de Dood (London, 1979).

29 J. Kirk T. Varnedoe, 'The Artifice of Candor: Impressionism and Photography Reconsidered', *Art in America*, LXVIII (January 1980), pp. 66–78.

30 Herbert, *Impressionism*, p. 72, argues that the man in *Chez Père Lathuille* is attempting to pick up the old lady at the table. He is not her lover. Herbert sees the table as set only for one, and builds his contention on that. But it is not clear that the two people did not already know each other. In any event, the meal is at an end, as Herbert notes, signalled by the presence of the waiter with coffee.

31 See Gail Levin, *Complete Oil Paintings of Edward Hopper* (New York, 2001), no. O–322, p. 288.

32 Another 1970s artist who subtly destroyed the satisfactions of eating was Julian Schnabel. From 1978 he created paintings with broken dinner plates. The subject matter of these images rarely touches on food, but underlying (or overlying) the pictures are the platters of mealtime, smashed and thrown together to form a rough texture. Schnabel supposedly was led to use broken ceramics by the example of Antonio Gaudí, who did so as a sumptuous yet folksy decorative surface on many of his buildings. Gaudí, however, employed all sorts of pottery shards, while Schnabel used exclusively dinner plates – food accessories – to create fields of violence.

33 Caravaggio's innkeeper waits patiently, but he is really a foil for the disciples. The latter recognize the Son of God and the truth of Christ's resurrection. The innkeeper is unaware of the great truths revealed in his tavern.

34 E.g., *Merry Company*, 1620–22; Museum of Fine Arts, Budapest.

35 See, for example, David Wilkie's *Village Festival* of 1811 (Tate Britain, London) and Adam Wolfgang Toeppfer's *Country Festival* of around 1820 (Oskar Reinhart Foundation Museum, Winterthur).

36 The Pushkin Museum painting by Monet is his final sketch for a large-scale work that he was unable to complete – because of the difficulties of painting the huge canvas out of doors. He eventually cut up the large, incomplete canvas. making the largest fragment a separate painting, which now hangs in the Musée d'Orsay, Paris. This major fragment, showing the woman laying out the dinnerware, has a much more informal composition than the Pushkin Museum sketch. The random appearance

is partly due to its sliced-out history.

37 On the histories of coffee, tea and chocolate, see Gregory Kicum and Nina Luttinger, *The Coffee Book* (New York, 1999); Sophie D. Coe and Michael Coe, *The History of Chocolate* (New York, 1996); Denys Forest, *Tea for the British* (London, 1973); James Shellech, *Tea* (New York, 1972); William Ukers, *All About Coffee* (New York, 1935); William Ukers, *All About Tea* (New York, 1935); Alfred Franklin, *Le Café, le thé et le chocolat* (Paris, 1893).

38 On this still-life, see *Spanish Still Life from Velázquez to Goya*, no. 30.

39 Charles de Secondat, baron de Montesquieu, *Persian Letters* [1721] (New York, 1973). Piero Camporesi, in *Exotic Brew: The Art of Living in the Age of Enlightenment* (Oxford, 1994), sees the introduction of these exotic drinks into Europe as a sign of a new gentleness of spirit – very much in line with the views of Elias and Mennell.

40 See Edward Said, *Orientalism* (New York, 1978).

41 On van Gogh's concerns and attitude, see *The Complete Letters of Vincent van Gogh*.

42 On Signac's anarchist proclivities, see John Leighton, 'Out of Seurat's Shadow', in *Signac*, exh. cat., Grand Palais, Paris, Rijksmuseum, Amsterdam, and Metropolitan Museum, New York (2001), pp. 12–14, and no. 24 in the same catalogue.

43 On Duchamp, the chocolate grinder and the *Large Glass*, see A. d'Harnoncourt, K. McShine *et al.*, *Marcel Duchamp*, exh. cat., Museum of Modern Art, New York (1973).

44 See also John Everett Millais's *The Bridesmaid* of 1851 (Fitzwilliam Museum, Cambridge). Millais's bridesmaid, following an old custom, is passing a piece of wedding cake through a ring in order to see a vision of her future husband. She wears a sprig of orange blossoms on her bodice and has an orange on her plate. See Mary Bennett, *Millais*, exh. cat., Walker Art Gallery, Liverpool (1967), no. 33; and *The Pre-Raphaelites*, exh. cat., Tate Gallery, London (1984), no. 37.

45 A still-life painting by Zurbarán of a cup of water and a rose is in the National Gallery, London. The motif might be a reference to the Virgin – but neither oranges nor lemons, prominent in the Norton Simon painting, are usually found in pictures of the Virgin Mary.

46 The satiric interpretation of Brueghel's art is widespread, but not universal. See the summary of recent literature on Bruegel in Ethan Matt Kavaler, *Pieter Bruegel: Parables of Order and Enterprise* (Cambridge, 1999), pp. 24–28. Kavaler's chapter 4, on *The Fight Between Carnival and Lent*, is also valuable.

47 Jordaens's Twelfth Night paintings include two in Brussels (Musées Royaux des Beaux-Arts), Paris (Louvre), Vienna (Kunsthistorisches Museum), Kassel (Staatliche Museen), Celle (Schloss) and St Petersburg (Hermitage). The St Petersburg painting includes the ham.

48 See Westermann, *Amusements of Jan Steen*, pp. 158–63. On Epiphany celebrations and other standard holiday activities, see P. Burke, *Popular Culture in Early Modern Europe* (London, 1978).

49 The altarpiece dates from *circa* 1480, and its artist is

called the Master of the St Godelieve Legend.

50 On Murillo's beggar children, see Jonathan Brown, *Painting in Spain, 1500–1700* (New Haven, CT, and London, 1991), pp. 227–9. It is generally believed that, since there are no precedents for this kind of subject matter in Spanish art, Murillo developed his scenes of beggar children from Dutch and Flemish sources.

51 An overwhelming majority, but certainly not all, 'saying grace' paintings involve the young. One by Nicolaes Maes in the Rijksmuseum, Amsterdam, for example, shows an old woman praying before her Lenten repast.

52 On some different but related artistic reactions to the devastation of the First World War, see Kenneth Silver, 'Purism: Straightening Up after the Great War', *Artforum*, XV/7 (March 1977), pp. 56–63, and John Golding, *Léger and Purist Paris*, exh. cat., Tate Gallery, London (1970).

FOUR

1 See Sasha Newman *et al.*, *Félix Vallotton*, exh. cat., Yale University Art Gallery, New Haven, CT (1991); Werner Weber, *Eden und Elend, Félix Vallotton* (Zurich, 1998); Maxime Vallotton, *Catalogue raisonné de l'oeuvre gravé de Félix Vallotton* (Geneva, 1972); Marina Ducrey, *Félix Vallotton: La vie, la technique, l'oeuvre peint* (Lausanne, 1989); see also Ralph Shikes, *The Indignant Eye* (New York, 1969).

2 Emile Mâle, *The Gothic Image* (New York, 1958), p. 30. St Augustine had earlier expressed the same idea. Mâle notes, however, that many medieval representations of fruit in cathedrals and manuscripts were decorative; plants and animals did not always have a symbolic meaning.

3 Jacob Cats, *Jacob Cats: Sinne-en minnebeelden*, ed. H. Luijten (The Hague, 1996).

4 See Schama, *Embarrassment of Riches*, pp. 382–4. Eddy De Jongh has led the way in the use of emblem books to understand seventeenth-century Dutch art. Svetlana Alpers has countered De Jongh's view with an emphasis on the purely descriptive aspects of Dutch art. See S. Alpers, *The Art of Describing* (London, 1983).

5 See Pontus Hulten *et al.*, *The Arcimboldo Effect*, exh. cat., Palazzo Grassi, Venice (1987).

6 On Mannerism, see John Shearman, *Mannerism* (Harmondsworth, 1967).

7 On the Land of Cockaigne tale, which goes back to Lucian's *True History* of the second century AD and is described in Dante's *Divine Comedy* and various thirteenth- and fourteenth-century poems from France, England and the Netherlands, see V. Vaananen, 'Le "fabliau" de Cockagne', *Neuphilologische Mitteilungen*, XLVIII (1947), pp. 3–36, and Herman Pleij, *Dreaming of Cockaigne: Medieval Fantasies of the Perfect Life* (New York, 2001).

8 For example, J. Grauls, *Volkstaal en volksleven in het werk van P. Bruegel* (Antwerp, 1957), pp. 205–7; W. Gibson, *Bruegel* (New York, 1977), pp. 178–80; R. H. Marijnissen and M. Seidel, *Bruegel* (New York, 1984), p. 50; R. van der Heiden, *Pieter Bruegel der Altere* (Munich, 1985), pp. 5–28.

9 Late in life, in 1975–6, Buñuel claimed that he used a calf's eye to shoot the famous eye-slashing scene. See T. Turrent and J. de la Colina, *Conversations avec Luis Buñuel* (Paris, 1993), p. 32. But before then, many reports claimed that Buñuel had employed a pig's eye to make the horrific episode – and thus Magritte's ham steak may have referred to the Surrealist film more pointedly than it seems to do today. Even the most popular press and critics often associated the *Un chien andalou* eye-slashing with a pig. See, for example, Roger Ebert, 'Un chien andalou', *Chicago Sun Times*, 16 April 2000, p. 22.

10 See, for example, Jeanne Siegel's interview with Rosenquist in *Artforum* (June 1972).

11 A good example of this sort of decorative food appears in the manuscript of a chronicle attributed to Baudoin d'Avesne (MS KB 71 A 15, fol. 1r, 1480–90; Koninklijk Bibliothek, the Hague). The illuminations by a follower of the Master of Antoine Rolin include a picture of *Pharisees, Sadducees and Essenses in Discussion* – with strawberries scattered in the margins, with birds and leaves.

Bibliography

Thomas Archer, *The Pauper, the Thief and the Convict* (London, 1865)

J. P. Aron, *Le mangeur du XIX siècle* (Paris, 1976)

Jean-François Bergier, *Une histoire du sel* (Fribourg, 1982)

Ingvar Bergstrom, *Dutch Still-life Painting in the Seventeenth Century* (London, 1956)

H. Birkmeyer, 'Realism and Realities in the Paintings of Velázquez', *Gazette des Beaux-Arts*, LII (July–August 1958), pp. 63–77

Peter Brears, *Food and Cooking in 16th-century Britain* (London, 1985)

—, *Food and Cooking in 17th-century Britain* (London, 1985)

—, *All the King's Cooks* (London, 1999)

J. A. Brillat-Savarin, *The Physiology of Taste*, trans. M.F.K. Fisher (New York, 1949)

Marjorie Brown, 'The Feast Hall in Anglo-Saxon Society', in *Food and Eating in Medieval Europe*, ed. Martha Carlin and J. T. Rosenthal (London, 1998), p. 12

Norman Bryson, *Looking at the Overlooked: Four Essays on Still-Life Painting* (Cambridge, MA, 1990)

Dan Cameron *et al.*, *Wim Delvoye: Cloaca. New and Improved* (Milan, 2002)

Piero Camporesi, *Bread of Dreams* (Chicago, 1989)

—, *Exotic Brew: The Art of Living in the Age of Enlightenment* (Oxford, 1994)

—, *Harvest: Food, Folklore and Society* (Cambridge, 1998)

Martha Carlin and J. T. Rosenthal, eds, *Food and Eating in Medieval Europe* (London, 1998)

Georges Chaudieu, *De la gigue d'ours au hamburger* (Paris, 1980)

Alan Chong, 'Contained under the Name of Still Life: The Associations of Still-life Painting', in *Still-Life Paintings from the Netherlands, 1550–1720*, exh. cat., Rijksmuseum, Amsterdam, and Cleveland Museum of Art (1999), p. 20

— and W. Kloek, *Still-Life Paintings from the Netherlands, 1550–1720*, exh. cat., Rijksmuseum, Amsterdam, and Cleveland Museum of Art (1999)

S. D. Coe and M. Coe, *The History of Chocolate* (New York, 1996)

Brandford Collins, *Twelve Views of Manet's Bar* (Princeton, NJ, 1996)

C. Counihan and P. van Esterik, eds, *Food and Culture: A Reader* (New York and London, 1997)

C. Counihan and S. Kaplan, eds, *Food and Gender* (London, 1998)

Alan Davidson, ed., *The Oxford Companion to Food* (New York, 1999)

E. De Jongh, 'Realisme en schijnrealisme in de Hollandse schilderkunst van de seventeen eeuw', in *Rembrandt en zijn tijd*, exh. cat., Paleis voor Schone Kunsten, Brussels (1971), pp. 143–94

—, *Still-Life in the Age of Rembrandt*, exh. cat., Auckland City Art Gallery (1982)

Jean-Philippe Derenne, *L'amateur de cuisine* (Paris, 1996)

Jacques Derrida, *Spectres de Marx* (Chicago, 1994)

Denis Diderot, *Oeuvres complètes*, 15 vols (Paris, 1876)

Georges Dogaer, *Flemish Miniature Painting in the 15th and 16th Centuries* (Amsterdam, 1987)

Sybille Ebert-Schifferer, 'Caravaggios Fruchtkorb: das früheste Stilleben?', *Zeitschrift für Kunstgeschichte*, LXV/1 (2002), pp. 1–23

Norbert Elias, *The Civilising Process*, 2 vols (Oxford, 1978–82)

J. A. Emmens, '"Eins aber is notig": Zu Inhalt und Bedeutung von Markt- und Kuchenstucken des 16 Jahrhunderts', *Album Amicorum J. G. van Gelder* (The Hague, 1973), pp. 93–101

Emilio Faccioli, ed., *Arte della cucina: libri de recette testi sopra lo scalco, il trinciante e i vini del XIV al XIX secoli* (Milan, 1966)

Reindert Falkenburg, 'Matters of Taste: Pieter Aertsen's Market Scenes, Eating Habits and Pictorial Rhetoric in the Sixteenth Century', in *The Object as Subject*, ed. Anne W. Lowenthal (Princeton, NJ, 1996), pp. 13–28

B. Fischer, ed., *Foodculture* (Toronto, 1999)

F. Foster and O. Ranum, eds, *Food and Drink in History* (Baltimore, 1979)

Hal Foster, 'The Art of Fetishism: Notes on Dutch Still Life', *Fetishism as Cultural Discourse*, ed. Emily Apter and William Pietz (Ithaca, NY, and London, 1993) pp. 251–65

Georg Frei and Neil Printz, eds, *The Andy Warhol Catalogue Raisonné*, vol. 1 (London, 2002)

Sigmund Freud, *Standard Edition of the Complete Work of Sigmund Freud*, ed. J. Strachey: 'Fetishism', vol. XXI (London, 1961); 'Splitting the Ego in the Process of Defence', vol. XX (London, 1964)

Walter Friedlander, *Die altniederlandische Malerei*, 14 vols (Berlin and Leiden, 1924–37)

J. G. van Gelder, 'Van Blompot en Blomglas', *Elsevier's Geillustreerd Maandschrift*, XLVI (1936), pp. 73–82

Mark Girouard, *Life in the English Country House* (New Haven and London, 1994)

Jack Goody, 'Industrial Food', in *Food and Culture: A Reader*, ed. C. Counihan and P. van Esterik (New York and London, 1997), chapter 24

Alfred Gottschalk, *Histoire de l'alimentation et de la gastronomie* (Paris, 1948)

B. A. Henisch, *Fast and Feast: Food in Medieval Society* (University Park, PA, 1976)

Robert L. Herbert, *Impressionism* (New Haven and London, 1988)

Howard Hibbard, *Caravaggio* (New York, 1983)

Erich Hobusch, *Histoire de la chasse* (Paris, 1980)

Julie Hochstrasser, 'Feasting the Eye: Painting and Reality in the Seventeenth-century "Banketje"', in *Still-Life Paintings from the Netherlands, 1550–1720*, exh. cat., Rijksmuseum, Amsterdam, and Cleveland Museum of Art (1999), p. 73

— ,'Seen and Unseen in the Visual Culture of Trade', *The Low Countries in the New World(s): Travel, Discovery, Early Relations*, ed. Johanna C. Prins *et al.* (Lanham, MD, 2001)

Elizabeth Anne Honig, 'Desire and Domestic Economy', *Art Bulletin*, LXXXIII/2 (June 2001), pp. 294–315

Richard J. Hooker, *Food and Drink in America: A History* (Indianapolis, 1981)

Pontus Hulten *et al.*, *The Arcimboldo Effect*, exh. cat., Palazzo Grassi, Venice (1987)

Guido M.C. Jansen, '"On the Lowest Level": The Status of Still Life in Netherlandish Art Literature of the Seventeenth Century', in *Still Life Paintings from the Netherlands, 1550–1720*, exh. cat., Rijksmuseum, Amsterdam, and Cleveland Museum of Art (1999), pp. 51–7

Barthélémy Jobert, *Delacroix* (Princeton, NJ, 1998)

Lee Johnson, *The Paintings of Eugène Delacroix: A Critical Catalogue*, 6 vols (Oxford, 1981–9)

W. B. Jordan and P. Cherry, *Spanish Still Life from Velázquez to Goya*, exh. cat., National Gallery, London (1995)

E. M. Kavaler, *Pieter Bruegel: Parables of Order and Enterprise* (Cambridge, 1999)

G. Kicum and N. Luttinger, *The Coffee Book* (New York, 1999)

K. F. Kiple and K. C. Ornelas, eds, *The Cambridge World History of Food.* 2 vols (Cambridge, 2000)

Eberhard König, Christiane Schön *et al.*, *Stillleben: Geschichte der klassische Bildgattungen in Quellentexten und Kommentaren* (Berlin, 1996)

Susan Koslow, *Frans Snyders: The Noble Estate; Seventeenth-century Still-life and Animal Painting in the Southern Netherlands* (Antwerp, 1995)

Gail Levin, *Complete Oil Paintings of Edward Hopper* (New York, 2001)

Claude Lévi-Strauss, *From Honey to Ashes* (London, 1973)

—, *The Origin of Table Manners* (London, 1978)

—, *The Raw and the Cooked* (London, 1969)

José López-Rey, 'Goya's Still-lifes', *Art Quarterly*, XI (1948), pp. 210–60

John Loughman and John Michael Montias, *Public and Private Spaces: Works of Art in Seventeenth-century Dutch Houses* (Zwolle, 2000)

Anne W. Lowenthal, ed., *The Object as Subject* (Princeton, NJ, 1996)

—, *Joachim Wtewael and Dutch Mannerism* (Doornspijk, 1986)

Georg Lukacs, *The History of Class Consciousness* (London, 1971)

Corinne Mandel, 'Food for Thought: On Cucumbers and their Kind in European Art', in *Foodculture*, ed. B. Fischer (Toronto, 1999), p. 53

K. McShine, *Andy Warhol: A Retrospective*, exh. cat., Museum of Modern Art, New York (1989)

George Marlier, 'Het Stilleven in de Vlaamsche Schilderkunst der XVIe Eeuw', *Jaarboek van de Koninklik Museum voor Schoone Kunsten, Antwerper* (1941), pp. 89–100

Karl Marx, *Das Kapital*, in *The Pelican Marx Library* (Harmondsworth, 1975)

Stephen Mennell, *All Manners of Food*, 2nd edn (Urbana and Chicago, 1996)

—, 'On the Civilizing of Appetite', in *Food and Culture: A Reader*, ed. C. Counihan and P. van Esterik (New York and London, 1997)

Keith Moxey, *Pieter Aertsen, Joachim Beuckelaer and the Rise of Secular Painting in the Context of the Reformation* (New York, 1977)

Linda Nochlin, 'Eroticism and Female Imagery in Nineteenth Century Art', in her *Women, Art and Power, and Other Essays* (New York, 1988), pp. 136–44

Gunnar Ottoson, *Scholastic Medicine and Philosophy* (Naples, 1984)

H. Perry Chapman *et al.*, *Jan Steen, Painter and Storyteller*, exh. cat., National Gallery of Art, Washington, DC (1996)

Roderick Phillips, *A Short History of Wine* (New York, 2000)

Charles Pierce, *Le Diner à la Russe* (London, 1857)

Griselda Pollock, *Mary Cassatt: Painter of Modern Woman* (London, 1998)

Avigdor Poseq, 'The Hanging Carcass Motif and Jewish Artists', *Jewish Art*, XVI/XVII (1990–91), pp. 139–56

Robert Rosenblum, *Transformations in Late Eighteenth Century Art* (New York, 1960)

Redcliffe Salaman, *The History and Social Influence of the Potato* (Cambridge, 1949)

Simon Schama, *An Embarrassment of Riches: An Interpretation of Dutch Culture in the Golden Age* (New York, 1987)

Meyer Schapiro, *Modern Art: 19th and 20th Centuries. Selected Papers* (New York, 1978)

Terence Scully, *The Art of Cookery in the Middle Ages* (Woodbridge, Suffolk, 1995)

—, *The Viandier of Taillevent* (Ottawa, 1988)

Frederick Simmons, *Eat Not This Flesh: Food Avoidances from Prehistory to the Present* (Madison, WI, 1997)

R. L. Spang, *The Invention of the Restaurant* (Cambridge, MA, 2000)

Charles Sterling, *La nature morte de l'antiquité à nos jours* (Paris, 1952)

Margaret A. Sullivan, 'Aertsen's Kitchen and Market Scenes: Audience and Innovation in Northern Art', *Art Bulletin*,

LXXXI (June 1999), pp. 236–66

Kirby Talley, '"Small, usuall, and vulgar things": Still-life Painting in England, 1635–1670', *Walpole Society*, XLIX (1983), pp. 133–223

Reay Tannahill, *Food in History* (New York, 1973)

Keith Thomas, *Man and the Natural World: Changing Attitudes in England, 1500–1800* (London, 1983)

Guy Thuillier, *La vie quotidienne dans les ministères au XIXe siècle* (Paris, 1976)

Maguelonne Toussaint-Samat, *History of Food*, trans. A. Bell (New York, 1998)

T. P. Turrent and J. de la Colina, *Conversations avec Luis Buñuel* (Paris, 1993); as *Objects of Desire* (New York, 1992)

Roger Vaultier, 'La gastronomie régionale en France pendant la Revolution', *Grandgousier*, VII/4 (1940), pp. 80–81

Céline Vence and R. J. Courtine, eds, *Les grands maîtres de la cuisine française du Moyen Age à Alexandre Dumas* (Paris, 1972)

A. S. Weber, 'Queu du Roi, roi des Queux: Taillevent and the Profession of Medieval Cooking', in *Food and Eating in Medieval Europe*, ed. Martha Carlin and J. T. Rosenthal (London, 1998), p. 155

Mariet Westermann, *The Amusements of Jan Steen: Comic Painting in the Seventeenth Century* (Zwolle, 1997)

C. Anne Wilson, ed., *The Appetite and the Eye* (Edinburgh, 1987)

—, *Food and Drink in Britain from the Stone Age to the 19th Century* (Chicago, 1973)

—, ed., *Luncheon, Nuncheon and Other Meals* (London, 1994)

Barry Wind, 'Annibale Carracci's "Scherzo": The Christ Church Butcher Shop', *Art Bulletin*, LVIII (1976), pp. 93–6

C. Wischermann and Elliott Shore, eds, *Advertising and the European City: Historical Perspectives* (Aldershot, Hampshire, 2000)

Acknowledgements

The author and publishers wish to express their thanks to the following sources of illustrative material and/or permission to reproduce it (donor or collection details are in some cases also given below):

Photo A.C.L., Brussels: 2; © ADAGP, Paris and DACS, London, 2004: 20, 80, 105, 121, 122, 143; Albright-Knox Art Gallery, Buffalo, New York: 20 (Room of Contemporary Art Fund), 50 (bequest of Elisabeth H. Gates); photo © Alinari/Art Resource, New York: 36; photo Jörg P. Anders/Staatliche Museen Berlin/bpk: 51, 61, 79, 112; photo Archivio Fotografico dei Musei Civici di Torino/Andrea Panni: 73; photos © 2002, The Art Institute of Chicago, All Rights Reserved: 66 (Mr and Mrs Lewis Larned Coburn Memorial Collection), 106 (Friends of American Art Collection); photo Bayerische Staatsgemäldesammlungen, Munich: 22, 33, 59, 93, 140 (Alte Pinakothek), 83 (Neue Pinakothek); photo © Beeldrecht: 98; photo Joachim Blauel –Artothek: 53; photo Blauel/Gnamm-Artothek: 68; photos The Bridgeman Art Library: 28 (© Museum of fine Arts, Boston), 104, 115, 124, 131, 133; photo Bridgeman-Giraudon/Art Resource: 78; Carnegie Museum of Art, Pittsburgh (Howard A. Noble Collection): 48; photo courtesy of the Governing Body, Christ Church, Oxford: 21; photo © Christie's Images, Inc., 1996: 99; photo © Cleveland Museum of Art (John L. Severance Fund): 34; photo The Samuel Courtauld Trust, Courtauld Institute of Art Gallery, London (Courtauld Collection): 46; Currier Museum of Art, Manchester, New Hampshire (Museum Purchase, Currier Funds): 76; © DACS, London 2004: frontispiece, 120, 146; © DACS, London/VAGA, New York 2004: 29, 144; Dallas Museum of Fine Arts (Dallas Art Association purchase), photo © 1991 Dallas Museum of Fine Arts: 70; Des Moines Art Center, Iowa (permanent collection; purchased with funds from the Edmundson Art Foundation, Inc.): 72; photo courtesy of the Gagosian Gallery, New York: 13; photo Giraudon/Bridgeman Art Library: 80; photo Glasgow Museums: 84; photo Tom Haartsen/Fotografie Beeldende Kunst: 86; Hirshhorn Museum and Sculpture Garden (Smithsonian Institution), Washington, DC (Museum Purchase), photo Lee Stalsworth: 107; photo © Galerie Ghislaine Hussenot, Paris: 9; photo © IRPA-KIK, Brussels: 49, 81, 129; Metropolitan Museum of Art, New York (bequest of Benjamin Altman), photo Photographic Services, Metropolitan Museum of Art: 127; Philippe Migeat/© CNAC/MNAM/Dist. RMN/Art Resource, New York: 119; Minneapolis Institute of Arts (the Eldridge C. Cooke Fund): 85; Moderna Museet Stockholm, photo Statens Konstmuseer/© James Rosenquist/VAGA, New York/DACS, London 2004: 145; © Munch Museum/Munch Ellingsen Group, BONO, Oslo, DACS, London 2004 (photo © Munch Museum (Andersen/de Jong): 71; Museum of Modern Art, New York, photos © The Museum of Modern Art/Licensed by SCALA/Art Resource, New York: 132 (Mrs Simon Guggenheim Fund); 143 (gift of Kay Sage Tanguy); photos © National Gallery, London: 52, 60, 96, 138; photo © National Gallery, Prague (photo archive): 146; National Gallery of Art, Washington, DC: 63 (Chester Dale Collection), 90 (Gift of Adele R. Levy Fund, Inc.), 109 (Samuel H. Kress Collection), 117 (Collection of Mr and Mrs Paul Mellon), 137 (Chester Dale Collection), 141 (Samuel H. Kress Collection); photo National Gallery of Australia (NGA 1979.68), © The Estate of Roy Lichtenstein/DACS 2004: 74; photo Norton Simon Foundation: 31; photo Öffentliche Kunstsammlungen, Basel/Martin Bühler: 6, 92; photo Hans Petersen/ Statens Museum for Kunst, Copenhagen: 116; Philadelphia Museum of Art (The Louise and Walter Arensberg Collection), photo Graydon Wood: 123; photo © Photographie Musée des Beaux-Arts, Rouen/Catherine Lancien, Carole Loisel: 91; photo Rheinisches Bildarchiv Köln: 24; photos © Rijksmuseum, Amsterdam: 26, 30, 75, 97, 125; photos RMN, Paris: 1 (RMN-Jean), 12 (RMN-Hérve Lewandowski), 16, 19 (RMN-Gérard Blot), 35 (RMN-Hervé Lewandowski), 57, 58 (both RMN-J. G. Berizzi), 64 (RMN-Hérve Lewandowski), 67 (RMN-R. G. Ojeda), 69 (RMN-Hervé Lewandowski), 77 (RMN/Art Resource, New York), 95 (RMN-Harry Bréjat), 105 (RMN/Art Resource, New York-Bulloz), 113, 139 (RMN-J. G. Berizzi); printed by permission of the Norman Rockwell Family Agency, © 2004 the Norman Rockwell Family Entities licensed by Curtis Publishing, Indianapolis: 45 (photo Norman Rockwell Museum), 134; San Diego Museum of Art, (gift of Anne R. and Amy Putnam): 62; photos: Scala/Art Resource: 11, 17 (Biblioteca Marciana MS. lat. I, 99), 25 32, 88, 89, 103, 114, 130; photo Schalwijk/Art Resource, New York: 65; photo Sheffield Galleries and Museums Trust/Bridgeman Art Library: 100; Smithsonian American Art Museum, Washington, DC (museum purchase): 144; photo Staatliche Museen, Kassel: 18; photo © Stichting Kröller-Müller Museum: 121; photos Stichting Vrienden van het Mauritshuis: 37, 94; © Succession H Matisse/DACS 2004: 92, 124; © Succession Marcel Duchamp/ADAGP, Paris and DACS, London 2004: 123; © Succession Picasso/DACS 2004: 103, 117; photo © Tate, London 2004: 27, 38, 40, 128; photo Claude Theriez: 14; Van Gogh Museum, Amsterdam (Vincent van Gogh

Foundation), photo VGM Enterprises: 39; photo © Virginia Museum of Fine Arts: 4; photos Elke Walford: 54, Elke Walford/© Hamburger Kunsthalle/bpk: 102; Walker Art Center, Minneapolis, (gift of T.B. Walker Foundation, Gilbert M. Walker Fund): 44; © The Andy Warhol Foundation for the Visual Arts, Inc./DACS, London 2004. Trademarks Licensed by Campbell Soup Company, All Rights Reserved (photo courtesy of the Gagosian Gallery, New York): 13; photo courtesy of White Cube Gallery, © Damien Hirst/Science Ltd: 47; Whitney Museum of American Art, New York (Purchase, with funds from the Larry Aldrich Foundation Fund): 29; Worcester Art Museum, Worcester, Massachusetts (gift of Mr. and Mrs. Milton P. Higgins): 7.

Index

Schmitt